Atlantic Tabor

About the Author

Dr Patrick Claffey, born in Castlerea, County Roscommon, is Wallace Adjunct Assistant Professor at the Department for the Study of Religions and Theology, Trinity College Dublin. His areas of interest are African and Asian Christianity and the religions of Southeast Asia. He he has travelled widely in these parts of the world for almost forty years. He has published several books and writes for a number of journals and reviews. He is a priest currently working in Dublin.

About the Photographers

Tomasz Bereska was born in 1982 in Poland. He graduated from Silesian Higher School of Economics in Katowice and moved to Ireland in 2007. He has worked as a freelance photographer with publications in Polish community magazines in Ireland and in European music magazines. Co-founder of freelance photojournalism agency Uspecto Images, he is also a producer and videographer of music videos for the leading Irish singers and bands.

Tomasz Szustek was born in 1975 in Poland, graduated from Jagiellonian University, Kraków and moved to Ireland in 2003. He has been working as a freelance photojournalist for Polish community magazines and websites in Ireland and developing at the same time personal photographic projects in Ireland and North Africa. His photos have been published in newspapers and magazines across the Europe. Co-founder of freelance photojournalism agency Uspecto Images, at the end of 2014 he published his first book, *Visual Notes from the Recession Time. Ireland 2008-2013.*

www.uspecto.com

Atlantic Tabor

The Pilgrims of Croagh Patrick

Text:
Patrick Claffey

Photographs:
Tomasz Bereska and Tomasz Szustek

The Liffey Press

Published by
The Liffey Press
Raheny Shopping Centre, Second Floor
Raheny, Dublin 5, Ireland
www.theliffeypress.com

A catalogue record of this book is
available from the British Library.

ISBN 978-1-908308-89-4

The poem 'Atlantic Tabor' was originally published in
Poetry Ireland Review. We are grateful to the editors
for allowing us to give it a new lease of life here.

Printed in Spain by GraphyCems

Contents

Acknowledgements

I have long had an interest in travellers and travel writing. My earliest memories include reading of the discovery of the Americas and other parts of the world in an encyclopaedia sent to me from New York by one of my aunts, a hand-me-down from one of her own sons, I think, and a treasure trove to me. The names rolled out, not just Christopher Columbus, but Vasco da Gama, the impressively named conquistador Hernán Cortés de Monroy y Pizarro, and for some reason a favourite, the man who 'discovered' Canada, Samuel de Champlain, 'the Father of New France'. It drew me into a new world and I have little doubt that it played an important part in shaping my later life and interests. It certainly transported me away from Roscommon.

It is, then, hardly surprising that I have maintained my interest in the genre we know today as 'travel writing', though I am not sure that term really describes the best of it; it is more than that. I am picky about the writers I like and there are some I dislike a lot, but then there are 'the greats', those who *see*, who empathize, and who can write about it reflectively. Despite his many personal foibles, Sir Richard Burton (1821–1890) is one I admire, having read his *A Mission to Gelele, King of Dahomé* (1864) when researching and writing about that country several years ago. Wilfrid Thesiger was also a giant in this tradition, writing almost

a hundred years later, notably his marvellous *Arabian Sands* (1959) and *The Marsh Arabs* (1964). Patrick Leigh-Fermor (1915–2011) is erudite but different, less austere and full of charm, humour and empathy. His *Time of Gifts* (1977) is an enduring classic, written over forty years after he made his youthful pilgrimage, walking from the Hook of Holland to Constantinople, starting in 1933 and finishing in 1935.

However, in this book I have looked to three writers I consider to be the best in the genre over the past thirty years, and also as having particular relevance here. I believe them to go several steps beyond simple 'travel writing' in their engagement with the people and the worlds they have encountered, and I admire all of them deeply.

Colin Thubron (b. 1939), whom I met briefly at a book launch in Dublin, personifies the great British travel writer. From a military family, educated at Eton, intelligent and deeply attentive to his experiences and the lives of real people, he is also something of a loner, as indeed are many travellers and travel writers, as Mark Cocker suggests in his study *Loneliness and Time: British Travel Writing in the Twentieth Century* (1993). Thubron seems to follow the Buddha's counsel: 'Should a seeker not find a companion who is better or equal,' the Buddha said, 'let them resolutely pursue a solitary course.' One critic notes: '[he] doesn't expect, and doesn't experience, consoling revelations on his unbelieving pilgrimage, which he makes alongside genuine pilgrims, pious Hindus from Southern India and elsewhere…' But there is little doubt that he is a genuine pilgrim and his *dharma*, in a non-theistic Buddhist sense, is indeed to be a wanderer, seeking only the truth that comes from within. In this, I think, he is very much of our post-religious time, speaking to many pilgrims of today, including many of the pilgrims I met on Croagh Patrick. He is also a great writer,

whose work *To a Mountain in Tibet* left a tremendous impression and was an inspiration when I went back to research and think about *Atlantic Tabor*.

William Dalrymple (b. 1965) has been my guide to India, its people and a large part of its history in three great books: *City of Djinns* (1994), *The Last Mughal: The Fall of a Dynasty, Delhi 1857* (2006) and *Nine Lives: In Search of the Sacred in Modern India* (2009). In *City of Djinns* he led me to the Nizamuddin Dargah in the heart of New Delhi, while *Nine Lives* provides a great insight into the ongoing sense of the sacred in modern India in all its complexity. He is indeed more than a travel writer, since Dalrymple is also, or perhaps above all, a historian, and somebody who has received wide acceptance in India, as well as being an impeccable stylist.

Robert Macfarlane (b. 1975) is a writer of the younger generation with a remarkable sense of place. He focuses his attention minutely on these islands and notably their ways and paths. He is also a walker with a deep sense of what walking, and indeed pilgrimage, is all about, both here and in the wider world. His books *The Wild Places (2007)* and *The Old Ways: A Journey on Foot (2012)* are full of knowledge and insight. He also has much to offer in understanding both mountains and the exercise of pilgrimage as his writing on Kailas and Minya Konka testify. He provided me with much valuable information and also with inspiration.

Fiona Rose McNally's MLitt thesis, 'The Evolution of Pilgrimage in Early Modern Ireland', completed in the Department of History, NUI Maynooth in 2012, was an invaluable, if somewhat providential, discovery, which I came across on a Google search. The cyber gods had smiled on me, as it is an excellent thesis in itself, providing a wealth of information but, of course, like all well-researched work, it opened up other fruitful paths

of inquiry and provided a lot of understanding. I have tried to contact Ms. McNally but without success; I am, however, greatly in her debt for substantial amounts of material used here.

Harry Hughes is a local businessman and Chairman of the Croagh Patrick Archaeological Group, with a lifelong family attachment to the Reek. His short book, *Croagh Patrick: A Place of Pilgrimage, A Place of Beauty,* provided much useful information and several very helpful references.

My lifelong friend, Peter McDermot, has taught me more about the flora, fauna, geology and landscape of Ireland than anybody else. Like Macfarlane, he is a seeker of the little path. Together with his wife, Margaret Mernagh, we have holidayed in and explored the west coast and its islands, from Donegal to Kerry. We visited Skellig Michael twice on a 'bad sea', as our skipper Joe Roddy described it. It left an indelible impression on me and is amongst the three or four most spectacular sites of any kind I have ever visited. Peter's library is a very impressive private collection to which I have always had access and unlimited borrowing rights. He introduced me to Peter Harbison's concept of the Western Maritime Pilgrimage,[1] and also to Estyn Evans' important book, *Ireland and the Atlantic Heritage: Selected Writings* (1996), both of which gave much food for thought as well as invaluable information.

Father Joseph Kallanchira, with whom I worked in Africa for many years, encouraged me greatly in my interest in his native India in all its complexity and urged me strongly to go there. In 2012, I joined him on my first trip, when he introduced me to 'God's own country', Kerala, and to his own Syro-Malabar rite as well as various forms of ancient Syrian Christianity found amongst India's 'Thomas Christians', who trace their origins back to the doubting apostle. This was followed by several more

visits, to the point where India has now become something of a passion.

Angela Crean and Irene Nealon have gone beyond the call of friendship, as they have been over the typescript several times. They have not just spotted many typographical errors but made several helpful suggestions on the text in order to bring greater clarity to my writing. I am very grateful to them for this time-consuming task, but I accept full responsibility for any gremlins that might have slipped through in this rigorous process.

Professor Maureen Junker-Kenny, Jane Welch and the Department of Religions and Theology at Trinity College Dublin graciously provided a lovely space in the small Sean Freyne Library, where every Wednesday I was guaranteed the quiet needed for this work, with the late Professor Sean Freyne, the eminent Mayo scholar, benignly smiling down on me from the wall.

Rosie McGurran and the Inislacken Project in Roundstone provided a time and a place to work out the last chapter of this book on what was one of my regular pilgrimages to Connemara; my thanks to everybody there.

While I sat comfortably in my study or in the Freyne Library, the photographers, Tom Szustek and Tom Bereska, were out there, in the field, in all weathers, gathering the wonderful images that form the heart of this book. This kind of work requires back-up and both photographers would like to express their gratitude to Kasia Sudak, Agnieszka Saczynska, Tomasz Wybranowski and Nadia Bereska who, over five years, provided indispensable assistance in the always challenging weather conditions on the slopes of Croagh Patrick. They would also like to thank the Collins family of Drumshinnagh House B&B, near Castlebar, who showed them the best example of a true Irish and always warm *fáilte*.

All three 'authors' would like to thank David Givens of The Liffey Press for his encouragement in accepting this book for publication.

Dublin, 31 July 2016, Reek Sunday

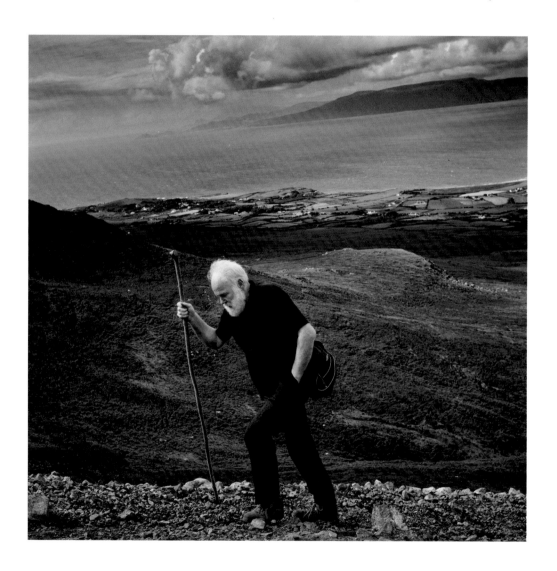

Atlantic Tabor

Patrick Claffey

The rain lashed the gable
that summer morning.
Soft Atlantic rain plashing
on the wall of that small church,
hidden in the shadow
of our holy mountain.
The last Sunday in July
I think it was,
the Sunday after the Connacht Final,
as the peaked caps and
craggy faces clambered in
the steps of the saint,
Rosary and ash plant in hand,
drovers of sin.

No miracles
on this rain-swept
wind-blasted mountain,
this Atlantic Tabor.

No tear-stained Virgin,
no turning disks
or flashing lights –
no charter flights,
this is altogether
ruder stuff and
strictly not for tourists.
I have heard it said
that they go barefoot,
leaving their blood on
stones, a kind of
expiation for their
long-forgotten untold sins
or those of ancestors.

It's sure I've been
Away too long, too long
And too far away.
I didn't understand.
They seemed so strange,
another tribe, another time,
this people of mine.

– July 1990

Dedicated to Pilgrims and Seekers everywhere
but especially the Pilgrims of Croagh Patrick
who keep the story alive

Introduction

The emptiness of that land was greater than I could imagine,
but in the faces of those people and the way they moved there
was something I seemed to know so well....
– Markéta Luskačová

This book is the result of a chance meeting that had nothing to do with what eventually became 'the Atlantic Tabor project'. My involvement started when a young Polish photographer, Krzysztof Maniocha, came to me at Trinity College Dublin, seeking my advice as a specialist in African Christianity on a photographic project he was undertaking on African Initiated Christian Churches. We had several very stimulating discussions around the whole area of the study of religions, while we also discussed his area of interest, photography, and the USPECTO project of photojournalism.[2] This was of great interest to me as I had a personal enthusiasm for ethnophotography from when I had worked in Africa, where I took many still, sadly uncatalogued, photographs. This has continued as my interest has spread to Asia with the great advances of digital photography.

During a later conversation with Tomasz Bereska, who had been introduced to me by Krzysztof, he told me that he had

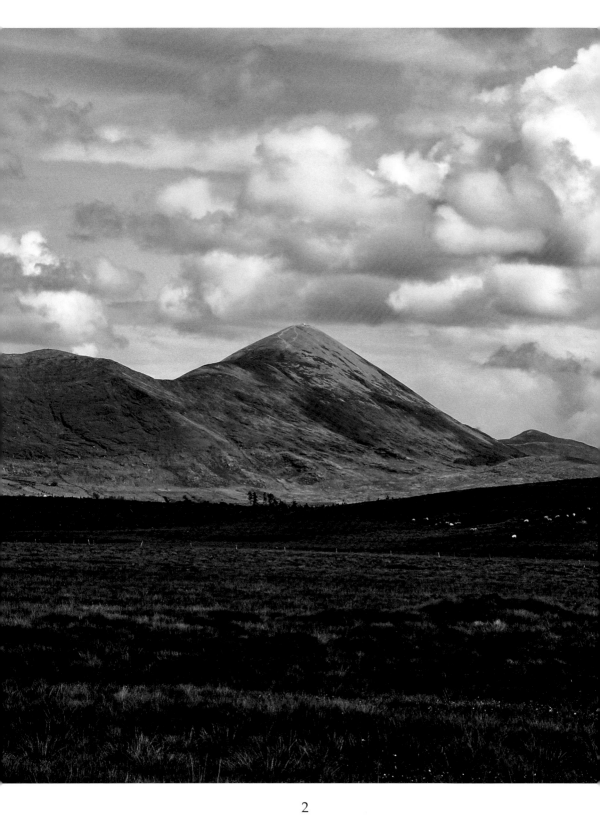

started work on a project relating to Croagh Patrick with his colleague Tomasz Szustek. I mentioned the Croagh Patrick photographs of Markéta Luskačová, which I had found many years previously,[3] while also showing him my poem 'Atlantic Tabor', which had been published in *Poetry Ireland Review*[4] and had, to a great extent, been inspired by her remarkable work. What impressed me most about her photographs was the deep empathy for and understanding of the place and of the people she encountered. Tom photographed the poem on his iPhone and later told me he had kept it and referred to it several times over the following year and a half as the project developed. I like to think that several of the photographs in this book were inspired by images in the poem, and in that sense the poem was somehow at the heart of the project. This book is essentially a conversation between the poem and the moving photographs that are at its centre.

This exchange, in any case, led to Krzysztof's colleague Tom Szustek inviting me to join them as a writer in their very interesting project. The initial idea was to write a Foreword or a brief introduction to a book of very good photographs. However, it soon became apparent to me that both of these photographers brought to this work a very Polish sensitivity to the whole understanding of pilgrimage, and the project expanded to become a very different kind of book. The Polish experience of the twentieth century underlay Szustek and Bereska's personal and artistic view of the world and also their religious faith. At the centre of this, I believe, was the idea of suffering. This was not dramatic suffering, as in situations of war and other great human tragedies, but rather the existential suffering of people in their everyday lives, in the often difficult business of living. They also understood the imaginary behind significant religious gatherings and the symbolism they involve. The pilgrimage to the Black Madonna in Jasna Góra

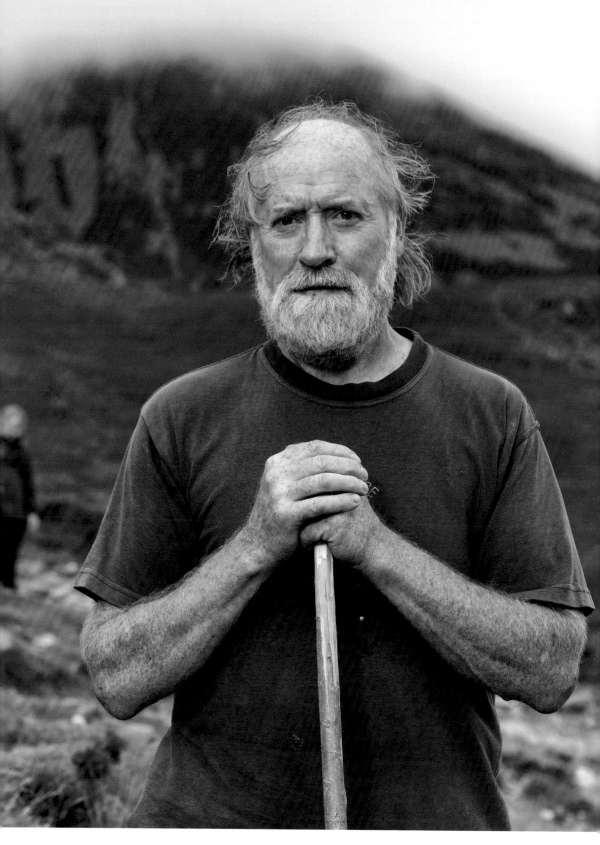

Gerry, County Galway

Monastery, Częstochowa, the great Polish Marian pilgrimage, is simply part of who they are. As one can see in the book, they had an inherent sympathy for and solidarity with the people they were photographing and the stories that were etched into their faces. They were well qualified for the task and this has been confirmed many times as I go back over the 150 photographs they sent me as we worked on the book.

An Eastern European Sensibility

Having left Ireland to live for many years in Africa, I never really thought much about Croagh Patrick until I came across Markéta Luskačová's remarkable photographs of the pilgrimage in the literary review *Granta* in 1989.[5] Looking at them in a remote bush village in West Africa, they came as a powerful evocation of my own experience of the mountain and seemed to bring it all back in another way. As the poem says, I felt closer but at the same time far removed from these people I knew to be my own. However, all the images, filed somewhere in the recesses of my mind, began to live again in my imagination. While I never climbed the mountain again, I visited the area around Croagh Patrick in July 1990, and however poems come to be, this was the day 'Atlantic Tabor' happened. With significant social change in Ireland, the crowds were much diminished but the people were still the same – they were local with their local faces, their local accents, and they were visiting *their* mountain. I, on the other hand, felt that I had changed. The poem itself was actually written when I got back to Africa and engaged with that experience and with the photographs once again. 'Atlantic Tabor' came as a response to this experience and to Luskačová's work, which had somehow crystallised it.

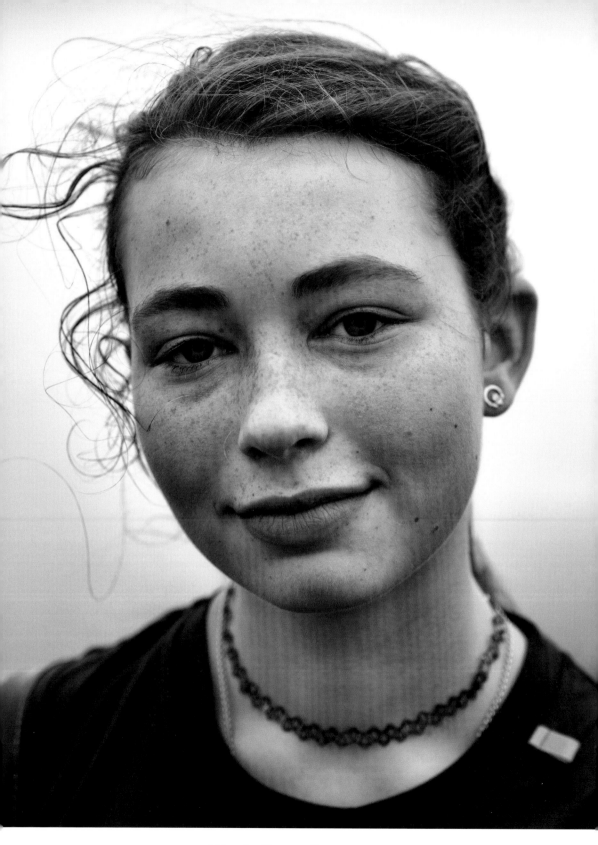

Niamh, County Roscommon

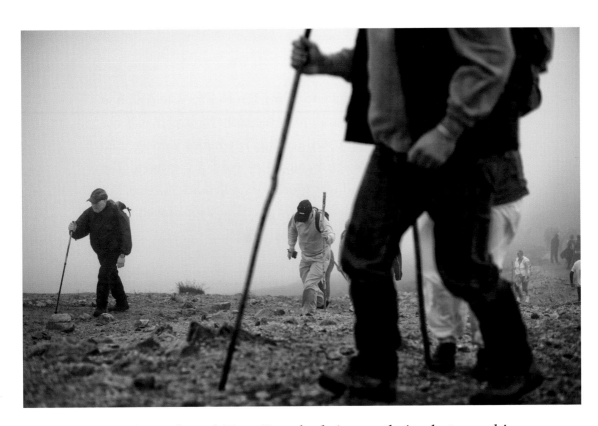

Tom Szustek and Tom Bereska bring to their photographic work the eye of the sympathetic stranger. They also bring, of course, their Eastern European sensibilities, including their distinctive religiosity, a faith that was forged in a time of oppression, which surely helped them to relate to the Reek pilgrims. Like Luskačová, they come from a culture where pilgrimage is important, where it is living, and touches the lives of people, often in their struggle for survival. Their observations are marked by a deep sense of empathy. But, of course, that isn't really the point. Gerry Badger writes of Luskačová, noting that 'she talks essentially about humanity, she explores what it is to be human … the primary tenor of her work is the everyday business of how people live and interact with each other, how they face the livelong day and get on with the often painful process of ordering

their lives.'[6] She reflects on the experience of taking the photographs in a marvellous passage when she writes:

> I couldn't find any meaning in my life so I tried to find it in my photographs. The summit of the Holy Mountain was bitterly cold and it didn't stop raining. My hands were so cold and wet that I scarcely managed to hold my camera. The emptiness of that land was greater than I could imagine, but in the faces of those people and the way they moved there was something I seemed to know so well...[7]

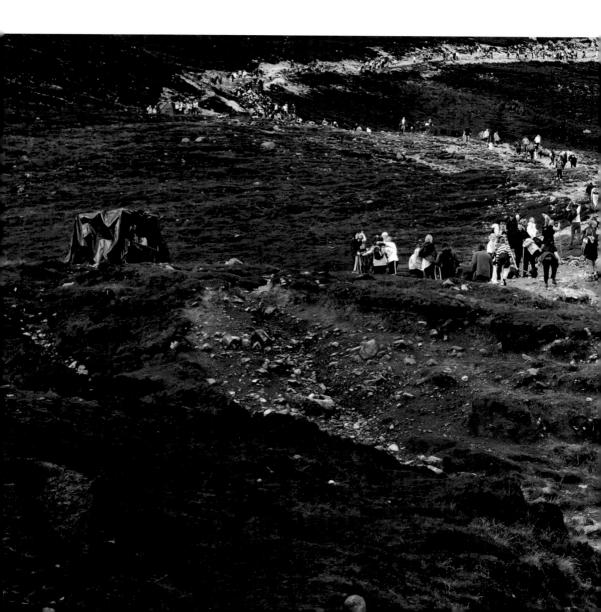

This is almost the definition of empathy and compassion, and it is shared by Tom Szustek and Tom Bereska in their work. Many of the photographs in this book convey a sense of exhaustion, of suffering and 'unspeakable sadness' that is perhaps best expressed in the Buddhist concept of *dukkha*,[8] since they speak essentially of the reality of suffering in people's lives and one of the ways they deal with it and seek *moksha*.[9] Similar pictures could, no doubt, have been taken on the *Hajj* to Mecca, during the *Kumbh Mela*, the 'world's largest congregation of religious pilgrims',[10] or on the *Camino de Santiago*, since in many ways the

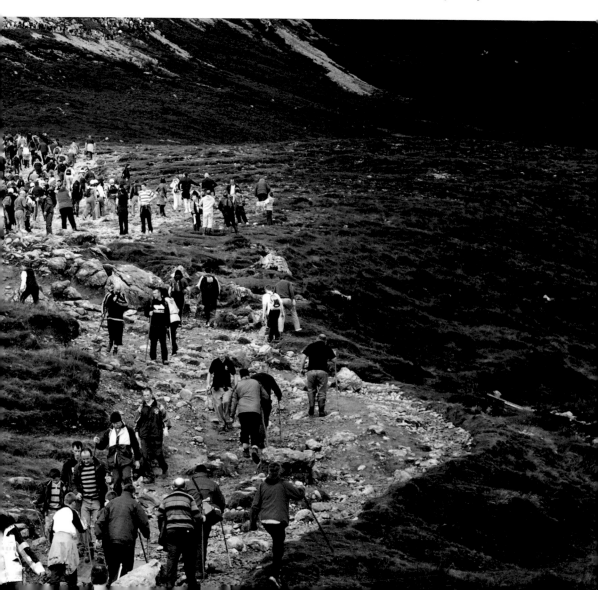

Jonathan, France

search is essentially the same and the pilgrims bring to it the same human sufferings and a deep desire for liberation.

A Sense of Place and National Identity

In addition to empathy and compassion, Markéta Luskačová's 'images have a specific sense of place and national identity in each and every case, and they are naturally informed by her upbringing and culture, but their essence is something we all recognise, from whatever background. She is, in short, concerned with eternal verities, another notion which has become somewhat unfashionable in recent years.'[11] In a letter he wrote to me early in this project, Tom Szustek set out his objectives:

> We wanted to produce a project which would be focused on Irish identity, heritage or Irish culture in general. But it was the people we were interested in – not landscape or historic monuments…. We wanted to show the diversity of pilgrims and that this tradition is still alive and plays an important role in the annual calendar for many people. Not every participant of the pilgrimage can be called pilgrim in religious terms, some of them made the climb just to experience the 'well known Irish' event, but this didn't bother us. The fact they did the climb on Reek Sunday means something, even if there was no overtly religious driven intention.

The colour photographs seem to me to be particularly successful in this regard. They bring us the essence of the people they portray: these are real people with real stories we can only guess at.

As Gerry Badger and Maria Klimešová express it in their very perceptive essay:

[Luskacova's] Croagh Patrick pilgrims are flagellants, resign-
edly bent before the flailing wind and rain, scrambling up
the rocky scree of the bare hillside to the stone chapel on the
summit. The mist, the evocative bleakness of the surround-
ings and the spirituality of the situation accurately reflected
her state of mind at the time.

Szustek and Bereska succeed admirably in entering into the
lives of their subjects; they are indeed what anthropologists and
ethnographers often describe as 'participant observers'.[12] They
empathise with these people in the daily struggles that they
bring to 'offer up', as they themselves would put it, in a very Irish
Catholic understanding of the meaning and sense of suffering.
In the same letter Tom wrote:

At the beginning we wanted to limit the project just to por-
traits but it was impossible for documentary photographers
to resist the temptation to photograph all the things that were
happening around us out there on Reek Sunday. I had a feel-
ing, perhaps illusory, that, in this place, the way people were
behaving was somehow very authentic and natural, despite
the fact that they were taking part in an ancient religious rit-
ual. The physical hardship of the climb had a part in it, I be-
lieve…. They didn't mind being photographed, which I think
is visible in our pictures. There were no suspicious gazes as
can be seen sometimes in street photography where passers-
by have no clue of photographers' intentions and behave in
assertive way. It appeared to me they had other things on
their minds.

In fact, of course, like pilgrims and devotees I have seen in
several parts of the world, they were going about what can be
described as the 'business of religion', which in their worldview

Jonathan, France

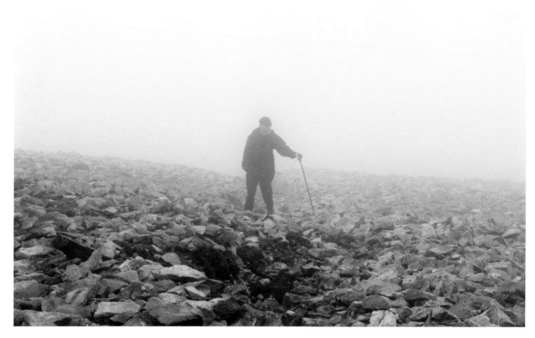

is simply part of the business of living and finding meaning in
their lives.

The black and white photographs, which are so powerful, suc-
ceed in capturing the drama of the mountain but also the essence
of the pilgrimage at a deep human level. These are mostly Irish
people who have done this for generations. Now, however, they
have been joined by others, young and old, who know little of
Saint Patrick but still want to be part of the pilgrimage for what-
ever reason. They want to be there. The weather as it is captured
is fast-changing and even dangerous as the cloud sweeps in over
the mountain and at times envelopes it, reducing visibility to a
few metres. The striking photographs of 'the drowned drumlins
of Clew Bay' in the Atlantic far below put it all in perspective.
Here, we are in another place and with another sense of time.
We are in the world but also out of it and, for these few hours,
time seems to have somehow stopped. One of the most striking

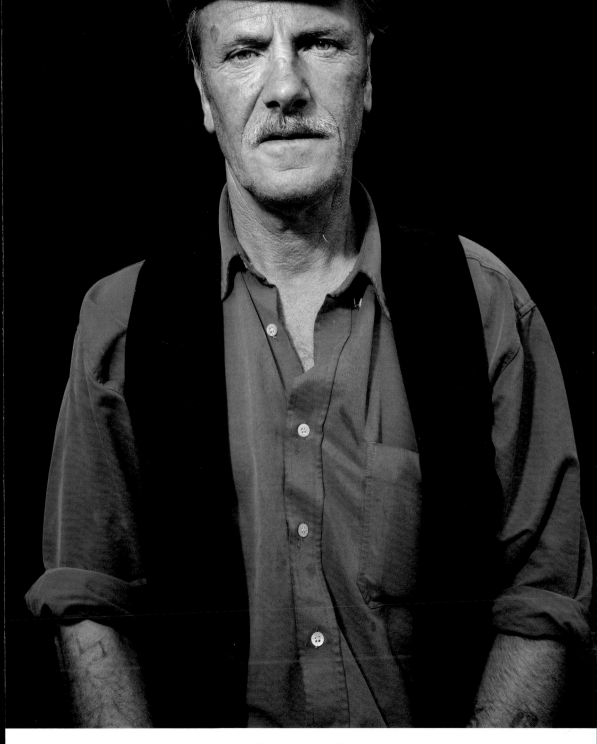

Brendan, County Sligo

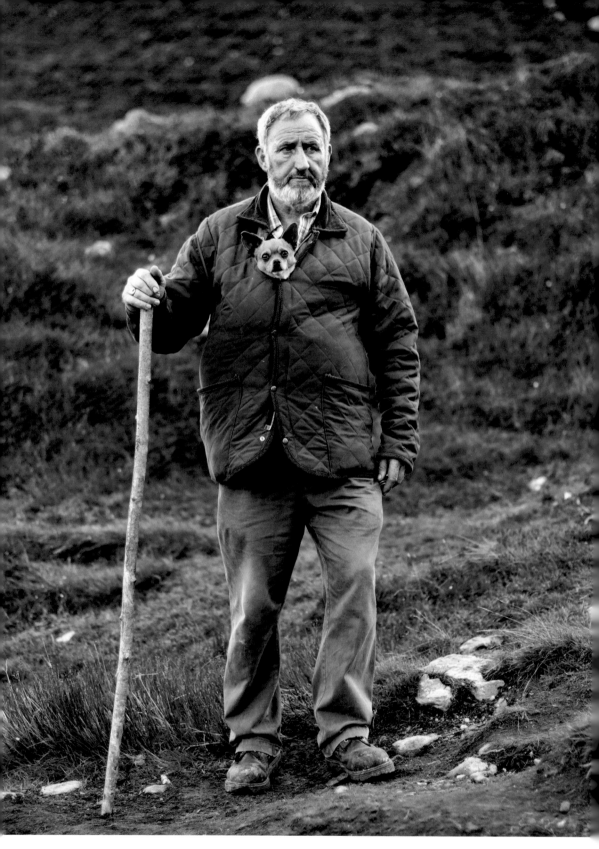

Dominick with his dog Edward, County Meath

images in the book can be seen below. It seems to bring together the weather, the mountain, the saint and solitary pilgrim with his own story. And there are many of these deeply personal narratives here, stories that can only be guessed at but which are no doubt quite real. It is in these studies that we come to the heart of what the pilgrimage is all about as it is etched in the faces of those who are doing it, with their *peaked caps / and craggy faces, [clambering] in the steps of the saint, / Rosary and ash-plant in hand / drovers of sin*. These are images one will go back to, simply to look at those faces and the questions they raise.

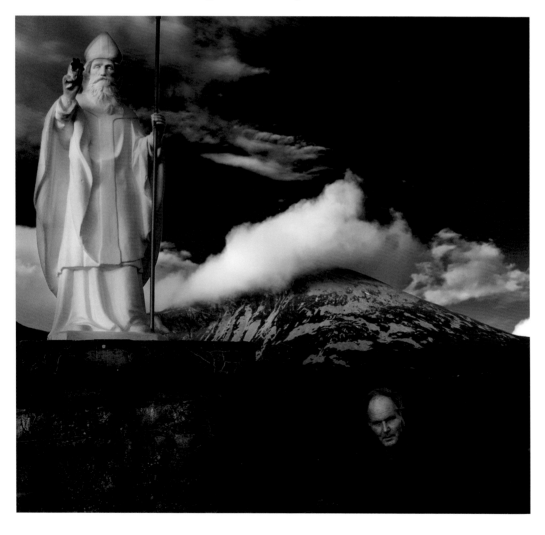

Why 'Atlantic Tabor'?

E. Estyn Evans, in his posthumous volume of essays *Ireland and the Atlantic Heritage*, clearly articulates the idea of an Atlantic European cultural community, a 'closed Atlantic community… which extended 'from Brittany to Norway and from Orkney to Spain.' As a geographer with a specific interest in pastoralism, Evans looks at the wider picture, writing:

> I also have in mind the extended meaning of pastoralism, the strong spiritual forces which have repeatedly have welled up and flowed out to enrich the whole Western World. Again and again saints and scholars, singers and orators, preachers and teachers, poets and dramatists, political leaders and agitators have raised their voices and gone forth.[13]

In Evans' view, it is clear that in this European Atlantic world Ireland was a centre rather than a periphery. This was very much the case along the western seaboard where there was a great amount of contact and activity, involving not just commercial exchange but the interaction of ideas of all kinds. Peter Harbison has advanced the idea of the Western Maritime Pilgrimage, where pilgrims travelled by boat from Kerry to Galway and Mayo and on to Donegal and beyond, linked to the cult of Saint Brendan, which explains how the great chain of early Christian remains all along the western seaboard came to be, most notably the remarkable concentration of sites on the Dingle Peninsula. The southernmost 'anchor' of all this enterprise was, of course, Skellig Michael which, in its breathtaking grandeur and splendid isolation, holds its own with any of the great pilgrimage sites of the world. Croagh Patrick and Inishglora off the Mullet Peninsula were part of that maritime pilgrimage. This remote coastline at the edge of Europe was in fact at the centre of an

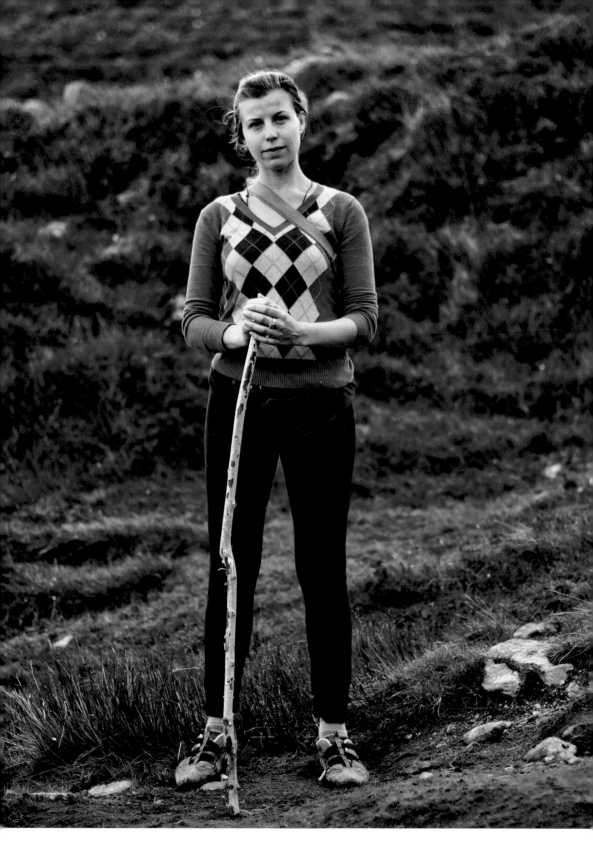

Tara, USA

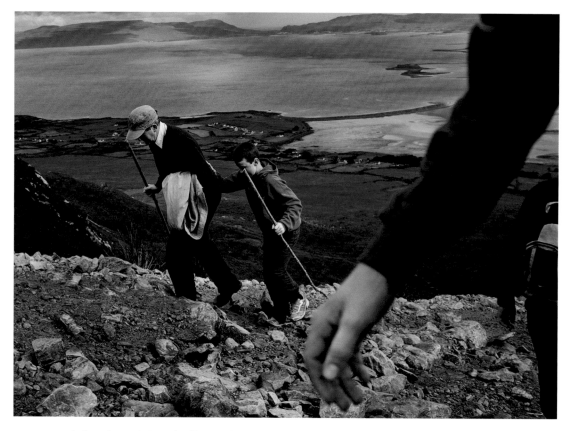

Atlantic spiritual *oikouménē*, a civilisation, which reached its height in the monastic missionary movement of the sixth and seventh centuries, when Irish monks founded important monasteries in Scotland and further afield in continental Europe, particularly in Gaul, where it is still remembered and acknowledged.

One of things I seek to do in this book is to place Croagh Patrick in a wider context of pilgrimage and holy mountains in the world. The choice of Mount Tabor was largely a question of scale, but also of narrative and of practical poetics. In writing the poem, I was seeking a mountain in the Judeo-Christian tradition that could be seen as paradigmatic, an archetypal holy mountain, and Tabor worked best. At 2,285 metres, Mount Sinai was too high – it was a real mountain. The narrative of Moses receiving the Decalogue (Exodus 20:1–17; Deuteronomy 5:4–21) also did

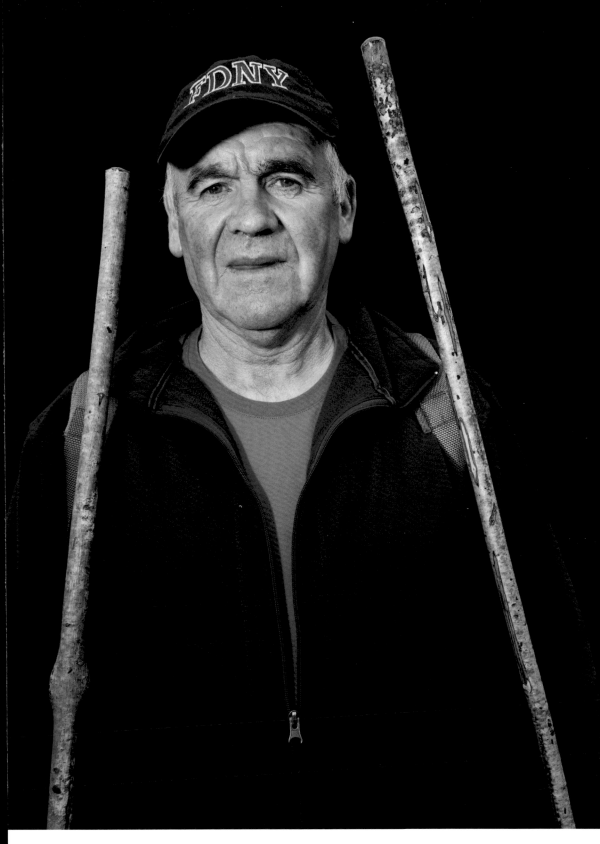

Martin, County Galway

not quite fit with the Croagh Patrick myth. Mount Tabor at 575 metres, however, and more or less on the same scale as Croagh Patrick, which has an elevation of 762 metres, seemed like a good choice. Mount Tabor is also believed by many Christians to be the site of the Transfiguration of Jesus (Matthew 17:1–9), that *kairos* moment of insight and understanding in the life of his apostles that led them to belief. This was much closer to the Croagh Patrick story.

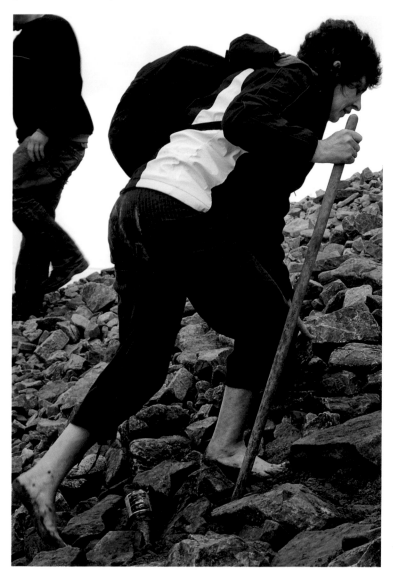

1.

Pilgrimage: Stepping out of Place and Time

The sheerness of 'never' is beyond us.
– Colin Thubron, *To a Mountain in Tibet*

A t the centre of several of the world's great religions one finds the concept and the practice of *pilgrimage*. Essentially, pilgrimage involves the idea of a journey, walking in its earliest practice, to a place of particular significance, often a *sacred place*, a place apart from the world. It is usually accomplished in a *sacred time,* a time that is somehow outside ordinary time, a time set apart from the temporal cycles of life. It can certainly be linked to the understanding of life itself as a journey, which leads to another place, a place beyond, set in another kind of time, or perhaps even out of time. In its religious sense, the journey is often a kind of seeking. It may be seen as part of our deep desire to move beyond the boundaries of the quotidian, for glimpses, perhaps, of an ultimate reality, or at least another perspective on our 'normal' life.

Writing somewhat more prosaically in the *Encyclopaedia of Religion and Ethics,* Hastings and Selbie observe:

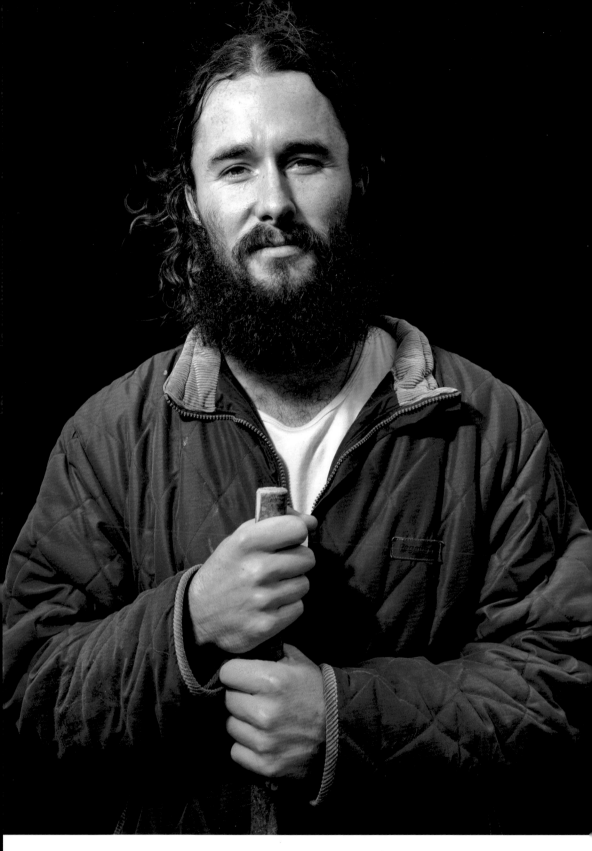

Ronan, County Donegal

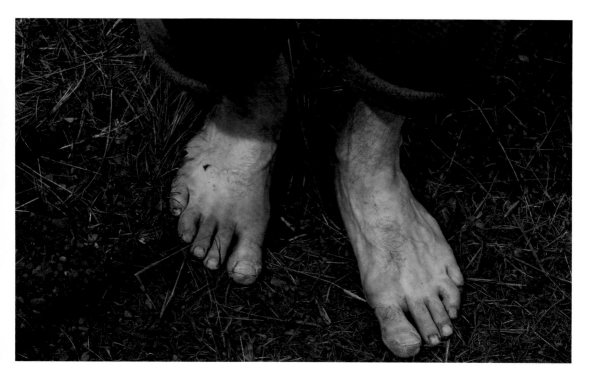

Most people understand pilgrimage as a journey to a holy place or shrine, either in the pilgrim's native land or abroad. The object of pilgrimage is to obtain some benefit – material, symbolic, moral or spiritual – which the sanctity of the chosen spot is believed to confer. A pilgrimage may be undertaken because such a journey is considered meritorious. The idea of the acquisition of divine favour, either directly or through a saint, is generally associated with such a journey.[14]

However, it can also be understood and lived as a journey into the self. Seamus Heaney captures this dynamic well with his suggestion that spiritual movement contains within it a definite excitement, a crossing over to a different place with a real sense of purpose. This is surely a part of pilgrimage.

Running water never disappointed.
Crossing water always furthered something.
Stepping stones were stations of the soul.[15]

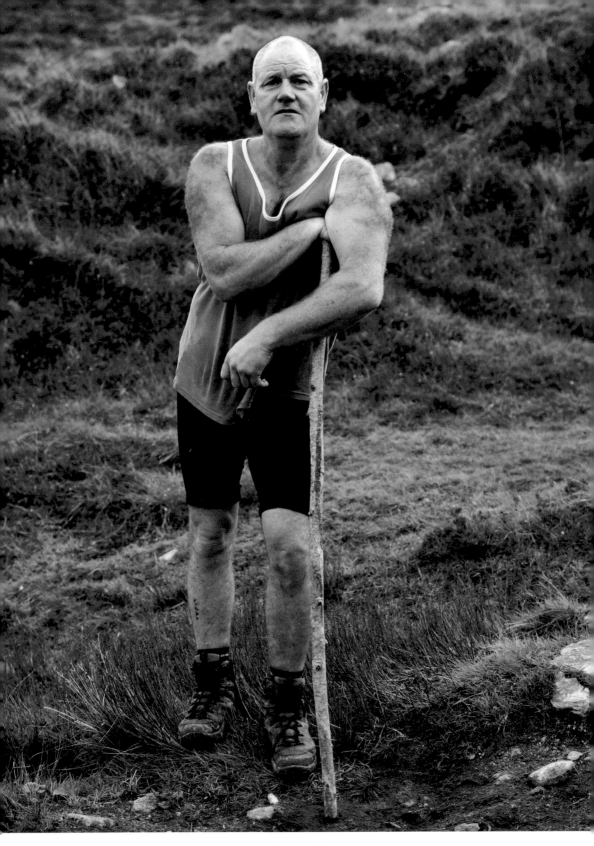

Tom, County Mayo

Encounter

In purely religious terms, pilgrimage is rooted in the deep desire to encounter what the great scholar of religion Mircea Eliade (1907–1986) calls the *ganz andere,* or the *totally other,* which he also refers to as *the really real.*[16] In terms of a more contemporary spirituality it can also express the desire to encounter the parts of the self with which we have perhaps lost touch, *the real self* that lies somewhere beyond the persona that has been constructed for us; that is, as a Buddhist might express it, beyond the illusion of self.

In the understanding of Eliade, all religious festivals, including pilgrimages, seek to bring to life sacred events from the mythical origins of humankind. In order to fully participate in them one is called to step out of ordinary time into sacred time, *the time of origins.* Sacred time is a time that is outside our modern, often frenetic, 24/7 year-round cycle, and so pilgrimages like other religious festivals occur periodically, often at the same determined time every year or every few years. Like all rituals, they are usually carried out in exactly the same, timeless way.

The scale of pilgrimages varies from the global to the very local. It is estimated that over 300 million people participate in pilgrimages every year as people seek travel with a purpose. It is a multi-billion dollar industry, with its own organisation, the World Religious Travel Association.[17] The global pilgrimages of the great world religions often have as their destination 'holy cities': Varanasi, the holiest city of Hinduism, to which there is a constant stream of pilgrims to bathe in the sacred Ganga, seeking the remission of sins that will lead to *moksha* or the liberation from *samsara,* the cycle of life and death; Jerusalem, which is holy to the three Abrahamic religions, with holy sites for Judaism, Christianity and Islam; Rome, the centre for the world's 1.2

billion Catholics, where the pilgrim, as opposed to the simple tourist, is traditionally required to visit seven churches – San Giovanni Laterano, San Pietro, San Paolo fuori le mura, Santa Maria Maggiore, San Lorenzo fuori le mura, San Sebastiano and Santa Croce in Gerusalemme – while the pilgrimage takes on special significance during declared Holy Years;[18] and the holy city Mecca, to which all devout Muslims desire to make the *Hajj* held annually in the twelfth Muslim lunar month of *Dhu al-Hijjah*.

I came to better understand and appreciate the depth of the whole concept of pilgrimage when Fatima, a Muslim woman in

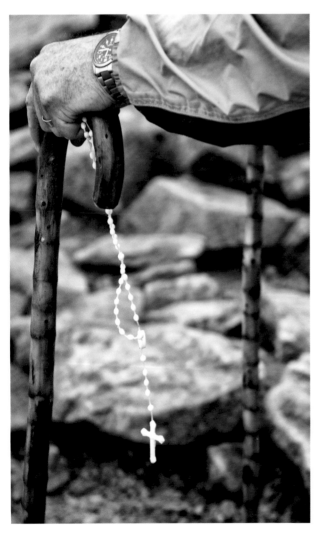

the village where I lived for many years in West Africa, told me of her grandfather's pilgrimage from northern Nigeria to Mecca, which she said he had made on a bicycle, probably in the early part of the twentieth century. He travelled for almost two years and his *Hajj* became a village legend. Today, of course, airports throughout the world are crowded every year as over 3 million people travel to Mecca, seeking to assure their salvation.

During the *Kumbh Mela*, the great Hindu Festival which lasts 55 days and is held at the

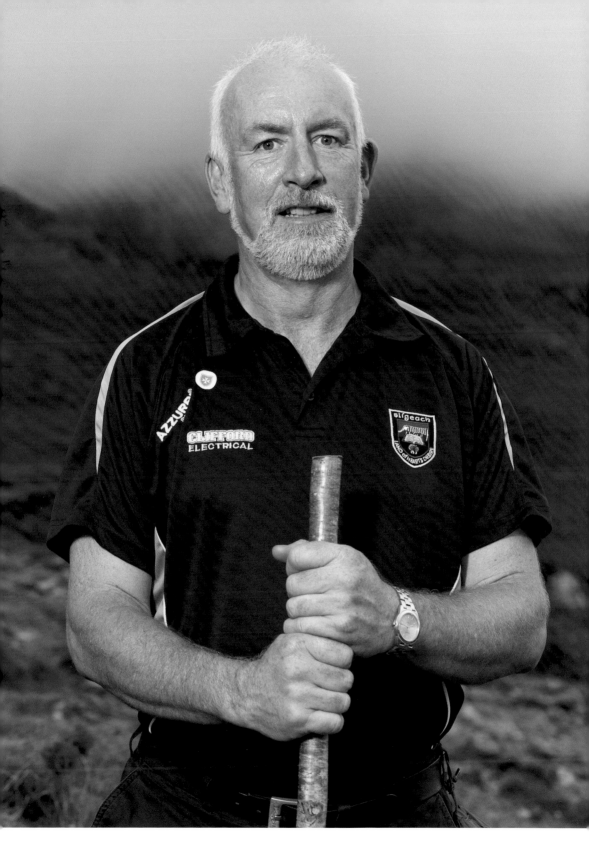

Aidan, County Sligo

place where the Ganges, Yamuna and mythical Saraswati rivers converge in Allahabad, India, every 12 years up to 100 million pilgrims make the journey from the farthest ends of the subcontinent to bathe in these holiest of waters.[19]

In addition to these, there are many other less well-known local pilgrimages, often based on a devotion to a popular deity, sometimes very local, or a revered 'saint', of which there are many in all the religions. The locations vary as pilgrims go

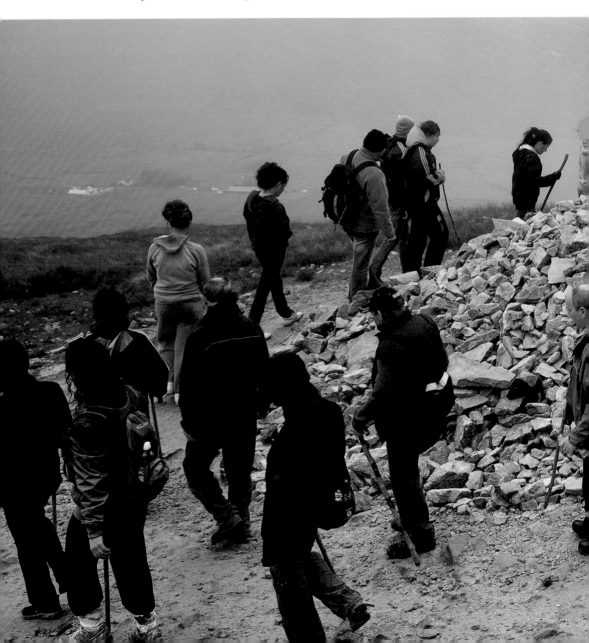

to holy cities and other sacred sites – mountains, rivers, forests, holy wells, tombs and grottoes – seeking those moments of encounter, however it is named, which is so much the innate desire of *homo religiosus*.[20] Many of these places are related to ancient religious rituals, sometimes pre-dating the religion that now claims ownership of them, while others have their origins in more recent devotional practices or the reputed apparitions and other apparently extraordinary or miraculous events that

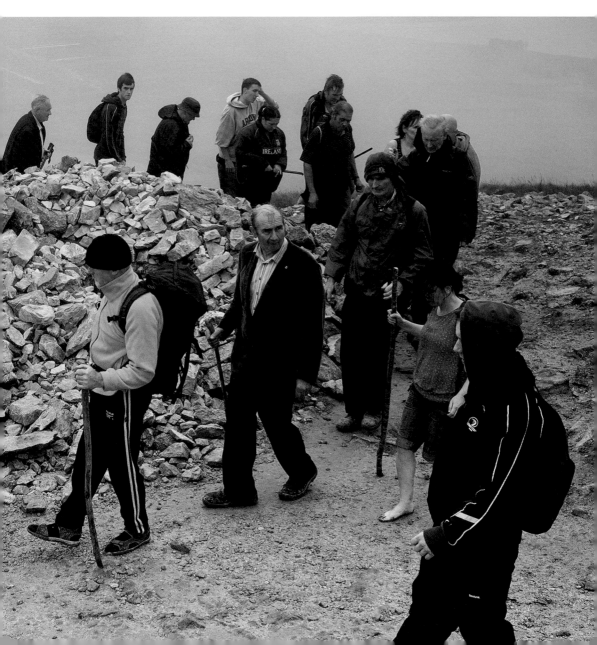

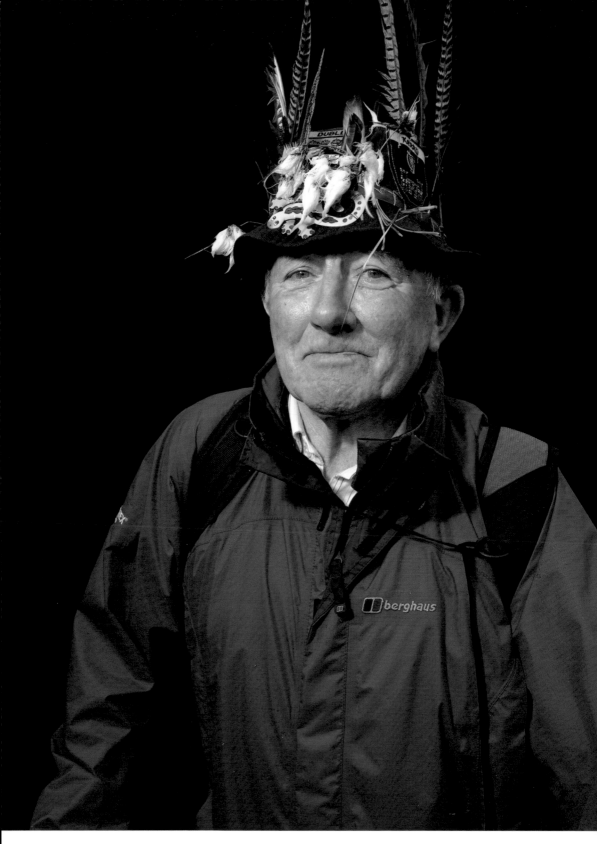

Tom, County Wicklow

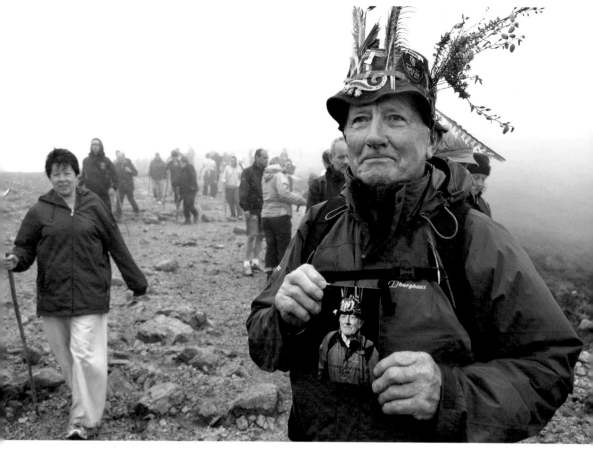

are part of what is described in contemporary Catholic terms as 'popular piety'.[21]

In Catholic terms, the best known pilgrimages in Europe are to the Marian Shrines at Lourdes (France) and Fatima (Portugal) which take place throughout the summer. Like the Irish Marian Shrine at Knock, County Mayo, these originated out of reported apparitions of the Blessed Virgin in the late nineteenth and early twentieth centuries. In Poland, the Black Madonna in Jasna Góra Monastery, Częstochowa, has a history going back at least 600 years and a pilgrimage, starting from Warsaw every August 6 for the nine-day 225 kilometre walk, has existed since 1711. During the latter half of the twentieth century this pilgrimage took on an added significance as the Black Madonna became an icon of Polish nationalism, worn defiantly on his lapel by union leader Lech Walesa, and a powerful rallying point for politico-religious

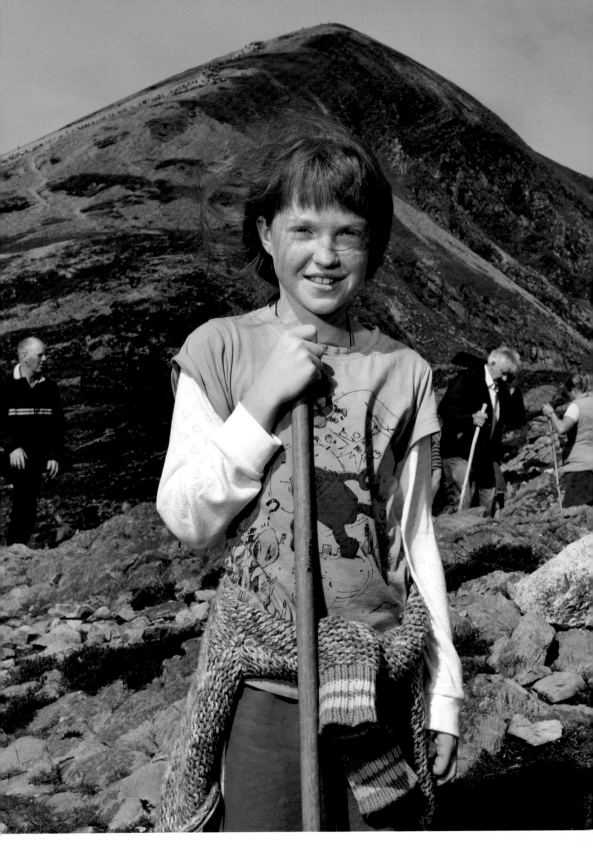

Nadine, County Galway

sentiment in the years leading up to the fall of communism, not just in Poland but, in a more or less domino effect, all over eastern Europe.[22] In the Americas, Saint Juan Diego's reported vision of Our Lady of Guadalupe in Mexico in 1531 remains central to American Catholicism, and the Basilica at Guadalupe is the most popular Catholic pilgrimage site in the world and the world's third most-visited sacred site.[23]

Walking the Walk: Pilgrimages Sacred and Secular

A non-Marian pilgrimage that has come to prominence in more recent times, while it remains relatively modest with perhaps 200,000 pilgrims annually, is the *Camino de Santiago*. The *camino*, as it is called by the pilgrims, has its origins as far back as the ninth century and grew in importance in the twelfth to

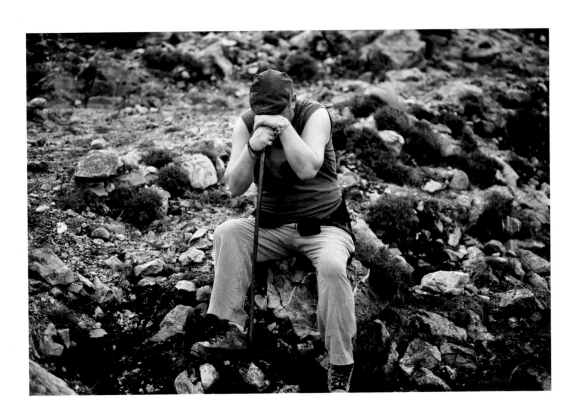

Daniel, County Galway

Christy, County Galway

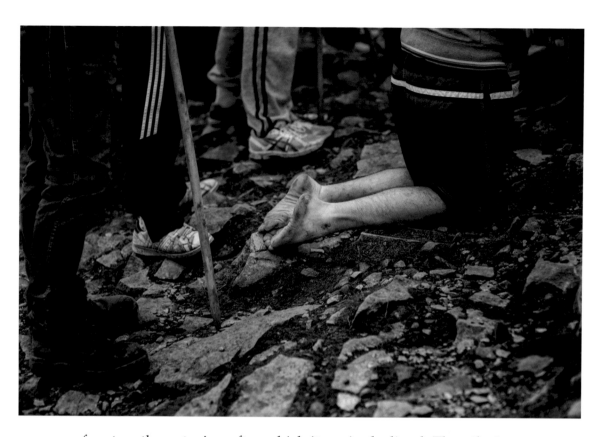

fourteenth centuries, after which it again declined. The pilgrimage can start at any one of four major routes through France, but mostly it follows the *Camino Francés*, a four or five-week trek across northern Spain, leading to Santiago de Compostela.[24] In sociological terms the *camino*, along with the Taizé Community and events like Catholic World Youth Days, can be described as part of a new form of religious socialisation or engagement with an emerging form of spirituality.

Celebrated in Emilio Estevez' very successful film *The Way* (2010), the *camino* is of particular interest because, as the film shows, it attracts a wide variety of people with all kinds of life narratives, many of which may not be traditionally religious. However, it is also of significance because it has come to prominence in an age that is largely secular and even post-Christian.

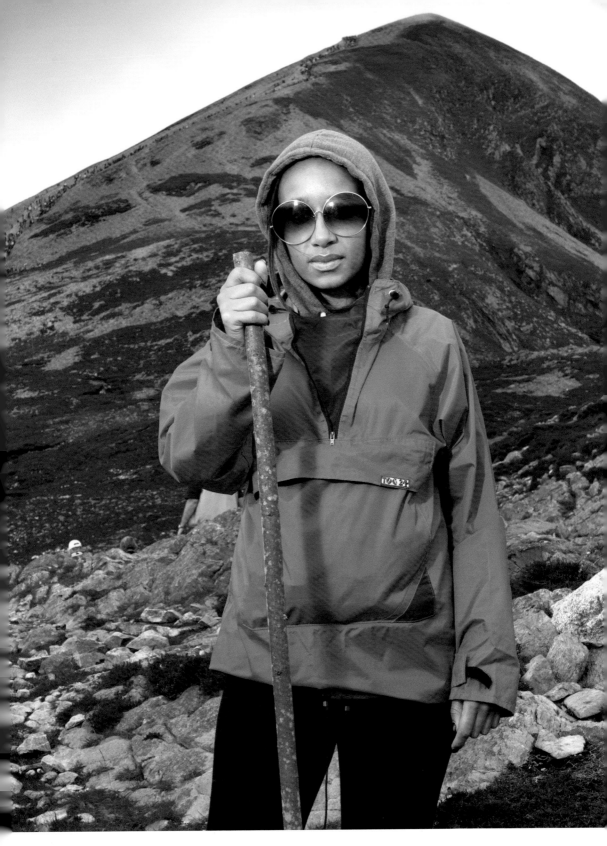

Aisling, UK

While many of the pilgrims are perhaps practising Christians, a large proportion also come from the contemporary *believing* (kind of, more or less!) but certainly not the institutionally *belonging* side of Christianity. Many, of course, may neither believe nor belong in any conventional sense, but, for whatever reason, as seekers they still do it.

The great Scottish-American explorer of the High Sierra, John Muir, wrote: 'I only went out for a walk, and finally concluded to stay out till sundown, for going out, I found, was really going in.'[25] For some it is no doubt simply the walk in itself that is in some way therapeutic. Robert Macfarlane tells us that John Clare (1793–1864) liked footpaths as he found them 'rich and joyful to the mind', and concludes that for the great but deeply troubled poet 'ways of walking were always ways of thinking'.[26] Walking requires a kind of 'mindfulness' that allows one to take a reflec-

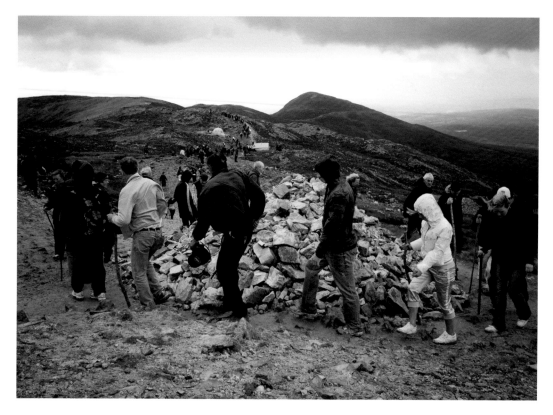

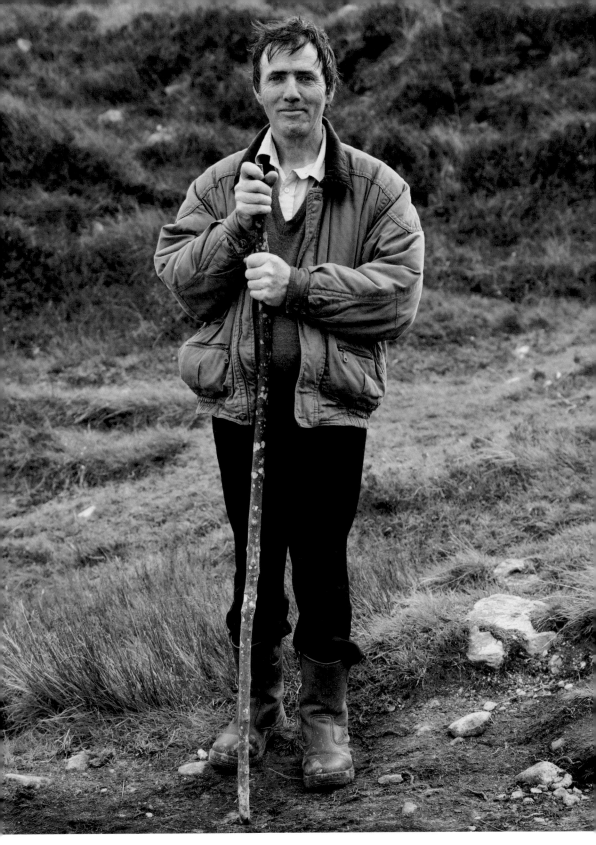

Michael, County Galway

tive distance from the problems of daily life, seeking some kind of salutary perspective that will allow them simply to carry on. So, following the counsel attributed to Søren Kierkegaard (1813–1855), they take a long walk:

> Above all, do not lose your desire to walk. Every day, I walk myself into a state of well-being and walk away from every illness. I have walked myself into my best thoughts, and I know of no thought so burdensome that one cannot walk away from it. But by sitting still, and the more one sits still, the closer one comes to feeling ill. Thus if one just keeps on walking, everything will be all right.[27]

The great American transcendentalist Henry David Thoreau (1817–1862) wrote: 'Me thinks that the moment my legs begin to move; my thoughts begin to flow.' Thoreau, however, moved only a short distance from his home town of Concord, near Boston, to live for two years, two months, and two days in a cabin

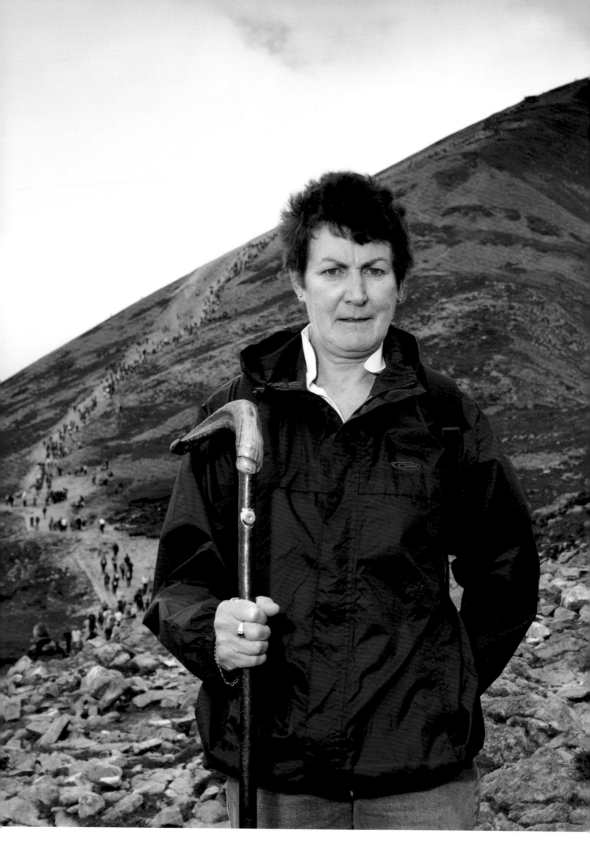

Noreen, UK

he built at Walden Pond. However even this short journey certainly had the spirit that, like that of his Danish contemporary Kierkegaard, would resonate with the kind of *mindfulness* sought by many modern pilgrims.

> I went to the woods because I wished to live deliberately, to front only the essential facts of life, and see if I could not learn what it had to teach, and not, when I came to die, discover that I had not lived. I did not wish to live what was not life, living is so dear; nor did I wish to practise resignation, unless it was quite necessary. I wanted to live deep and suck out all the marrow of life, to live so sturdily and Spartan-like as to put to rout all that was not life, to cut a broad swath and shave close, to drive life into a corner, and reduce it to its lowest terms.[28]

This was, however, more than a Buddhist withdrawal to some kind of sacred forest. Thoreau and his kindred spirits, Whitman, Emerson and John Muir, had begun to question and doubt the American dream. In the move to Walden, it is argued, Thoreau was articulating a discontent or unhappiness with the mainstream American lifestyle, which he saw as engaged in 'the monomaniacal pursuit of success and wealth'. This, he believed, '[had] paradoxically cheapened the lives of those engaged in it,' making them unable to appreciate the simpler pleasures in life and in being which he had set out to experience at the pond.

But it was more than that and it had a strong transcendentalist religious tone. He had become aware that, despite the apparent prosperity, there was a 'lack of hope', even a certain despair, in the way his countrymen were living, leading him to conclude that 'they are unable to continue farther on their pilgrimage toward true redemption,'[29] to the real fulfilment of the dream. This,

David, County Galway

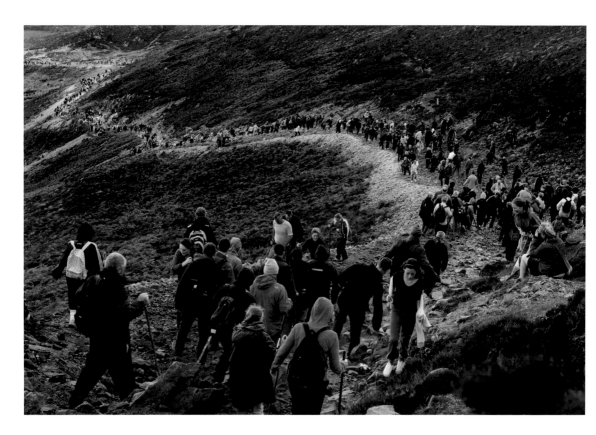

perhaps, offers an insight into the contemporary phenomenon of pilgrimage in the context of the doubt and uncertainties of a post-religious, secular, consumerist modernity that creates a thirst as much as it strives to quench it.

In another generation, and with another perspective, American writer Jack Kerouac (1922–1969) went hopefully on his own very different kind of pilgrimage, speaking for the 'beat generation' in its apparently doomed search for meaning and purpose:

> I was surprised, as always, by how easy the act of leaving was, and how good it felt. The world was suddenly rich with possibility…
>
> … Our battered suitcases were piled on the sidewalk again; we had longer ways to go. But no matter, the road is life.[30]

This, however, was a road and a life that would end tragically early in Kerouac's case with his death from liver failure due to alcohol abuse at the age of forty-seven.

A Pilgrimage to the 'Source of the Universe'

Mount Kailas,[31] which is near the sources of several of the most important rivers in Asia – the Indus, the Sutlej, an important tributary of the Indus, the Brahmaputra, and the Karnali, a

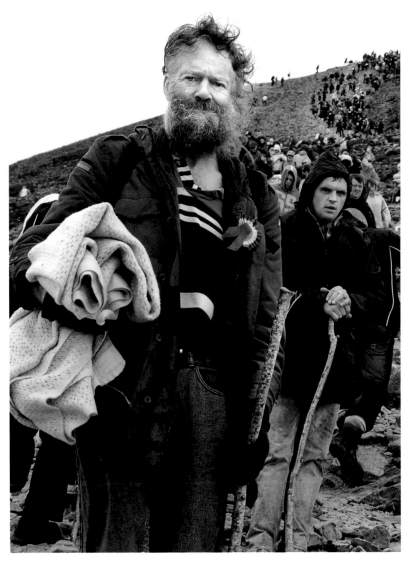

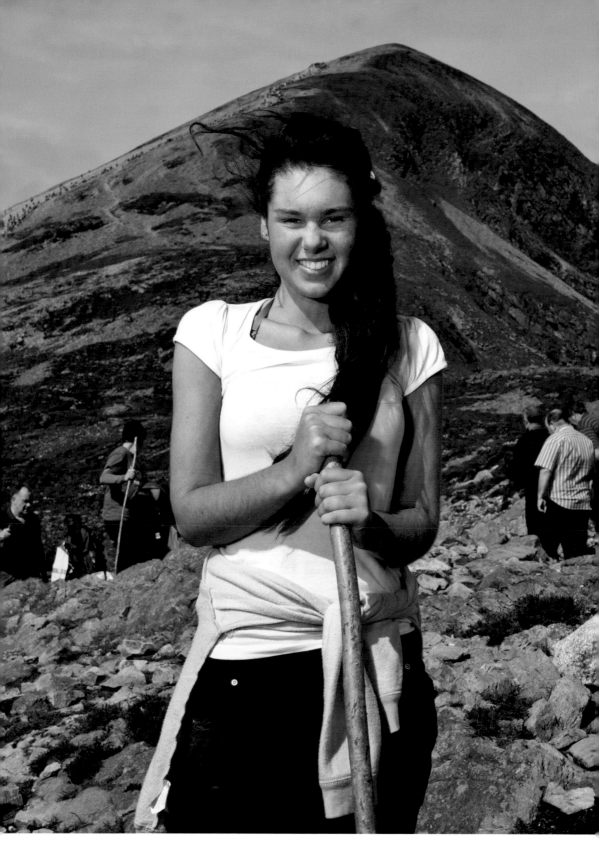

Amanda, Dublin

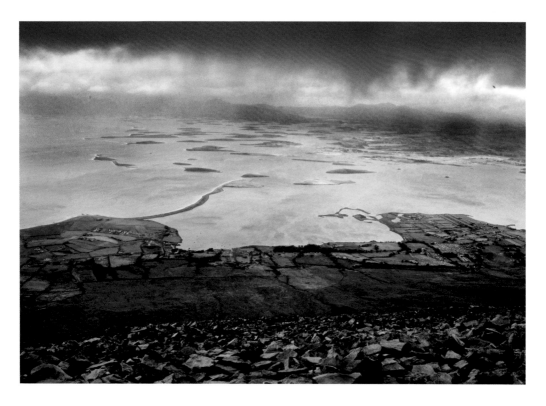

tributary of the Ganga – is sacred to four religions: Bön,[32] Buddhism, Hinduism and Jainism. For Buddhists, it is the holiest mountain, with a pilgrimage or *kora* that goes back thousands of years. Robert Macfarlane describes the most radical form of the pilgrimage 'in which the walker circumambulates, clockwise, the holy site – [and this] involves the pilgrim making body-length prostrations over the entire length of the circumambulation: *bend, kneel, lie face down, mark the earth with the fingers, rise, pray, shuffle forward to the finger marks, bend, kneel* … for thirty-two miles of rough rocky path, over the 18,000-foot Drölma pass.'[33]

The distinguished contemporary English travel writer Colin Thubron, in his marvellous book *To a Mountain in Tibet*, recounts his own pilgrimage around Kailas, offering another vision of pilgrimage that is perhaps more resonant with our times, one that

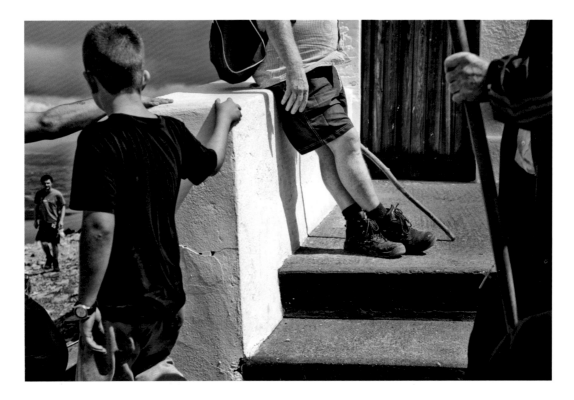

is rooted in a secular, existential and certainly not uncommon personal narrative:

> Uniquely for me, it originated in mourning. With my mother's death, the last of my family had gone, and I wanted to embark on something slow and contemplative. I chose to walk to Mount Kailas, the holy mountain in Tibet. It was an irrational instinct, a kind of secular pilgrimage.[34]

In one of the most remarkable passages in the book, his Sherpa guide, Iswor, asks him quite bluntly why he is doing this? Why is he setting out on this journey and, perhaps most critically, why is he travelling alone? It is, of course, the question every solo traveller asks themselves as they close the case or backpack to set off because, as I know from experience, every journey made alone, by choice, and without any apparent practical purpose, is

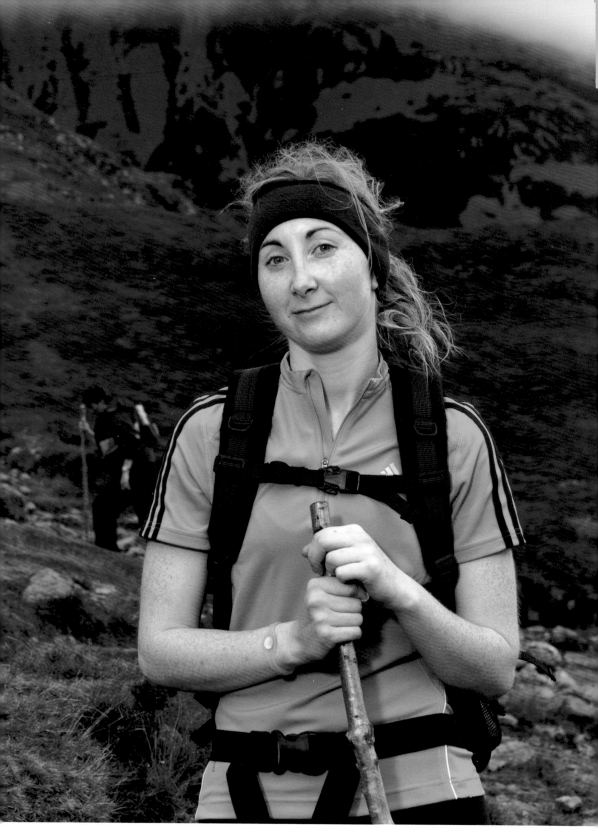

Ann, County Tipperary

at least partly a pilgrimage – a hill walk in Wicklow, a following of any of the many new Irish 'ways', a prolonged trip to the USA or India. The traveller is not simply addicted to the fumes of jet fuel but is really in search of something else that can only be found in movement. Thubron was taken aback by the question but his reply as expressed in the book offers great insight into his and other journeys:

> I cannot answer.
>
> I am doing this on account of the dead.
>
> Sometimes journeys begin long before their first step is taken. Mine, without my knowing, starts not long ago, in a hospital ward, as the last of my family dies. There is nothing strange in this, the state of being alone. The death of parents may bring resigned sadness, even a guilty freedom. Instead I need to leave a sign of their passage. My mother died just now, it seems, not in the way she wished; my father before her; my sister before that, at the age of twenty-one.
>
> Time is unsteady here. Sometimes I am a boy again, trying to grasp the words *Never; never again.* Humans, it is said, cannot comprehend eternity, in time or space. We are better equipped to register the distance spanned by a village drumbeat.
>
> The sheerness of *never* is beyond us.
>
> The Sherpa's eyes stay mute on me, puzzled. Solitude here is an unsought peril. I joke: 'Nobody's fool enough to travel with me!'[35]

The motivations for setting out are various and often very different, but there are elements of pilgrimage that are unchanging and it always has some kind of existential purpose. As in all pilgrimages, Thubron is going to a place that is almost unimaginably distant, seeking an encounter with he really knows not

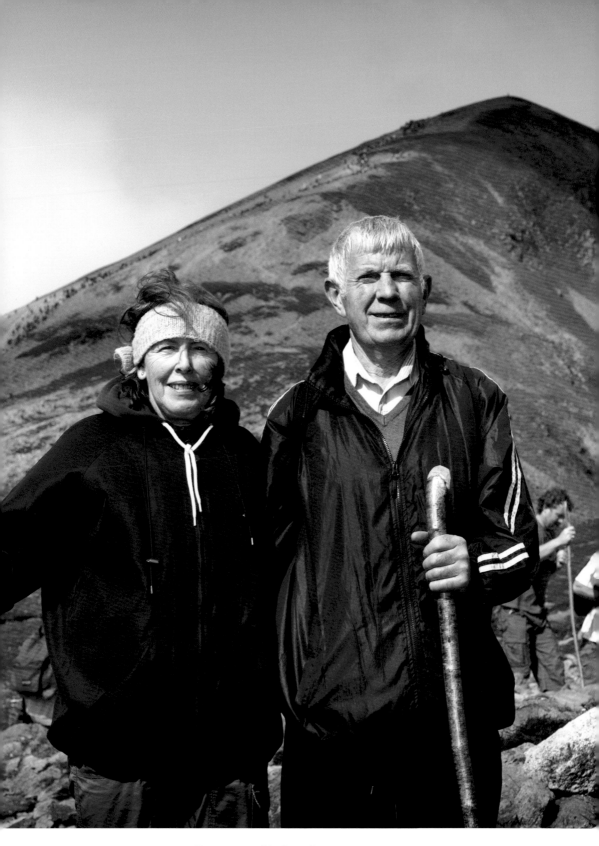

Breege and John, County Mayo

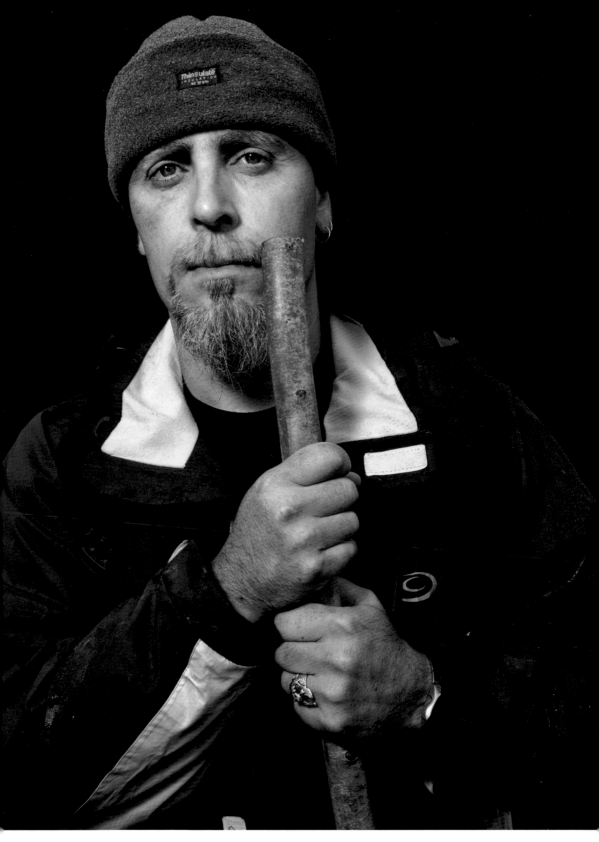

Ed, County Galway

what, but it is certainly outside the ordinary, both in place and in time:

> Mount Kaila is the most sacred of the world's mountains – holy to one-fifth of the earth's people – it remains withdrawn on its plateau like a pious illusion …

Is he fleeing his own illusions? If so, what is he seeking in this barren place, which he suspects may itself harbour illusions? He has stepped out of ordinary time, into a time that is, he tells us, *unsteady*, a time that is best expressed by the word *never*, a concept that seems more accessible than the *eternity* to a non-believer, even if it is only through *the sheerness of never*. Religious or secular, however, this is pilgrimage.

Pilgrimage an Opportunity to Delve Deeper

In his guide to the *camino*, John Brierley, writing from a personal experience 'born out of a mid-life crisis and the perceived need for time to reflect on the direction and purpose of life', gives an interesting and credible analysis of the phenomenon:

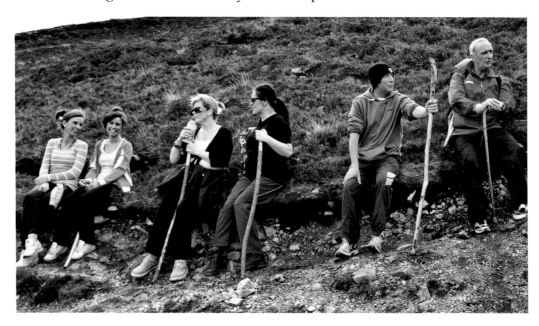

We have a sacred contract, a divine function and reason why we came here. Pilgrimage provides an opportunity to delve deeper into that purpose and the time to re-orientate our lives towards its fulfilment. We have been asleep a long time, but alarm bells are ringing for young and old and there are signs that we are collectively waking up.

Brierley sees the interest in the *camino* as part of a wider questioning of values in our largely post-Christian age, but an age that is still in search of faith. He continues: '

Along every path of enquiry there comes a point that requires a leap of faith, where we have to abandon the security of outdated dogma handed down to us over millennia. When we reach that point we have to let go of the safety of the familiar and dive into the unknown, with nothing but our faith to support us.

Brierley's view of the existentialist sense and purpose of the *camino* is decidedly modern as it places a great emphasis on the discovery of the *Self*. This, he asserts, is 'surely a primary purpose of pilgrimage and of life itself'.[36]

According to Robert Macfarlane, the paths walked by the great English poet Edward Thomas (1878 –1917):

connected real places but they also led outwards to metaphysics, backwards to history and inwards to the self.... Walking was a means of personal myth-making, but it also shaped his everyday longings: he not only thought on paths and of them, but also he thought with them.

Landscape, Macfarlane tells us, 'can enlarge the imagined range for the self to move in.'[37] Certainly my own conversations with friends (a retired solicitor, an archaeologist and expert on

Irish pilgrimages, a working single mother, a priest) and other people who have undertaken the *camino* confirm this and I have yet to meet one who was not touched in some way by the experience.

Over the centuries and into our own time, much of this has also been the context of the pilgrimage to Croagh Patrick. It draws on many of the common elements of pilgrimage the world over and brings them together on what I have described elsewhere as 'this wind-blasted mountain, / this Atlantic Tabor'.[38] It is a relatively small, local pilgrimage, drawing the majority of its annual pilgrims from a radius of about 80 kilometres, often coming literally from within sight of the holy mountain.[39] The preoccupations of its pilgrims may have changed somewhat over time – it

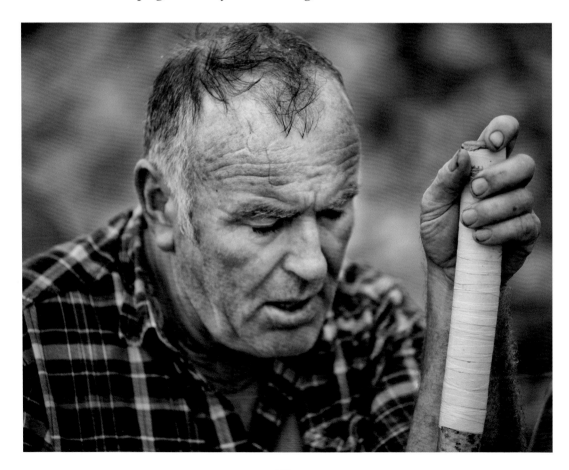

is perhaps less grimly penitential than in the past although that very Irish characteristic remains – but it is almost always deeply personal and, as with all pilgrimages, it is reflective of the concerns of the pilgrims of our own time all over the world. People bring to pilgrimage what they *are*, even if they are not always able to articulate it. They bring the various and disparate threads of their lives and seek to reconcile them into a whole that will make some kind of sense in a changing world that often seems confused. As we can see from the photographs in this book there is, as on the *camino*, a wide variety of people – the raingear is now often a colourful Gore-Tex, the staffs are more stylised but still

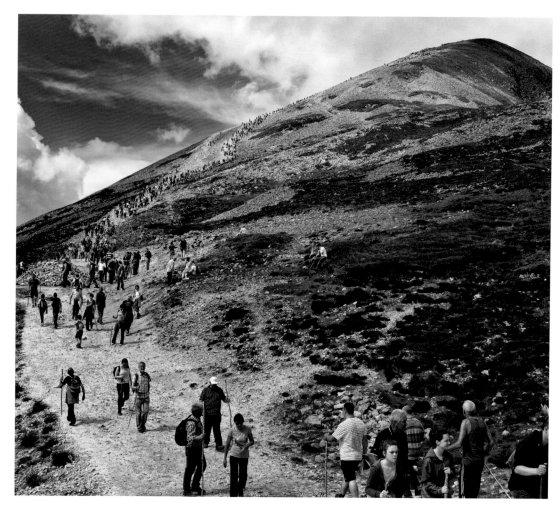

speak to us of pilgrimage, while the spirit is still much as it ever was and has much in common with all pilgrimages everywhere; it is still a crossing, a stepping out in the search for an encounter with the *totally other* and some kind of coming together of the *self*. In this sense, it continues to appeal to modern sensibilities, often to those whose relationship with 'organised religion' is tenuous or even non-existent. John, a professional man from Cork who does the pilgrimage annually with an old UCG friend, as well as several other pilgrims I met on the 2016 pilgrimage, say they are not religious in the more traditional sense, and certainly not regular in practice, but they see Reek Sunday as a day to somehow step out of life, perhaps to acknowledge a family tradition or to remember parents or friends who have trodden the way before them. As Heaney expresses it, pilgrimage in all its forms is, in one way or another, a journey along *the stations of the soul*.

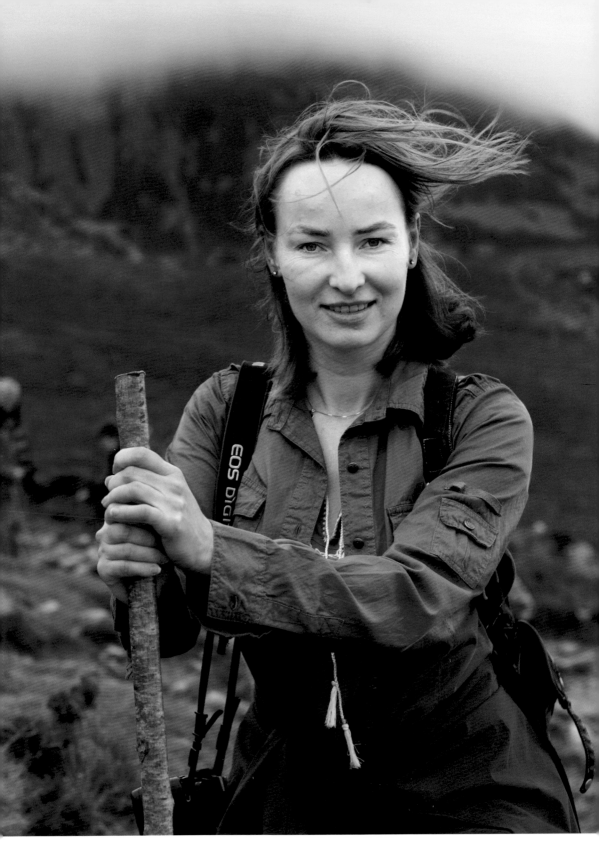

Anna, County Cork

2.

A Holy Mountain – The Reek in Myth, Prehistory and History

When I looked
at the mountain
long enough
I grew
to know
all manner of mountains.
– Peter Fallon, *Ballynahinch Postcards*

Cruach Phádraig, known in pre-Christian times as Cruachán Aigle,[40] near Westport, County Mayo, rises to a height of 762 metres and, as Peter Harbison so nicely expresses it, 'it looks down in a benign yet patriarchal fashion over the drowned drumlins of Clew Bay',[41] also known as the *Insule Fortunate*, the Fortunate Islands, on some early maps.[42] In my childhood, long before we went metric, it stood at a more impressive-sounding 2,500 feet;[43] a small 'mountain' in world terms but certainly more than a 'hill'.

In geological terms Croagh Patrick is one of a small number of quartzite peaks in Ireland, including the Sugar Loaf (Wicklow), Twelve Bens (Connemara) and Errigal (Donegal). That it became a holy mountain, a sacred site, is hardly surprising given its very striking bright quartz, pyramidal structure, drawing the

eye from a distance, especially in bright sunlight. It is not the highest elevation in Connacht, since this distinction falls to *Cnoc Maol Réidh*, the 'smooth bald hill' Mweelrea, soaring over Killary Harbour and looking out over the ocean, which at 814 metres (2,670 feet), with difficulty of access and a very brutal terrain is somehow very definitely a mountain. Many people, apart from the toughest hill-walkers, may not even know of Mweelrea, but everybody will know Croagh Patrick, given its visibility on clear days up to 80 kilometres away, across Mayo and into 'the flat plains of County Roscommon'.[44] It is from this area that is draws, perhaps, the majority of its pilgrims. The 'Reek' has dominated not just the topography but has also played an important part in the religious imaginary of the people living in this western part of Ireland going back into pre-Christian times.

Going Up the Seat of the Gods: Holy Mountains of the World

Mountains are seen as *holy sites* across many of the great religious traditions, if only for their remoteness and inaccessibility. They are seen as places of potential encounter with the supernatural, either benevolent or malevolent, and they can be dangerous places. Mount Fuji (3,776 metres), of which the Reek looks like a smaller version, is the highest volcano and highest peak in Japan and is considered one of the country's three holy mountains (along with Mount Tate and Mount Haku). Mount Meru (6,604 metres), the seat of the gods, with its five peaks, high in the Himalayas, is sacred in Hindu, Jain and Buddhist cosmology as the centre of all the universes – physical, metaphysical and spiritual. Colin Thubron offers a wonderful description of what he calls Kailas-Meru:

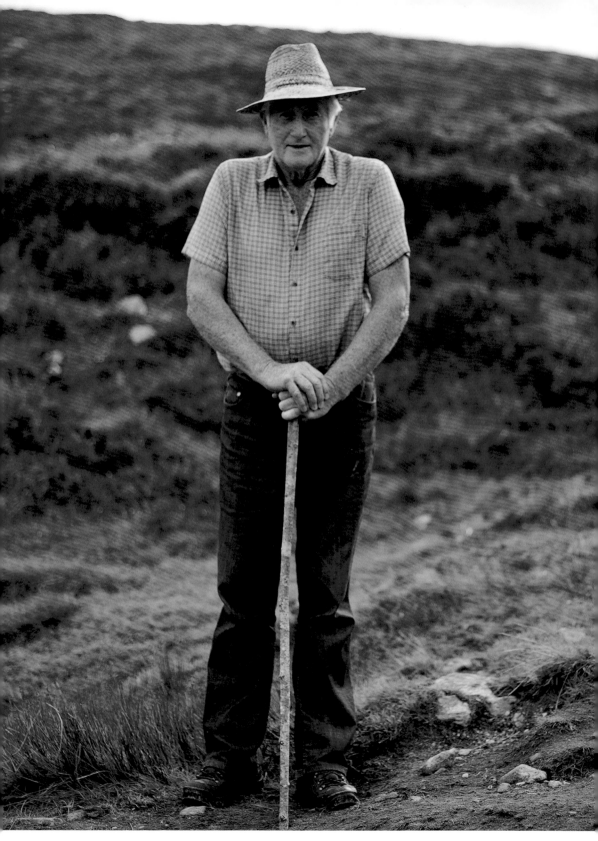

Austin, County Mayo

It was a site of astral beauty, separated from its companion Himalayas as if by divine intent. To the pious the mountain radiates gold or refracts like crystal. It is the source of the universe, created from cosmic waters and the mind of Brahma, who is yet himself mortal and will pass away. The sun and the planets orbit it. The Pole star hangs immutable above. The continents of the world radiate from its centre like lotus petals in a precious sea (humans occupy the southern petal) and its slopes are heady with the gardens of paradise.

But the God of death dwells on the mountain. Nothing is total, nothing is permanent – not even he. All is flux. In the oceans around Kailas-Meru, beyond the ring of iron mountains, countless embodiments of Meru, each identical to the last, multiply and repeat themselves, dying and resurrecting into eternity.[45]

This mountain is ambivalent, 'the source of the universe', coming as it does from the 'mind of Brahma,' the creator god; but also, as one might expect in these physical extremes, marked by

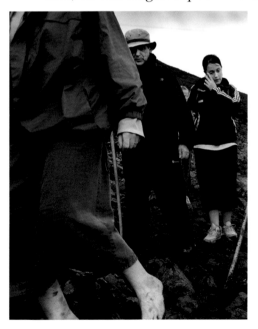

the precariousness and impermanence of life, where the 'God of death' also dwells. It is a place where there is a constant 'dying and resurrecting into eternity', a place where anything might happen.

Within the Judeo-Christian tradition there are, of course, many such sites, imposing mountains, but also small hills that serve as the locus for supernatural encounters and divine

intervention. The oldest and certainly the most celebrated is Mount Sinai (2,285 metres) in Egypt, one of the most important sacred places for Jews, Christians and Muslims. Bedouins hold that it was the mountain where God gave the laws, including the Decalogue or Ten commandments, to the people of Israel (Exodus 20:1-17). Christians, however, have traditionally placed this foundational event at the nearby Mount Serbal, where a monastery was founded as early as the fourth century CE, Christians having settled there as early as the third century.

> On the first day of the third month after the Israelites left Egypt – on that very day – they came to the Desert of Sinai. [2] After they set out from Rephidim, they entered the Desert of Sinai, and Israel camped there in the desert in front of the mountain.
>
> [3] Then Moses went up to God, and the Lord called to him from the mountain and said, 'This is what you are to say to the descendants of Jacob and what you are to tell the people of Israel: [4] 'You yourselves have seen what I did to Egypt, and how I carried you on eagles' wings and brought you to myself. [5] Now if you obey me fully and keep my covenant, then out of all nations you will be my treasured possession. Although the whole earth is mine, [6] you will be for me a kingdom of priests and a holy nation.' These are the words you are to speak to the Israelites.' (Ex. 19:1-7)

Moses was summoned to the mountain, where he 'went up to God' to receive the law but also to establish the covenant in which the people of Israel 'will be […] a kingdom of priests and a holy nation'. It is a place of rebirth for a previously downtrodden but now liberated people that pledges allegiance to God in a new covenant, with all its laws and obligations and with all that this implies in the beginnings of monotheism and the rejection of the

local deities. The narrative is paradigmatic and will be repeated in several variants in many places, including Croagh Patrick.

Mount Tabor is believed by many Christians to be the site of the Transfiguration of Jesus (Matthew 17:1–9).

> After six days Jesus took with him Peter, James and John the brother of James, and led them up a high mountain by themselves. [2] There he was transfigured before them. His face shone like the sun, and his clothes became as white as the light. [3] Just then there appeared before them Moses and Elijah, talking with Jesus.

The location again is 'a high mountain', to where Jesus has gone not alone but with three of his favoured apostles, and it is they who receive enlightenment as they see Jesus talking with both Moses and Elijah, the great prophets of Israel, before receiving affirmation from on high:

> 'This is my Son, whom I love; with him I am well pleased. Listen to him!'

There are lesser unnamed elevations where several events in Jesus' life are said to have occurred, most notably the temptations related in Matthew 4:8-11 and the Sermon on the Mount in chapters 5-7 of the same gospel account. In the context of Croagh Patrick and the patrician narrative, Matthew 4:8-11 is of great importance:

> [8] Again, the devil took him to a very high mountain and showed him all the kingdoms of the world and their splendour. [9] 'All this I will give you,' he said, 'if you will bow down and worship me.'
>
> [10] Jesus said to him, 'Away from me, Satan! For it is written: 'Worship the Lord your God, and serve him only.'
>
> [11] Then the devil left him, and angels came and attended him.

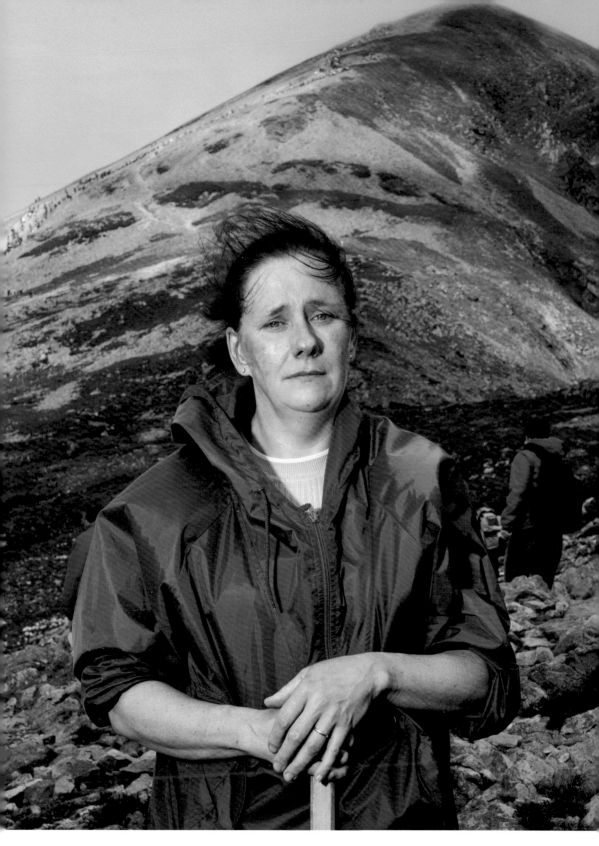

Carmel, County Sligo

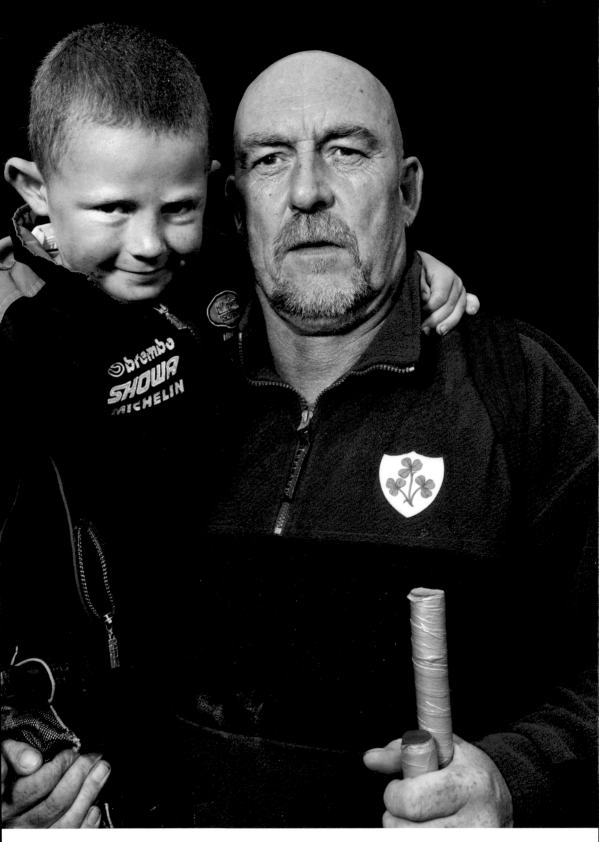

John with his son Michael, County Galway

Here the protagonists are different in that Jesus encounters not God but the devil, but faith in the one God is reaffirmed and acclaimed by God's messengers, the angels, who come to attend on him. Mercia Eliade points out, however, that for Christians, 'it is Golgotha that is on the summit of the cosmic mountain'.[46]

Eliade concludes that mountains are 'holy ground *because it is a place nearest to heaven*, because from here, from where our abode is, it is possible to reach heaven; hence our world is a high place'.[47] Holy mountains, wherever we find them, are invested with what he describes as an 'awe inspiring mystery (*mysterium tremendum*), the majesty (*majestas*) that emanates an overwhelming superiority of power', inspiring a certain religious fear in the presence of the fascinating mystery (*mysterium fascinans*) that is the *ganz andere*, the totally other.[48] We have here a great sense of the *sacred*, but also of tremendous *power* and for *homo religiosus* this is reality, the *really real*.[49] All of these represent a different sense of place and a different sense of time, places set apart on the heights, at the interface between heaven and earth, where these encounters with *total otherness* often take place, at the seat of the gods. They are frightening in their power. They are places of struggle, sometimes with the gods, but also with the forces of evil and indeed with the self, but they are ultimately scenes of victory; the Manichaean victory of light over darkness, good over evil and, ultimately, the Christian God over the lesser gods. Unsurprisingly, it is in these Judeo-Christian narratives we find much of the inspiration for Croagh Patrick.

Myth, Prehistory and Early History

Robert Macfarlane, writing of an expedition to the deeply mysterious Minya Konka[50] mountain and monastery in Sichuan Province in China, describes it in striking terms:

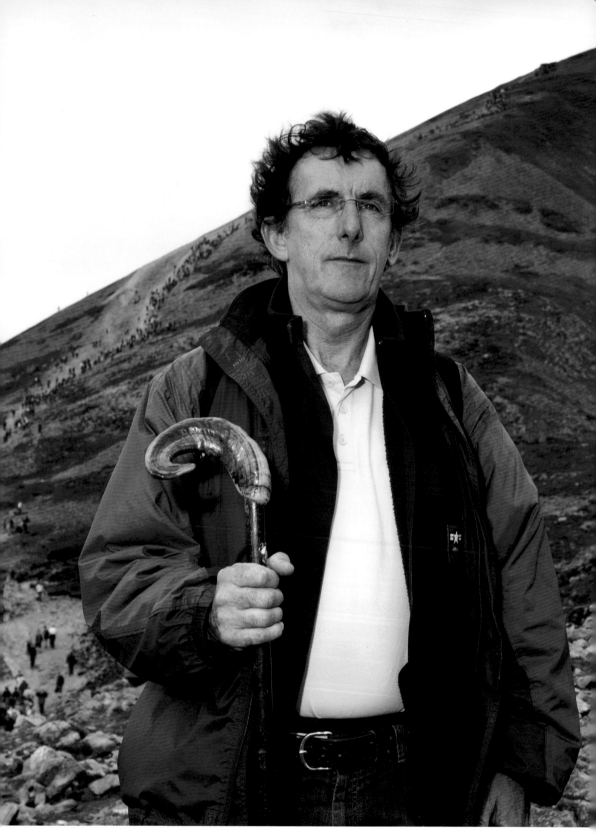

Charles, UK

Finally, we emerged from an arch in the trees and there right upon us was the Minya Konka Monastery, perched on the brink of a ravine, and right upon the monastery it seemed, was the mountain itself, hidden from us all morning by the slope and the trees.

I hadn't ever before reached a mountain landscape so wholly sacralised, in which almost every human mark was either an expression of devotion or a marker of hierophany. Everything was oriented towards the peak. On the west-facing slopes were stands of white wooden lances, ten or fifteen feet tall, each pennanted with white prayer flags that snapped in the wind, dispersing *om mani padme hums* to every direction. Wide stones marked with crosses or footprints showed places where lamas had self-arisen, creating images of themselves through intense meditation. There were stupas, and *mani* stone piles, and there was the monastery itself, its windows and doorways gazing up at Minya Konka.

'*Nayri*,' said John. '*Nayri* is the Tibetan for a sacred place such as this: *ri* means "mountain", and you'll find it everywhere in Tibet; *nay* means something like "embodiment of the sacred". *Nay* could be found in a series of rocks, or a tree, but it's most usually present in a mountain.'[51]

Croagh Patrick is such a place, a mountain that is somehow the embodiment of the sacred – *Nayri*. Its ritual significance, however, goes back into the mists of prehistory and of myth, quite possibly as far or further than Minya Konka. Evidence of various kinds, largely archaeological, continues to be amassed allowing us to have a much better picture of the Reek and the surrounding area. It is reported that material discovered included *fulachta fiadha* (Bronze Age cooking sites), megalithic tombs, standing stones, burial mounds, ringforts, monastic sites and *cillins* (or

lisheens), which were in later Christian times burial places of unbaptised children, although this may well have had an older pagan origin.[52]

There are traces of significant later-prehistoric and early historical ritual, ceremonial and defensive activities, confirming that it had been a 'sacred mountain' long before its Christian, syncretistic assimilation. Recent archaeological evidence, revealing the remains of a hill fort at the base and Neolithic art on a rocky outcrop known as 'Saint Patrick's Chair', suggests it goes far back into pre-Celtic times almost 6,000 years ago,[53] thus making it contemporaneous with the Céide Fields in north Mayo.[54] It can certainly be said to have been the kind of place where what Eliade describes as 'hierophonies'[55] might happen. These were those moments when a kind of breakthrough of the *sacred* into the region of the *profane* occurred, and which our religiously porous ancestors, with their openness to divine interventions of all kinds, saw as an encounter of those two very distinct spaces.[56] As Eliade expresses it: 'In each case we are confronted by the same mysterious act – the manifestation of something of a wholly different order, a reality that does not belong to our world, in objects that are an integral part of our natural 'profane' world.[57]

This, of course, accounts for the myths which arise in such places, of which there are several surrounding the two most important patrician sites of Croagh Patrick and Saint Patrick's Purgatory at Lough Derg. It was here, on the Reek, as Michael Dames notes, 'that Connacht mythology, like that of every other province, sought a suitable place to re-enact its own rebirth. Connacht's nativity occurred annually at the start of harvest at a conical mountain, tipped with white quartz.'[58] This was the site of the local, very ancient Lughnasa festival, originally established by Lugh, one of the chief gods of the Tuatha De Danann.[59] J.B.. Whittow refers to this 'quartzite pyramid with its

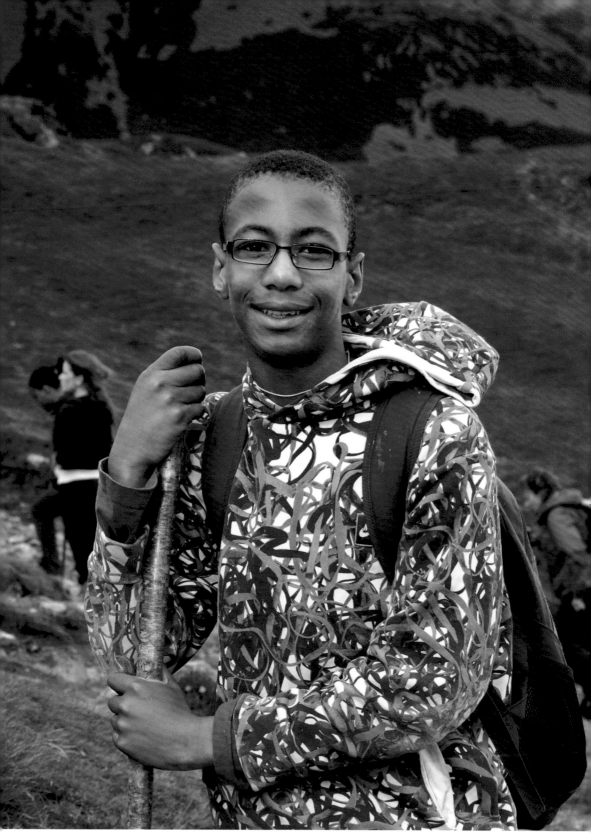

Chris, County Longford

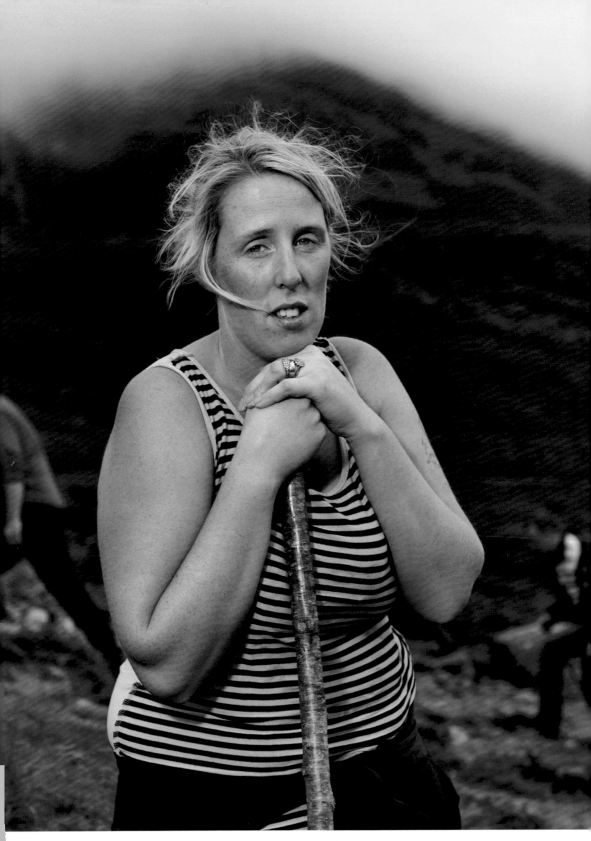

Cliona, County Sligo

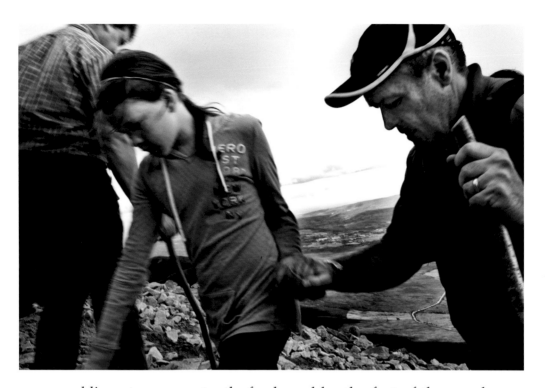

sparkling stones constantly freshened by the feet of thousands of pilgrims.'[60] His use of the word 'pyramid' is significant since although Croagh Patrick is perhaps not a pyramidal mountain in the technical sense of that term, it does indeed present as a pyramid from many vantage points. Robert Macfarlane tells us that: 'Pyramidal mountains fulfil the Platonic vision of a mountain, a dream of what a mountain should resemble. Their purity of form heightens the encounter',[61] and this is certainly so at the Reek.

Saint Patrick is said to have gone up the already sacred mountain at the time of the festival in the late spring or early summer of 441 CE, spending a scriptural forty days in penance and prayer on the summit, recalling both Israel's forty years in the desert, recounted in the Book of Exodus, but probably more precisely Jesus' forty days of struggle with temptation in the desert, including a direct confrontation with Satan (Matthew 4:1-11).

Patrick in the Battle for the Soul of Ireland

This is an archetypal narrative of the confrontation between the forces of the old and the new. These foundational narratives are, as we have seen, often depicted as a struggle between the forces of good and evil, in the form of the older pagan gods. In this case, Patrick, as representative of the newly arrived faith, is seeking to win the allegiance of the people, to draw them away from their long-established deities and win them over to the new, *one* and *true* God. This is consistent with other such narratives in other parts of the world explaining the demise of traditional religions in the face of the advance of what were to become the dominant world religions, notably Christianity and Islam, with their strong proselytising impetus, a mission to convert the world.[62] It can be read, and often is by folklorists, as a narrative of conquest or colonisation. What is interesting, however, is that it took place in a country that had not come under the influence of the Roman Empire and in a place that was at the geographically extreme limits of Europe. From a more traditional Christian perspective it can be read as the 'battle for the soul of Ireland', as it recounts the story of the victory over 'the lesser gods' and their fall into redundancy with the ineluctable advance of a perhaps more practical monotheism, which many sociologists see as the beginnings of 'the erosion of the supernatural'.[63] While there can be many hermeneutics, it is probably most useful to see it as part of a rational religious evolution that was inevitable and has certainly been repeated elsewhere.

In the case of Cruach Phádraig, Crum Dubh (Black Crom) was the dominant deity; owner of a bull and a granary of corn, symbols of power and prosperity, he was the ruler of the elements, as might be expected from a god inhabiting a striking and formidable mountain overlooking one of the world's great oceans. Crum

Daniel, County Mayo

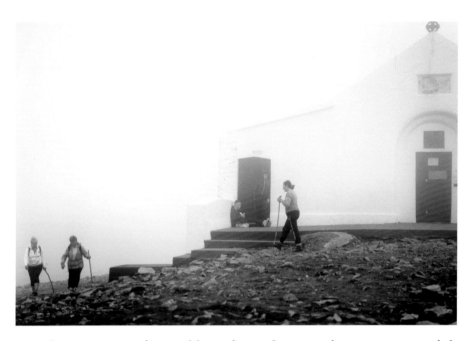

was, however, confronted by a force that was far more powerful than he, and Patrick was its emissary and champion. The 'saint' is equipped with the spiritual strength needed to dispossess the established lord of his wealth and power and so of his dominion. It was from this foundation narrative that we have the legend of the saint banishing from Ireland all demons and snakes, the symbols of evil and defiance of the one God.

The great Irish antiquarian John O'Donovan (1806–1861) tells us that the first demons, perhaps led by Crum Dubh, were said to have been overcome in a hollow at Log na nDeamhan (the Lake of the Demons), where Patrick vanquished him by throwing his black bell after them. A second demon called the Corra, said to be the devil's mother,[64] succumbed at what became Loch Nacorra in memory of this legendary victory. The same source, citing the Scottish monk Jocelyn, tells us 'that Ireland since its first habitation had been pestered with a triple plague, namely, a great abundance of venomous reptiles, with myriads of demons visibly appearing and with a multitude of

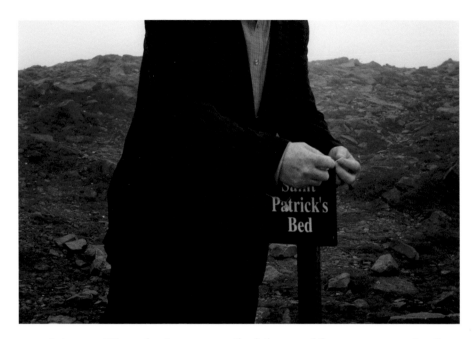

magicians…The glorious apostle laboured by prayer and other exercises of devotion to deliver the island from triple pestilence. Taking the Staff of Jesus in his hand he hurled the reptiles into Log na nDeamhan,'[65] from which, of course, sprung both the lake and the legend. Michael Dames presents a variant on this theme of conquest, referring to Corra as a goddess who presents herself as both a great bird and also as a monster serpent, mythical representations of evil.[66] In any case, it was from these intertwined narratives that we have the legend of the saint banishing all demons and snakes from Ireland and, of course, part of the origin of the imagining of Ireland as a land of 'saints and scholars', where the demons and the forces of evil have no place.

Traditions Die Hard

While the Croagh Patrick rituals had been largely Christianised there is definite evidence to suggest that an old pagan tradition may have lived on. At least one nineteenth century source is said to have heard pilgrims invoking the older pre-Christian

deities in their devotions.[67] McNally notes the station of *Leaba Phádraig* (Patrick's Bed) of which the evangelical polemicist Page wrote, 'none but those that are barren go there to commit the most abominable practices that would make human nature, in its most degraded state, blush'.[68] He describes the dreaded ritual in the station, which was 'forty yards in circumference' and which the pilgrims circumambulated seven times. In a custom clearly related to one that I have heard of amongst the traveller community in more recent times, at the grave of a reputed 'holy priest with cures' in a church cemetery at Cams, Cloverhill in County Roscommon, Page tells us that 'on entering the bed pilgrims removed small pebbles to bring home, in order to prevent barrenness, and to banish rats and mice'.[69] Otway was no less critical, when he described the Croagh Patrick pilgrimage as 'a gross and barbarous superstition, a thing only fit for darkness and dreariness'.[70] On my most recent visit to the mountain, I learned that it is still an important ritual for young traveller couples, who visit first to the Marian Shrine at Knock and then complete the pilgrimage to the Reek before getting married. This is surely an echo of a much earlier devotion.

To William Makepeace Thackeray (1811–1863), writing *The Irish Sketch Book* (1842)[71] it was clear that in the popular imaginary the battle with the pagan gods did not end with Patrick and they still had a grip on the mountain. He noted that at the outset of the pilgrimage on a Sunday the diocesan clergy, who had now taken control of the site, went up the mountain to forbid any kind of levity, music and dancing, while exhorting the pilgrims to strict adherence the performance 'of what are called religious duties'. The older gods were not giving up easily.

3.

Praying and Playing at the Reek

*One type of pilgrimage which the Irish came almost to
monopolise, though they were by no means the first to practice
it, was the ascetic pilgrimage. This involved leaving behind
one's land forever to embark on a life-until-death pilgrimage.*
– Fiona Rose McNally, *The Evolution of Pilgrimage in
Early Modern Ireland*

A Penitential Tradition

In terms of the study of religions, Croagh Patrick and Saint
Patrick's Purgatory can be classified as 'archaic' pilgrimages,
meaning that they 'have come down from very ancient times,
and little or nothing is known of their foundation, however, they
bear quite evident traces of syncretism with older religious beliefs
and symbols'.[72] That this is a very ancient Christian pilgrimage
is well supported by the evidence, which puts it back before the
seventh century, when Saint Patrick's prayer and fast on Croagh
Patrick is mentioned as an already well established tradition in
the *Book of Armagh*. This is the memoir of Tírechán, described by
McNally as 'a native of Connacht who wrote a memoir in Latin of
Saint Patrick's travels and foundations in Connacht and Meath,
some two hundred years after Patrick's death'.[73] Tírechán tells us
that 'Patrick proceeded to the summit of the mountain, climbing
Cruachán Aigli and stayed there forty days and forty nights and

David, County Longford

the birds were troublesome to him and he could not see the face of the sky and land and sea'.[74] This vision is the earliest recorded tradition of Croagh Patrick, which McNally tells us 'is re-echoed in the Dindshenchas poem on *Find-Loch Cera'*, where it is said 'a flock of birds of the Land of Promise came there to welcome Saint Patrick when he was on Cruach Aigle. They struck the lake (with their wings) 'till it was white as new milk, and they sang music there so long as Patrick remained on the Cruach'.[75]

The evidence is of a largely unbroken tradition of religious ritual and pilgrimage of one kind or another, going back thousands of years to Druidical times and surviving up to the Christian era and into the present, more secular, day. There are significant links between the two. In the Christian era both the spirit of the pilgrimage and the ritual are based in the strongly

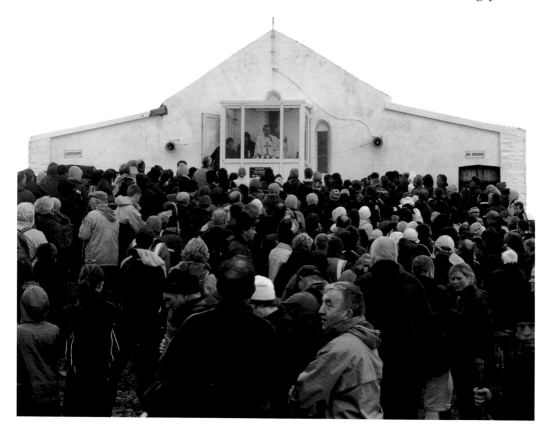

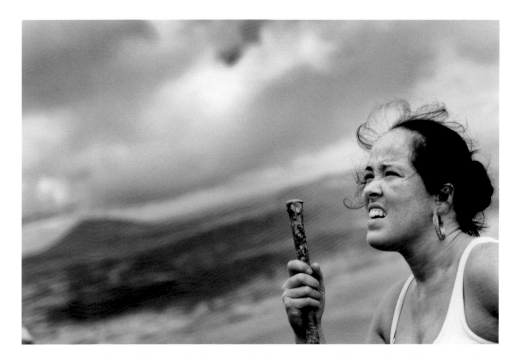

penitential tradition of Irish Catholicism, which can itself be traced to a Celtic understanding of penance. Janet Tanner provides an interesting analysis of this, identifying three models of penance: 'as healing, as restitution for an offence, and as journey.' She situates this within 'what is known of the Celtic legal system, the Celtic social context and the Druid religion,' concluding that 'ideas of Christian penance as healing, as restitution and as journey can be seen to have developed from within this local Irish context into the worked-out system that comes to us [today].'[76] Tanner cites Hugh Connolly, professor of Moral theology at Saint Patrick's College, Maynooth, who notes the 'contribution of the Druids to the healing and wholeness model of penance found in the later Irish penitentials'.[77] Connolly points out similarities between Christian and Druid understandings, and writes about the Druidical idea of health as achieving the mean-point between two poles. This can be interpreted as a mental and spiritual equilibrium, a reconciliation with God, the *other* and the *self*.

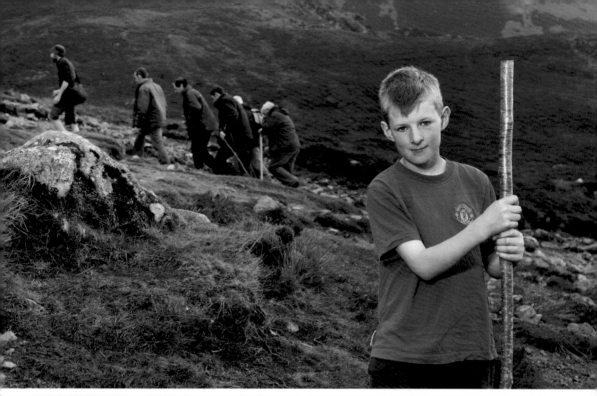

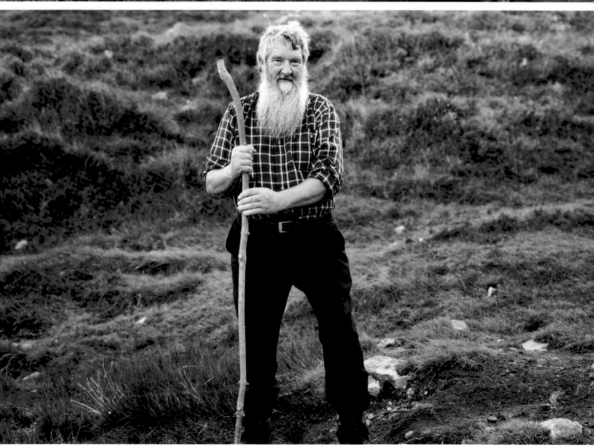

Colin, County Mayo (top) and Daniel, County Offaly (bottom)

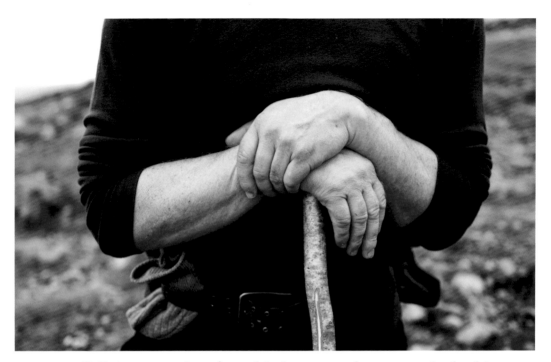

Religious practice of any kind emerges from a particular historical and social context, as people within that context seek to give voice to their needs, and often their discontents, and so, as Peter Harbison observes: 'For Ireland pilgrimage is a pious exercise that has helped to fulfil religious needs and yearnings for more than 1,400 years.'[78] In a recent historical study of the evolution of pilgrimage in Ireland, Fiona Rose McNally writes:

> Several forms of pilgrimage have flourished there. One type of pilgrimage which the Irish came almost to monopolise, though they were by no means the first to practice it, was the ascetic pilgrimage. This involved leaving behind one's land forever to embark on a life-until-death pilgrimage. Not far removed from this ascetic spirit was the penitential pilgrimage undertaken to expiate sin. Jonathan Sumption has noted that pilgrimage was much favoured by the Irish as a spiritual exercise. As a penance for the more enormous transgressions it was thought especially appropriate.[79]

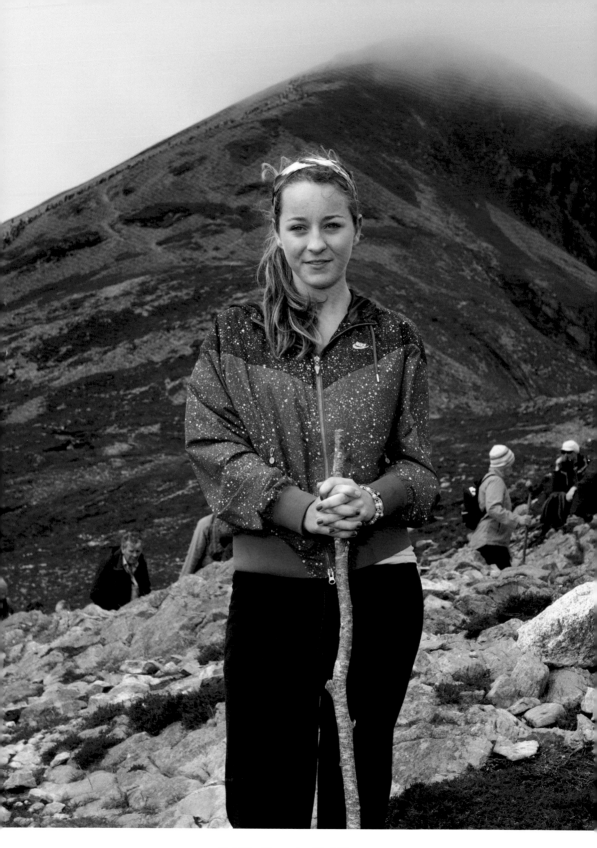

Edith, County Dublin

John Cunningham, writing of Lough Derg and Croagh Patrick, suggests:

> Perhaps Lough Derg answers a need in the Celtic soul which might be summarised as 'no gain without pain'. The other ancient Irish pilgrimage which involves the climbing of [the] mountain during the night[80] (preferably in bare feet) echoes Lough Derg in its uncompromising attitude to reparation for sin.[81]

In fact it would seem this should be the other way round, since while legends about Lough Derg date from the fifth century it really only took on significance in the early twelfth century, when in 1135 the Augustinian Canons took responsibility for the site.[82] It began to be mentioned in texts and shown on maps from all over Europe as its reputation grew from the fifteenth century.[83] While Croagh Patrick predates Lough Derg, there is certainly a close relationship between the two, including the fact that the goddess Corra is said to have re-emerged at Lough Derg – almost a thousand years after she had been vanquished by Patrick on the Reek.[84]

Having the 'Craic' at the Reek

The Celtic soul, however, also has other needs and Lughnasa certainly had another side that was not at all penitential. McNally remarks that:

> While Lough Derg and Our Lady's Island were free from the debaucheries of other sites, the boisterous patterns at Croagh Patrick, Struell Wells, and Ardmore were well documented in the writings of various representatives of the church, antiquarians and curious travellers in late eighteenth and early nineteenth centuries.[85]

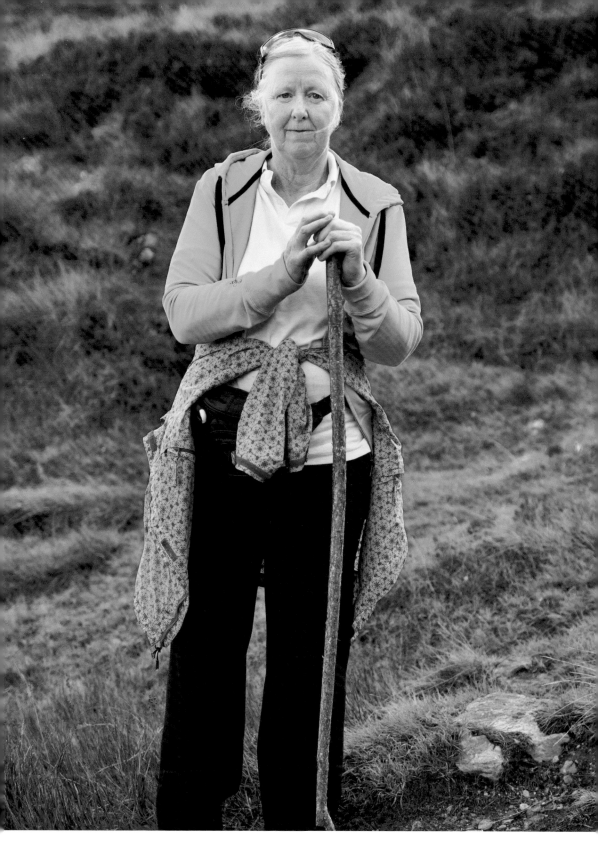

Eileen, County Louth

This had a long history going back to the Lughnasa festivals. According to Máire MacNeill, these had always included great gatherings with significant religious ceremonies, but also ritual athletic contests, feasting, matchmaking and trading. Here the sacred and the profane were apparently responding to 'market forces' in the social economy of the countryside and coming to some kind of agreement in an attempt to meet the needs of the devotees. As in many traditional religious festivals around the world, the more purely religious side of Lughnasa included an offering of the first of the corn, a feast of the new food and of bilberries, the blood sacrifice of a bull and a ritual dance-play. This is the stuff of the Old Testament and of Stravinsky's *Rite of Spring*,[86] a scene of colourful, highly charged ritual of the type the Old Testament prophets came to despise and reject, leading to monotheism and the emergence of a religion based more broadly on ethics than on ritual (Amos 5:21-24). The locus for this kind of activity at Lughnasa would normally have been on some elevation or mountain such as Cruachán Aigle. It is clear that many of these customs persisted well into the twentieth century, and are sometimes revived in events such as fair days, Garland Sunday, Bilberry Sunday, Mountain Sunday and even the more overtly pagan Domhnach Crom Dubh. In more recent times, Celtic neo-pagans have revived Lughnasa or a version of it as a religious holiday. Michael Dames posits that even today perhaps pilgrims come to the mountain in what he describes as 'a mood of double-coding', with a religious imaginary referring to the both old and the new religions, rather one of outright Christian triumphalism.[87]

Beyond the penance, the pilgrimage had a strongly festive, even somewhat bacchanalian side, which was no doubt a legacy from earlier pagan times. Writing in 1838, John O'Donovan observed:

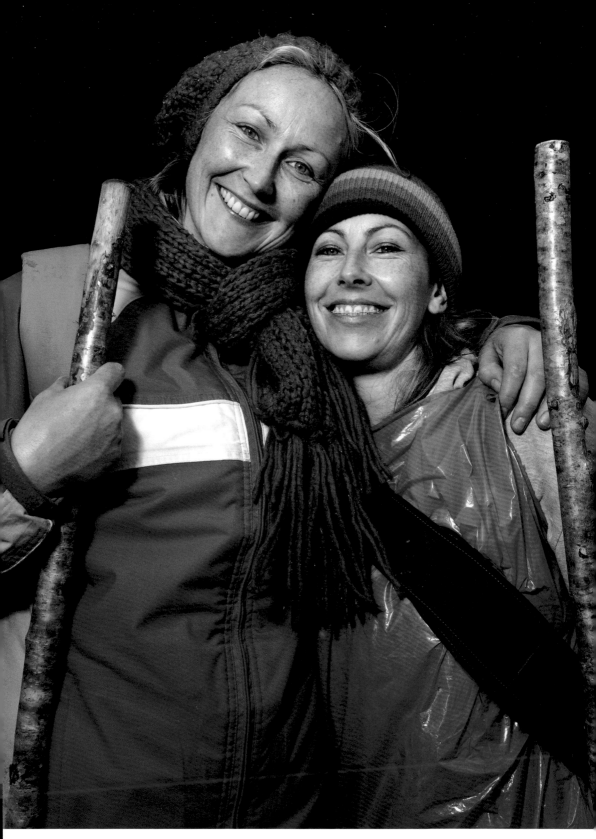

Emma and Karin, County Dublin

There were several enclosures of stone not all dedicated to St Patrick or the purpose of Penance but rather to Bacchus and built for sheltering whiskey drinkers from the asperity of the weather and the fury of the Atlantic blasts on the day of the pattern which is held on 15 August on the road at the base of the Reek.[88]

Visiting the area a few years later, William Makepeace Thackeray (1811–1863) in *The Irish Sketch Book* (1842)[89] delights in the mountain, in terms reminiscent of Paul Henry's several paintings of the Reek:

It was clothed in the most magnificent violet-colour, and a couple of round clouds were exploding, as it were, from the summit, that part of them towards the sea lighted up [with] the most delicate gold and rose-colour.

Attentive, as always, to the customs and mores of Her Majesty's wild Irish subjects, Thackeray noted that the spirit of Corra, the Devil's Mother, continued to inhabit the area. As Michael Dames, citing Thackeray, colourfully describes it:

After the business on the mountain came the dancing and the lovemaking at its foot. Fifty tents were set around 'a plain of the most brilliant green grass,' where they were sold 'great coarse damp-looking bannocks of bread … a collection of pigs' feet … huge biscuits, and doubtful-looking ginger beer. There were cauldrons containing water for 'tay', with other pots full of pale legs of mutton…The road home was pleasant; everybody was wet through, but everybody was happy.[90]

That side of the Irish spirit which ever rejoices in the *craic* was not so easily put down by imported puritanism, and it is certainly true that the pilgrimage still has a strongly festive side. The several pubs in Murrisk continue this festive side of

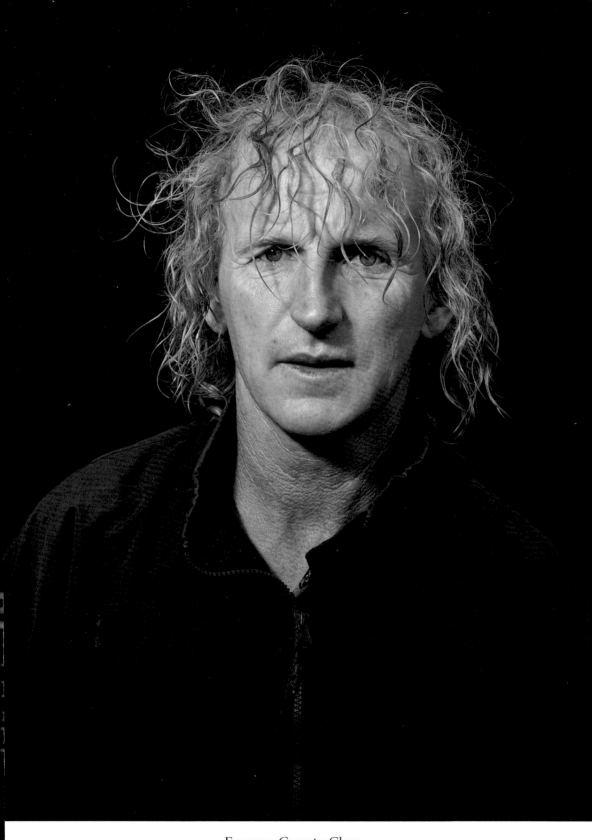

Eugene, County Clare

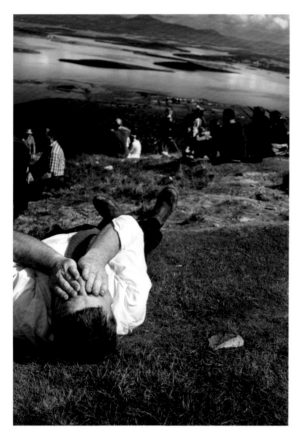

the event and my most lasting memories of my own pilgrimage in 1968, at the age of eighteen, was seeing 'the drowned drumlins of Clew Bay'[91] at six o'clock on a wonderfully clear morning as we descended, and then ceding to the temptations of Bacchus, if not to the Mother of the Devil herself, by 'breaking the pledge'[92] and drinking my first bottle of Guinness, sitting with two friends on the grass outside Campbell's lovely old pub at Murrisk. My father was not told this part of the adventure, although clearly I had not strayed far from some of the oldest traditions of the pilgrimage and I have no doubt that it was in its own rather Irish way a kind of initiation, replaced today by a wide variety of secular but equally ritualistic 'gigs'.

Freeing the Enslaved Gaels

The pilgrimage and other such events of Catholic popular piety certainly became the subject of a serious polemical debate during the period following Catholic Emancipation, and as evangelical Protestant proselytism, offended by everything about the place, became increasingly active in its attempts to win over the natives, enslaved, as they saw it, to 'superstition', 'Romishness' and 'popery' as well as the excesses of drink. McNally tells us

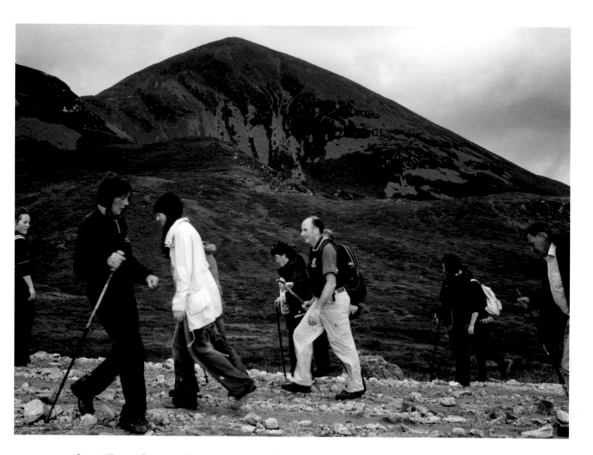

that 'Rev. James Page, in a polemic attacking the influence of Roman Catholicism in Ireland, referred to pilgrimage devotions as "debasing superstitions"'. He noted that the vast majority of the Irish, especially in the western parts, 'are as ignorant of the mind of God, as those who have been born where the light of Revelation hath never shined'.[93]

In the Irish collection at the National Gallery of Ireland there is a very striking painting by Sir William Orpen (1878–1931) painted in 1916 and entitled *The Holy Well*,[94] that makes the same point. At its mildest this can certainly be seen as little more than a rather harsh commentary, but there is also evidence of an ugly sectarian bigotry. Sympathetic scholars would certainly see a more nuanced picture, whether here or in other devotional events. John O'Donovan, in his own search for Ireland, was certainly

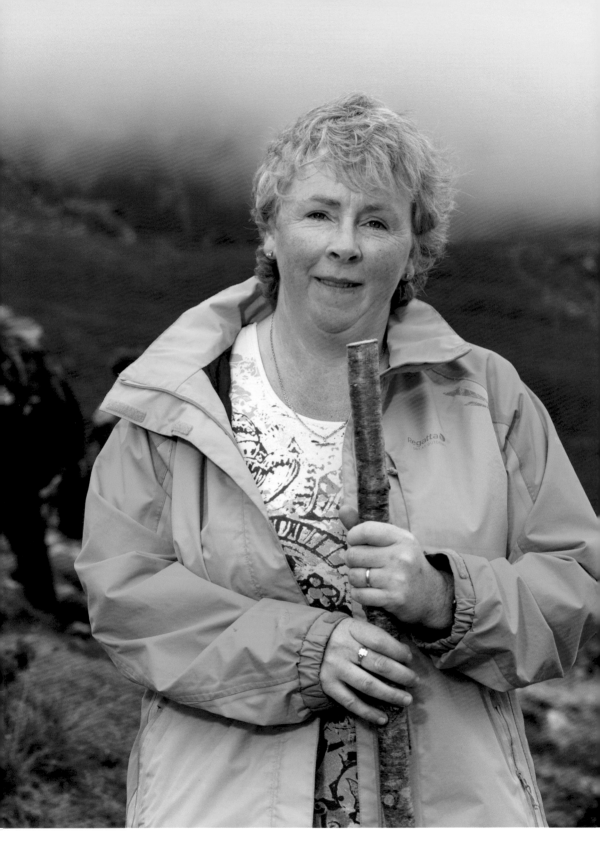

Geraldine, County Sligo

one of these. Stopping at Aghagower, half-way along the Tóchar Phádraig pilgrimage, he noticed an old women praying at the sacred spot and would 'never forget the enthusiastic glow of devotion to which her eyes gave expression'. McNally also tells us that the otherwise censorious Otway, who visited the Reek in 1839:

> ... was told by a guide about a certain Robert Binn, affectionate-ly known as 'Bob of the Reek'. Bob performed the pilgrimage daily 'for any poor sinner who either was unable, from want of health or other means, of coming themselves to the Reek'. During the winter season, Bob was kindly received by the neighbours, who fulfilled his wish to be buried on the mountain.[95]

It was interesting to note the presence of Ulster evangelicals at the pilgrimage this year, and apparently for the past twenty years, offering free refreshments, promoting the Word of God and Jesus as 'Lord and Saviour', but perhaps in more ecumenical terms. One young activist told me she had indeed made the ascent but pointed out that she had done so on her own terms rather than on the terms of the Catholic pilgrims making the same journey. When I asked an organiser of the group whether the intention was in fact to evangelise Roman Catholics involved in what could be seen as a superstitious ritual, he would only say that they were there to promote the Word of God and the message of Jesus Christ.

Patrick Kavanagh climbed the Reek as a journalist, producing a piece that was more than a little sentimental and overly pious, probably to please his patron at the Catholic weekly, *The Standard*, for which he did some occasional and much-needed paid work in the 1940s. However, like O'Donovan and Otwas, he was also impressed by a great depth of sincerity in the pilgrims. Una Agnew, an authority on the poet's spiritual journey, writes:

It is noteworthy that when acting as a journalist, Kavanagh encounters genuine instances of faith and then he is struck by its integrity. As he climbed Croagh Patrick, more out of curiosity than devotion, he fell into easy conversation with a Galway man who was climbing the reek. As they chatted easily together, Kavanagh was taken by surprise when the man excused himself to say a prayer at one of the stations along the way. Kavanagh is taken aback as he realises he is in the presence of genuine faith. Making notes then for a book on pilgrimages which never materialised, he acknowledges being 'struck hard' by being 'in the midst of a Faith of a most powerful simplicity':

You realize that it is no superficial romantic impulse that is behind this mountain climb. You are at the raw sensitive heart of the active faith; too raw and sensitive perhaps for poetic exploitation.[96]

Religious experience is a very complex area that escapes easy description, and Kavanagh was certainly in awe of what he witnessed, adopting a mode of respectful silence in the face of something he did not fully understand. One is sometimes appalled at certain aspects of popular religiosity but also surprised and even humbled at the deep sincerity of the kind of piety one finds in many of these places. As one writer put it when writing about African Pentecostalism, 'here one encounters the respectable, the delirious, the venerable, illusion merchants, true seekers of God, counterfeiters of the sacred, the deep breath of the spirit, as well as the occasional terrorist of the invisible.' The same could no doubt be said of pilgrimages the world over from time immemorial, and the Reek remains a fascinating place for the open-minded observer and scholars of religion in all its forms.

4.

The Reek and Connacht Catholicism

Think of this mountain as the symbol of Ireland's enduring faith and of the constancy and success with which the Irish people faced the storms of persecution during many woeful centuries. – Dr John Healy, Archbishop of Tuam

The dominant figure in Irish Catholicism in the nineteenth century was Paul Cardinal Cullen (1803–1878), Archbishop of Dublin from 1851. He was the most prominent and influential figure in the development of modern Irish Catholicism, setting it on course for all that it was to become in both the positive and the negative sense. He remains a controversial figure whose place in history is certainly less favourably judged than it may have been in the past. Donnchadh Ó Corráin describes him harshly and ignoring the context of the times as:

> ... the principal maker of the kind of modern Irish Catholicism that lasted from his day until the end of the twentieth century—pietistic, puritan, priest-ridden, apart from a certain nationalist rebelliousness from time to time. He is responsible for 'the devotional revolution', including the introduction of the Italianate *Quarant' ore* or 'Forty Hours Adoration', 'Benediction' and other devotions; and a corresponding rejection of any traditional devotion to local saints, patterns, holy wells and the like as superstitious and uncouth.[97]

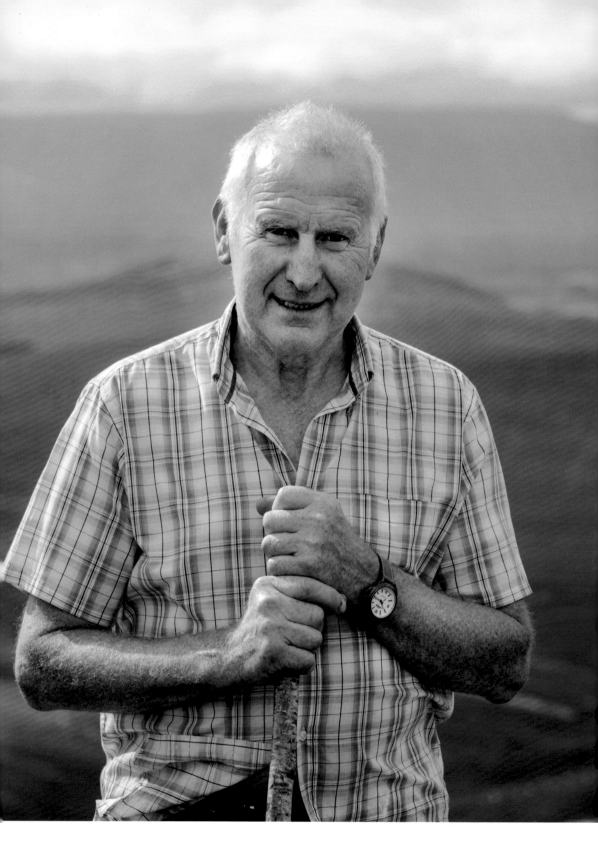

Eugene, County Longford

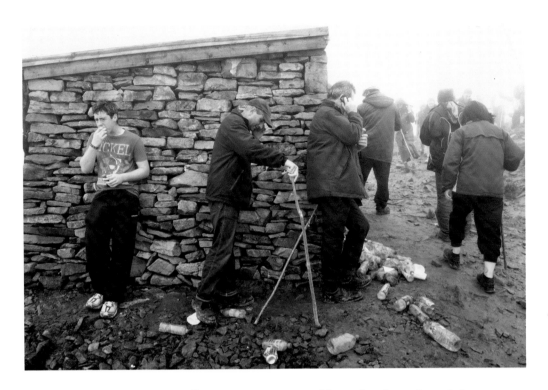

Ciarán O'Carroll is more measured but also less than fulsome in his evaluation when he notes that:

> For twenty-eight years this ecclesiastic, who was destined to become Ireland's first ever cardinal, was to dominate Irish ecclesiastical and religious life. The responsibility for an entire ecclesiological structure and many patterns of religious devotion as well as an impressive record of church building work, have all been laid at his feet. Indeed, his influence was so great that his achievements in Church affairs has been described as 'the Cullenisation of Ireland'.[98]

Whatever his positive qualities, and he was at least a formidable organiser, he does not seem to be a figure who inspires any great affection and even less so in a time when the institution he contributed so much to creating finds itself on the underside of history.

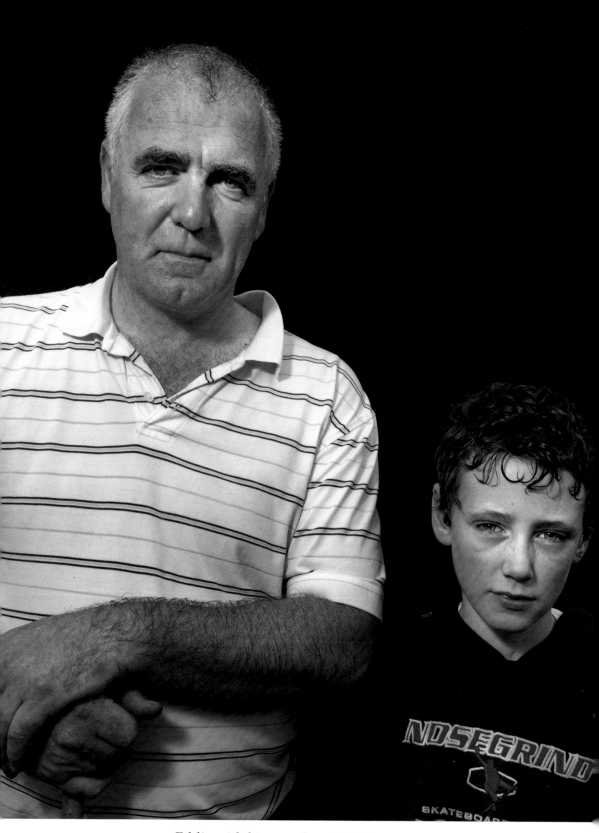

Eddie with his son, County Galway

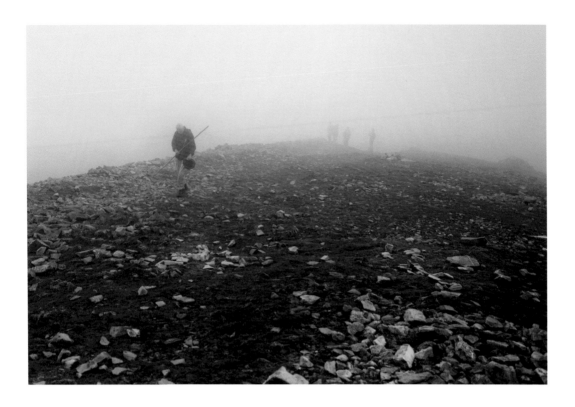

The other great ecclesiastical figure of that period was John McHale (1791–1881), the Irish-speaking, strongly nationalist Archbishop of the western archdiocese of Tuam, with its suffragan dioceses of Galway and Kilmacduagh, Elphin, Killala, Achonry and Clonfert. MacHale was in many ways Cullen's nemesis. Cullen was ultramontane, deeply marked by his Roman formation and determined to impose the Roman model in Ireland, in practice, in teaching and in discipline. Now that the Church had regained full powers, he was also to set about eradicating what he saw as degraded local or popular religious expressions. MacHale, on the other hand, was Gallican in ecclesial terms and clearly strong-minded and independent. Unusually for the time, he had completed all his studies in Ireland, and favoured the development of a more Irish Church with its roots in local traditions rather than the imported devotionalism favoured

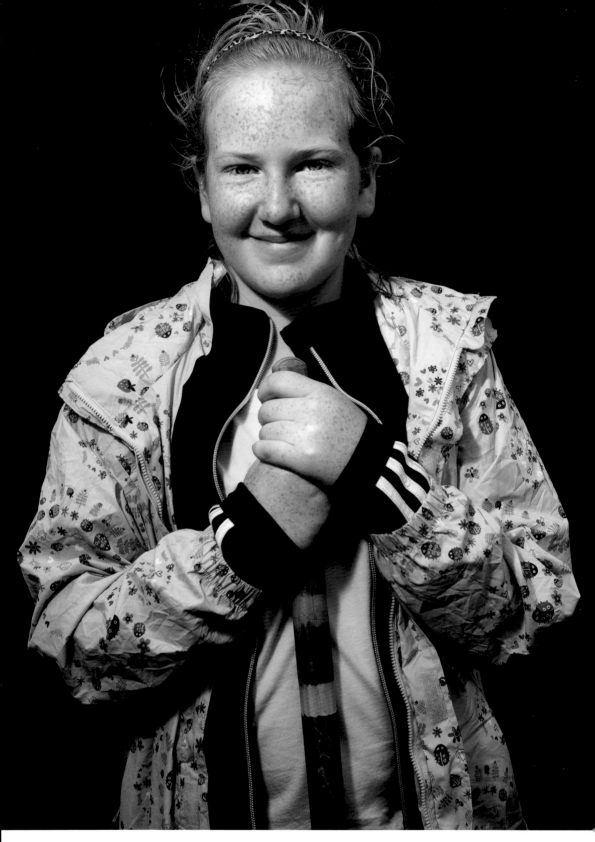

Grace, County Galway

by Cullen, which had become fashionable in the east of the country. Here Europe was making itself felt with the arrival of several religious orders, notably from France, determined to bring Ireland into the Catholic doctrinal and devotional mainstream, which had its *fons et origo* in Rome. This meant getting people away from the popular devotions, now viewed as superstitions, that had for so long been a part of Catholic belonging in Ireland and shepherding them into the pews of the many new churches that were being built around the country following emancipation, where they were more easily counted and identified as *belonging*.[99]

Cullen can be seen as a conservative ecclesiastical apparatchik, a 'churchman' in the narrow sense of that term, 'translated' from the historically important See of Armagh to the more politically and socially significant archdiocese of Dublin, with the clear agenda of reining in Irish Catholicism to the prevailing Catholic

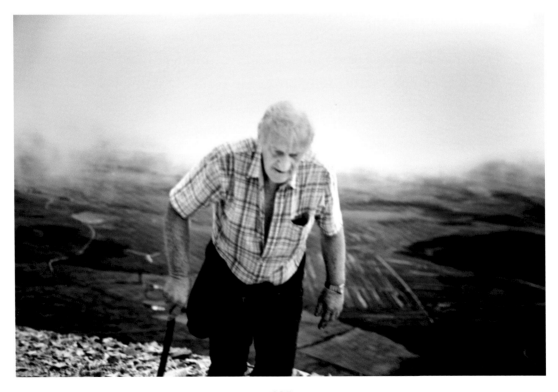

anti-modernist spirit of the times. He was certainly the man to do it. He was politically cautious and allergic to even a suspicion of revolution; 'a practical nationalist',[100] he was seeking the best conditions for the survival of the Church. Following the Synod of Thurles in 1850 he was also seeking the creation of an elite, Romanised, clerical caste that would be the moral guardian of the new Ireland that he knew was emerging. MacHale, on the other hand, was closer perhaps to Heaney's 'croppy priest'[101] in his solidarity with his oppressed people in the poorest part of Ireland. In his first speech as Archbishop in Tuam, he was certainly talking the language of liberation theology long before its time: 'In advocating the cause of the poor I am only fulfilling my covenant with my God and my people.' His early biographer, Bernard O'Reilly, writes of MacHale as 'an eloquent, consistent, and uncompromising advocate of national and popular rights,' engaged in an 'unceasing struggle with the men who misgoverned or misrepresented Ireland'. He stresses his 'fearless advocacy of Ireland's right to self-government and full political justice', while at the same time declaring 'uninterrupted warfare with the enemies of his religion'.[102] He certainly made his position clear in a letter written in August 1843:

> Next to the spiritual duties in which I am occupied, nay as intimately connected with them, I feel the weight of the obligation of cooperating peacefully and strenuously to free from the remnants of the most atrocious, the most continuous, and the most insulting system of civil and religious oppression that ever was carried on against the faith, the freedom, nay the very existence of a noble and faithful people.... We have no protection against the Punic faith of the treaty-breaking Saxons except in the strong and lofty fence of a native legislature.[103]

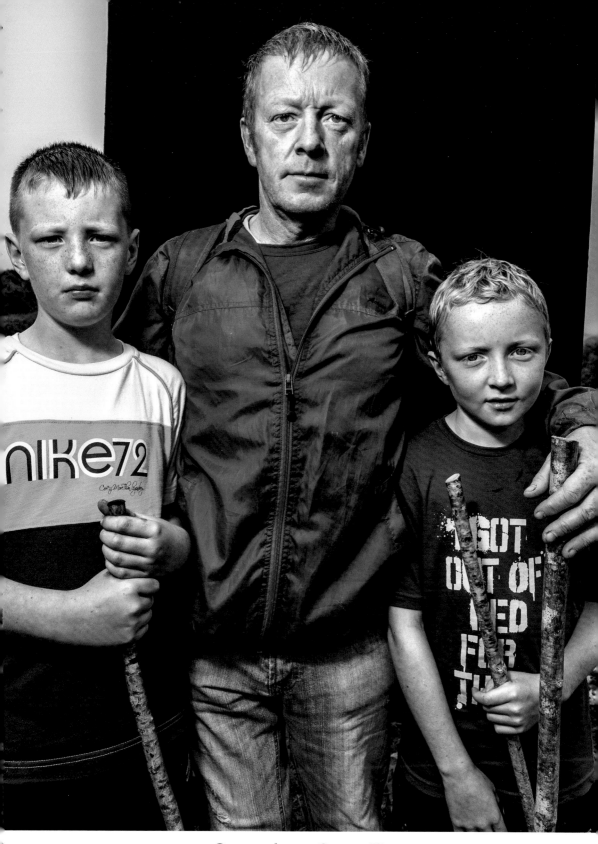

Gerry and sons, County Sligo

A close friend of Daniel O'Connell, the Liberator, who christened him 'the Lion of St Jarlath's', he was a loyal member of the Repeal Association from its foundation in 1830, advocating the end of the Union. An articulate theologian and polemicist, he wrote articles in the *The Freeman's Journal*, under the nom de plume Hieropolis. Dr Crotty, President of Maynooth, later wrote:

> Dr McHale took up his pen to vindicate the Catholic Church of Ireland against the virulent and unprovoked abuse, which for years was increasingly poured out against her doctrines and her clergy. If, in doing so, he transgressed the limits of legitimate defence, he was certainly guilty of no injustice against his aggressors.[104]

He was certainly not a man to mince his words. During the tragedy of the famine, which he experienced first-hand in what was one of the poorest and most remote parts of the island, he became involved in advocacy with the government in favour of the poor and later in activism in relief work. He is still remembered in the West as one 'of Ireland's great prelates who, in the dark days of penal oppression, fought and struggled with voice and pen for the religious and national freedom of Ireland'.[105]

There is no lack of evidence, both historically and in the modern world, of religion's power to create and sustain a political narrative. We have already noted this in the case of Poland and it can be suggested that this was very much part of the role John MacHale played in the creation of what I have come to understand as a particular type of Connacht Catholicism, which survives down to the present day in the priests from that part of the country who have distinguished themselves as independent scholars and poets who have not hesitated to present an alternative, often more radical, view. The late Sean Freyne,[106] in whose memorial library at Trinity College Dublin this passage is being

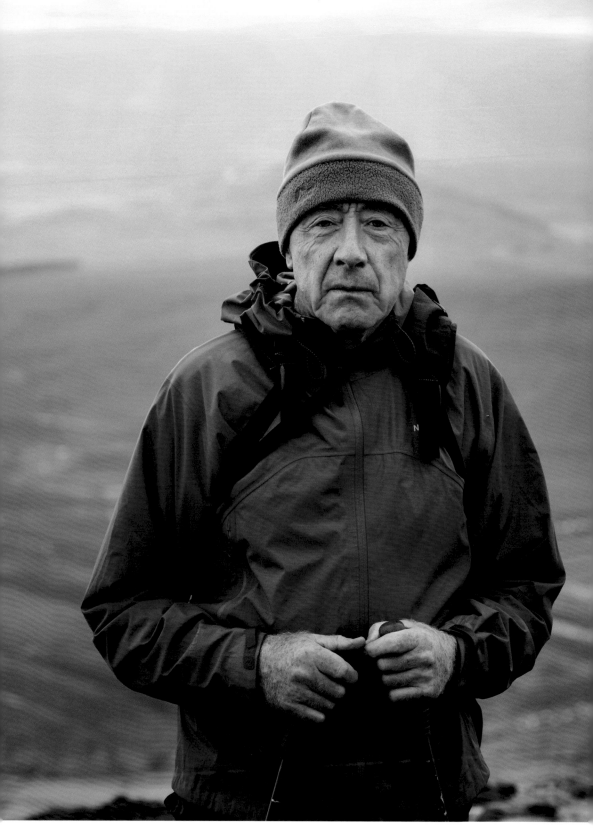

Eugene, County Kerry

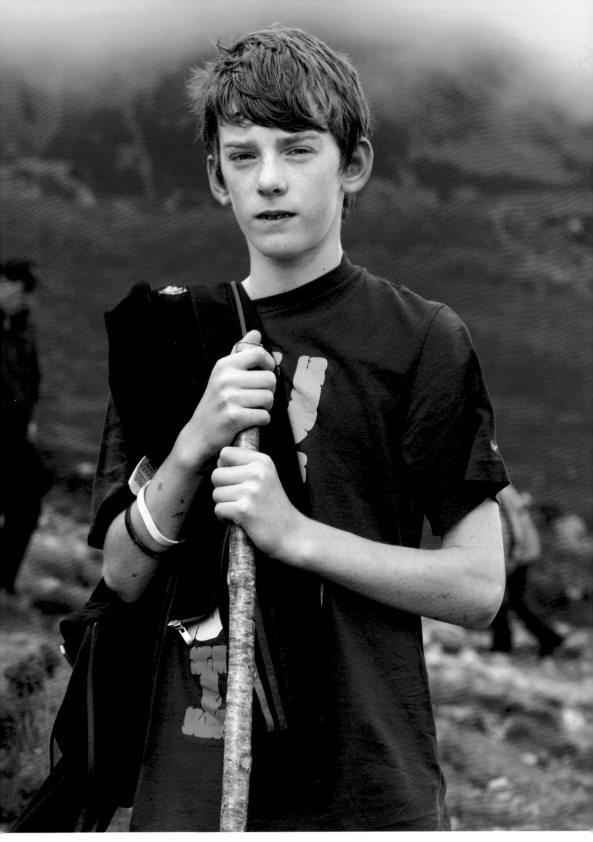

Fearghan, County Laois

written; Enda McDonagh,[107] who at times seemed to be one of the few Irish Catholic theologians engaged in conversation with the secular world; the philosopher John O'Donoghue,[108] whose thinking and spirituality could not be confined; and the poet Pat O'Brien, and several other priest-philosopher-poets who simply live there and identify with the place, are names that spring to mind.

MacHale, in contrast, and often in opposition to Cullen, can be said to have been the first rebel in this tradition. Lawrence Taylor says that 'Cullen was wary of his own "Gallican" bishops ... who supported national, over Vatican, control and ritual. Their Catholicism, like their politics, was too Irish...'[109] None more so than MacHale, with whom he was in constant conflict on both pastoral and political issues. It is certainly indicative of the depth of their differences that he was one of the very few prelates to speak and vote against the dogma of papal infallibility at the

First Vatican Council in 1869, for which Cullen had responsibility at the drafting stage. It is said that once the dogma had been voted he accepted it 'to be true Catholic doctrine, which he believed as he believed the Apostles' Creed.' However, this, written in the third person, has more than a suggestion of hagiographic revisionism about it and, although Cullen came to dominate Irish Catholicism, it seems probable that MacHale remained a rebel to the end. While he does not seem to have had any direct involvement with the

Carmel, County Kilkenny

Reek's revival as a pilgrimage site in the late nineteenth century, it can be said to have been born out of his spirit. This was a potent mix of nationalism legitimated by a popular religious narrative and centred on a holy mountain. McNally suggests that 'The success of the "devotional Revolution" from about 1850, owed as much to the advance of Irish nationalism, with its religious and cultural identity associations, as it did with Cullen's leadership' and MacHale was central in this. One of his successors in Tuam, Dr John Healy (1841–1918), reflected this Gallican tradition well when he wrote:

> In the future development of this country we must proceed
> on national lines. We have a national spirit and a national life
> of our own, and that national spirit and that national life are
> fed by the history and language and tradition of the past, the
> language of our sires.... Cultivate these memories, feed them,
> and if you do, you may be sure the national spirit will not
> die.[110]

The Reek, unlike so many of the imported practices of the 'devotional revolution', was something peculiarly Irish, taking its inspiration from deep within an age-old pre-Christian tradition. It was religion at a different level. It was also, in my view, something very local, from within Connacht, almost within sight of the mountain. Healy's belief and the sentiment of those around him was that it 'must be seen as the deliberate nurturing of a national spirit, a national life, a national distinctiveness from Britain.'[111] In his introduction to the 1992 edition of J.M. Synge's fascinating little book *The Aran Islands*, Tim Robinson writes, 'If Ireland is intriguing as being an island off the west of Europe, then Aran, as an island off the west of Ireland, is still more so; it is Ireland raised to the power of two.'[112] This is something of what was going on at the Reek during its late nineteenth and

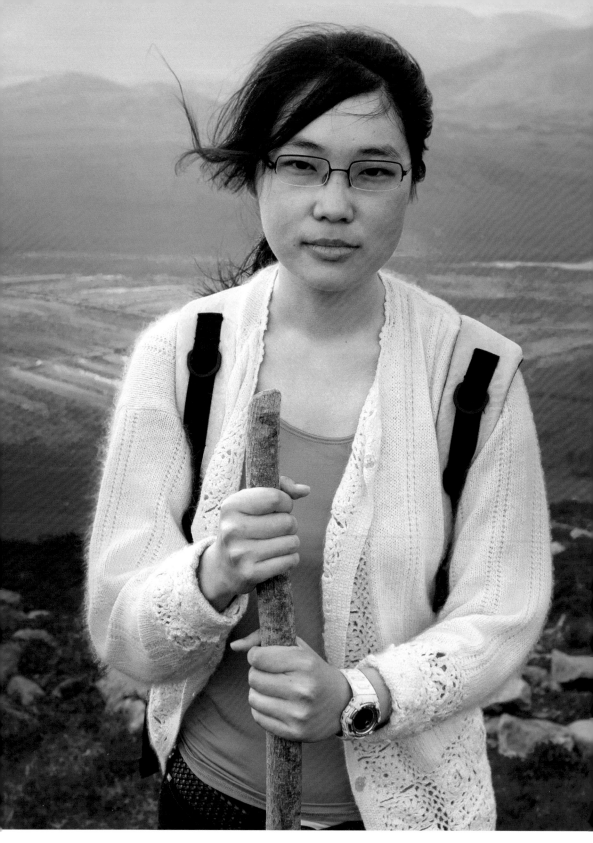

Jenny, Hong Kong

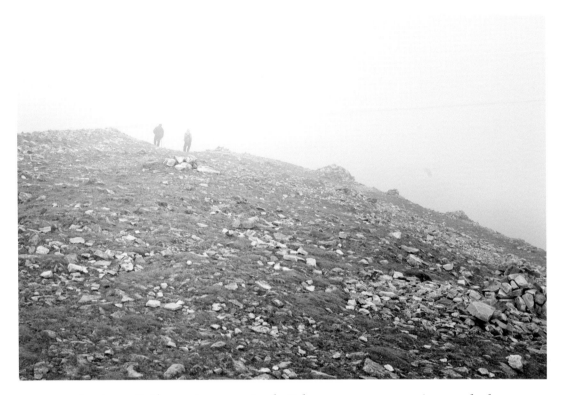

early twentieth century revival: it became once again our holy mountain, the place we could go in search of what we might be in a time of dramatic social and political upheaval, in search of our soul.

McNally notes that following his death '[MacHale's] views and activity became a model for priests and prelates in their work for an Irish nation.'[113] This became very obvious in his influence on 'Rev. John Stephens and Rev. Michael Clarke as they set about restoring the ancient pilgrimage of Croagh Patrick'.[114] This inspiration was brought to fruition with the appointment of a kindred spirit, Dr. John Healy. Healy was Archbishop of Tuam from 1903 until 1918, well into the troubled period leading to the creation of the Free State in 1922. The Reek was to enter into an era of revival and Healy was clear in his vision:

Noamson, India

> Think of this mountain as the symbol of Ireland's enduring
> faith and of the constancy and success with which the Irish
> people faced the storms of persecution during many woeful
> centuries. It is therefore the fitting type of Irish faith and Ire-
> land's nationhood which nothing has ever shaken and with
> God's blessing nothing can ever destroy.[115]

This was certainly religion and nationalism at its most potent,
and it became an essential part of the modern Croagh Patrick nar-
rative as Ireland moved into a new socio-political dispensation.
As was the case in Poland, the pilgrimage was to be an important
rallying point for the assertion of a renewed national identity.[116]

McNally provides a remarkable summary of the emerging
politico-religious narrative, as the revived pilgrimage grew
from a motley few hundred pilgrims gathering around the
makeshift chapel on the mountain in 1903 to a mass of 20,000

Jimmy, County Roscommon

people by 1908. The pilgrimage by that stage included a sub-
stantial number of participants from Dublin who were, it can
be argued, making their way into the west where, like Yeats
and other figures of the time, they believed the true Ireland
was to be found – and where better than from the oracle on a
holy mountain? The Reek like Aran was on the geographical
periphery, not just of Ireland but of Europe, but like Aran it had
become a symbolic centre from which the new nation might be
imagined.[117] As McNally tells us: 'The rhetoric of the sermons
made on the summit of Croagh Patrick during these years was
nationalistic and culturally separatist', with a strong emphasis
on the faith that had survived persecution and the attempted de-
spoliation of Ireland's spiritual heritage. This is well illustrated
by Dean Phelan, a visiting priest from Melbourne, Australia,
who elaborated on this point, arguing that England had robbed
Ireland of her churches and temples but not of her faith. He also
expressed a belief that his audience could 'look forward to the
day when the last link in the chain which England had forged
around the Irish people would be broken and when the Irish flag
would float over a free Irish nation'.[118] This was powerful stuff
from a priest from the far-flung Irish diaspora, many of whom
also looked back to the holy mountain with strong feelings.

One can certainly imagine the scene on the mountain and
particularly from 1906, after which time one of the two sermons
preached on Reek Sunday was in Irish – the holy language
coming back to the holy mountain in holy Ireland. This
carried tremendous symbolism and was sure to fire nationalist
sentiment in both the preacher and the enthralled congregation.
Father O'Fagan, speaking in 1909 in English, was certainly carried
away as he underlined this theme of cultural nationalism and Irish
particularism when, according to a reporter:

James, Dublin

He thanked God they were coming back to their own again; their language would soon be restored to them, and he asked them all to pray ... that they might always preserve the faith, and that they would not always be under the rule of the foreigner.

Archbishop Healy almost reincarnated MacHale when he returned to Croagh Patrick for the tenth anniversary of the revived pilgrimage, reiterating his favourite theme on the importance of an enduring commitment to nationhood and noting with enthusiasm that 'the ancient language of St. Patrick, at least to some extent, is with us still, and we have that ancient Celtic race which has survived in spite of all'.[119]

Many of what had come to be considered as deviant practices during the pilgrimages years of decline were stamped out. The prevailing 'devotional revolution' certainly cut the last links with the elder gods, at least publicly, as the pilgrimage was brought into line with what was considered to be dogmatic and devotional best practice. Crom had been vanquished, Corra succumbed at Lough Derg and Ireland was at last a Christian country. On another level, Croagh Patrick, like Lough Derg, came to symbolise the re-emergence of a Catholic Ireland, which had survived every effort to tear it away from that tradition. This is part of the often sad religious history of the island and one that it is still trying to resolve. The story of Croagh Patrick can never be separated from a narrative of social-political change and evolution; it can never be separated from the secular discontents of various periods in Irish history. This remains true today, but what remains above all is the mountain – the holy mountain with its pyramidal peak still drawing the eye and attracting up to 30,000 pilgrims on Reek Sunday as well as many individual pilgrims and tourist-seekers at various times of the year.

Krzysztof, Poland

5.

The Ways

*We have come to the Reek with a kind of personal love, not
merely on account of its graceful symmetry and soaring pride,
but also because it is Patrick's Holy Mountain.*
– Dr Healy, Archbishop of Tuam, 1903

Ballintubber Abbey and Tóchar Phádraig

Like many other pilgrimages, the Reek is also a *camino*, a *way* to be followed to the summit. The benefit lies as much in following the *way* as much as it does in arriving. Again, as in other pilgrimages, there are a number of ways of approaching Croagh Patrick. The oldest of these is Tóchar Phádraig, which is the final truncated part of a much longer journey that predates Saint Patrick. What has become known as Tóchar Phádraig starts at Ballintubber Abbey, directly to the east of the mountain.

Archaeological evidence suggests it was built around 350 CE and was initially part of an earlier chariot road to Cruachán Aigle, originating at Rath Cruachán (Rathgroghan, County Roscommon), an important ritual site in its own right, dating back 4,000 years and later to become the seat of the kings of Connacht. A more recent theory suggests that this *tóchar* or causeway may be associated with 'an ancient cosmological alignment, stretching 217 kilometres from the Hill of Slane, in the east, to

Croagh Patrick in the west, linking some of the most sacred sites associated with Saint Patrick.' This has led to the idea that Saint Patrick, if he ever passed this way, may have followed 'a sacred equinox journey'. The authors of this theory argue that 'evidence is emerging that significant archaeological sites dating from deep in pre-history are linked – not just through mythology, archaeology and cosmology – but through an arrangement of complex, and in some cases, astonishing alignments.'[120] All of this poses significant theoretical problems and remains somewhat in the realm of erudite speculation. The archaeological evidence, however, is quite substantial. A large boulder at Boheh, known as Saint Patrick's Chair, which is decorated with small circular hollows known as cup marks, suggests it dates from the Bronze Age and provides reliable evidence of its pre-Christian history.[121] Less than ten years after what may have been Patrick's arrival, however, it had been assimilated as a Christian pilgrim route and

Jarlath, County Sligo

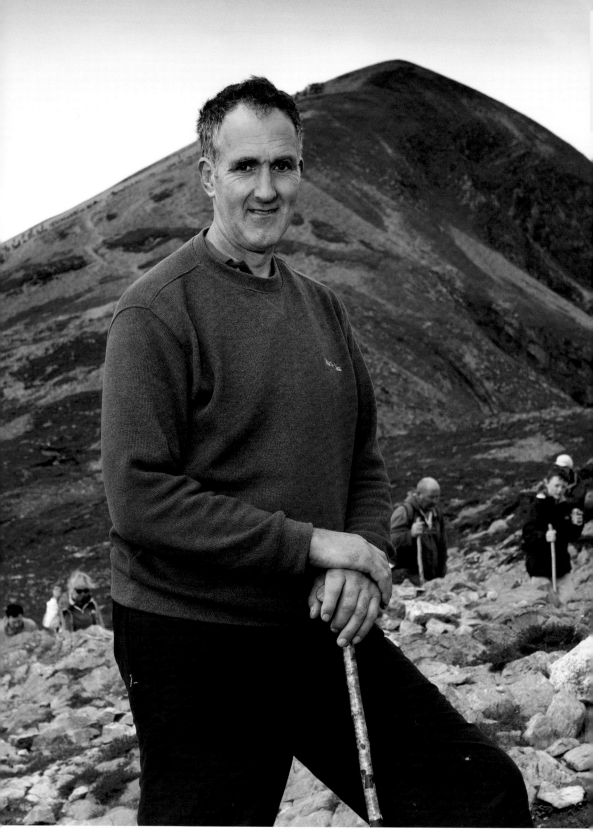

John, County Clare

came to be known as Tóchar Phádraig or Patrick's Causeway.
While the *tóchar* now starts at the Abbey, it seems probable that
originally pilgrims may have joined it at any point along the old
way from Rathcroghan, far back on the plains of Roscommon.

All pilgrimages are subject to both decline and revival, often
due to political or other circumstances in the countries where
they are situated. By the thirteenth century the holy places and
places of pilgrimage of Jerusalem had been cut off by the Muslim
Saracens. This in turn created the need for more local pilgrim-
ages, and it was at this time that both Croagh Patrick and Lough
Derg took on a new importance. Ballintubber Abbey is said to
have been built by King Cathal Crovdearg O'Conor in 1216 and
handed over to the Augustinian Canons Regular who were lead-
ing a reform of the Church in Ireland. The Canons eventually

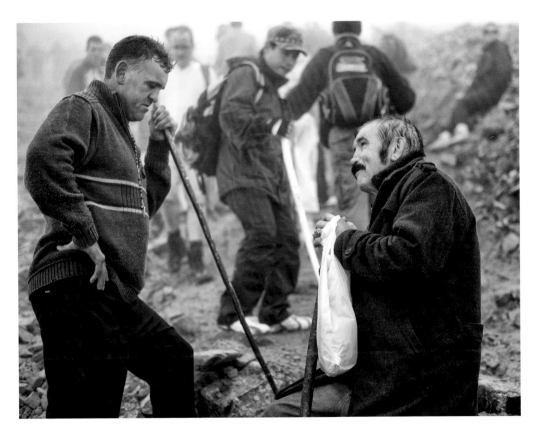

had up to 130 religious houses throughout the country, including several shrines and places of pilgrimage, which they were trying to bring into line with what might have been considered theological and devotional 'best practice' in mediaeval Europe. In Ballintubber they had taken charge of an important traditional spiritual centre and a hostel was built to cater for a growing number of pilgrims. The beautiful remains of this building are to be found in the grounds today. It included a place for both ritual washing and actual cleansing which was known as Danchara or the 'Bath of the Righteous'.[122]

Quarrelling Saints and Scholars

Ballintubber has a long history with archaeological evidence to suggest that the surrounding area was inhabited as far back as 3000 BCE. Legend holds that *Oileán na Scríne* – Shrine Island on nearby Lough Carra – was a burial place of ancient kings and also perhaps a sacred druidic site honouring the dead. Legend has it that Patrick banished nine goblins to it and it seems probable that it remained a pagan shrine up to the sixth century, when Saint Finan settled there. It is clear that there was a lot of religious activity in the area, with several, sometimes quarrelling, local saints and scholars, as well perhaps as holy fools,[123] establishing several small monasteries and hermitages around the lake. Cil Finan is where the monk of that name founded his small monastery in the sixth century, though little is now known about it. It seems probable that this foundation was not very successful and local legend speaks of a dispute with his saint-neighbour on the other side of the lake, Cormac, which may well have been a factor in his failure. In any case, when Cormac eventually left the area to settle elsewhere he predicted that Finan's foundation would never flourish – or did he curse it? It certainly never

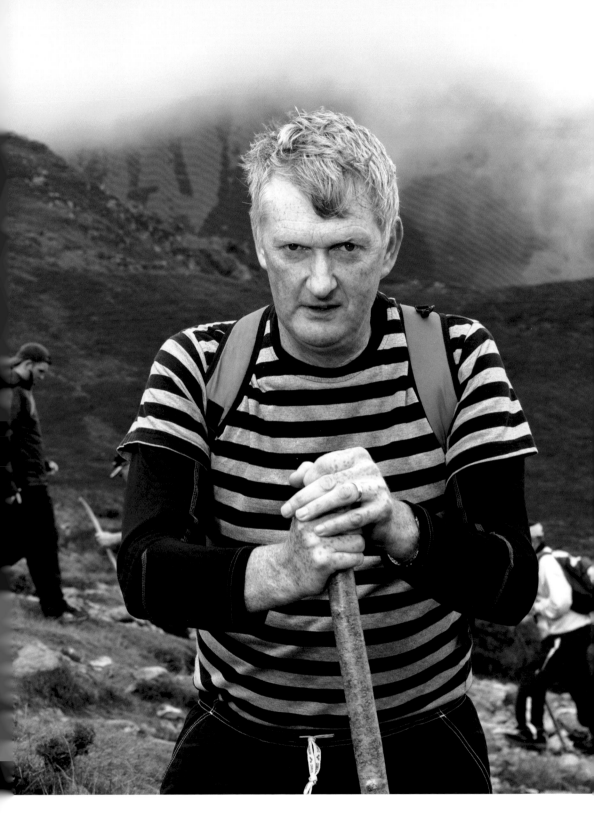

John, County Laois

gained any significance as a centre of spirituality or learning, and probably closed shortly after the death of the founder.

Another folk legend recalls Marbhan, a hermit-poet, who lived in the area for some time. This is of interest if only for the etymology of the name. As it is given here it is *marbhan,* which is Scottish Gaelic, the Irish Gaelic equivalent being *marbán,* meaning a dead man, a carcass or a corpse, which this ascetic man may indeed well have resembled given the rigours of the Irish monastic tradition. Local tradition also speaks of Cummin Mac Fiachra, a later priest from the Abbey, who spent 50 years on another island, apparently decorating the books and scrolls from the great Abbey, which would certainly have contributed to its reputation. This island is still sometimes referred to as Cummin's Island. The Church there has been restored and is now occasionally used for mass, which is celebrated on the ancient

Ballintubber Abbey (© Rob Bridge/ Redwood Photography)

black oak altar. This restored church is the fifth religious building on the island. It also has a round Neolithic remnant dating back to c. 3000 BC, as well as a very early seventh century Christian Church, which was restored in the eleventh century, then rebuilt in the fourteenth century, and now again fully restored. This is a remarkable history, illustrating in itself that the area, with the mountain as its focus, was a significant area of activity from earliest times in both the pre-Christian and Christian eras.[124]

Despoliation, Desecration and Revival

Inevitably, Ballintubber suffered the vicissitudes of both Irish and European religious history as well as natural disasters. The Annals of the Four Masters tells of a fire that partially destroyed the Abbey, notably the nave, in 1265, although it was completely restored by 1270. The big upheaval came, however, following the Reformation in the wake of which Europe was sundered by religious wars, leading to years of dreadful violence across both the continental mainland and these islands, which have deeply marked our history.

Legislation was enacted in Dublin in 1536 dissolving the monasteries. However, this does not seem to have been enforced outside the Pale, and Ballintubber Abbey and other foundations outside survived for another 70 years. In such a politico-religious maelstrom, however, it was unlikely that even churches on the very periphery of Europe would escape. Inevitably, in 1603 James I 'confiscated all the lands belonging to the abbey and effectively ended the presence of the Canon Regulars in the Abbey'.[125] A small remnant of mendicant Augustinian Friars, rather than the Canons, are thought to have struggled on until the violent burning of the Abbey in 1653 by the more religiously driven forces led by perhaps the most hated figure in Ireland history,

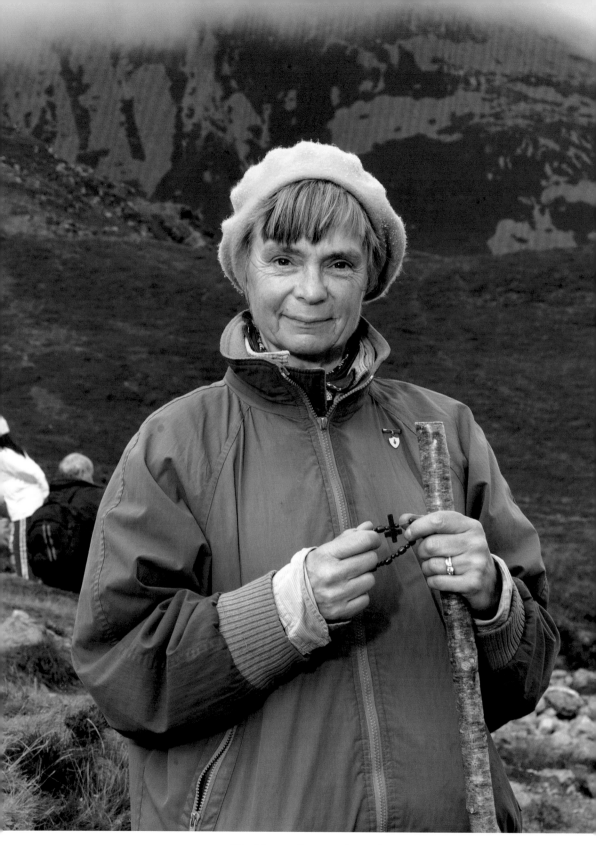

Kathleen, County Meath

God's Executioner, Oliver Cromwell.[126] This despoliation and desecration, however, does not appear to have been completely successful and, apart from the wooden structures, much of the monastery survived intact, including the internal stone-vaulted roofs of the chancel, the four side chapels and the old sacristy, and mass continued to be said there as it has been continuously for 750 years.

The twelfth century pilgrim way endured for almost 300 years. Like many such ways, however, this one eventually fell into decline from the end of the sixteenth century, finally disappearing in Penal times.

There was an early attempt to refurbish the Abbey in 1846, but this began just as the Famine struck the area and was quickly abandoned. Forty years later there was another attempt just as Irish Catholicism had entered its high period, which attracted an enormous amount of support and which can be said to have been the beginning of the modern pilgrimage. The renewal reached its apogee in the high period of devotional Irish Catholicism with a revival that started in 1903 under Archbishop Healy.[127] This endured well into the second half of the twentieth century with up to 70,000 people making the 'Reek Sunday' pilgrimage as recently as the 1970s. In 1966, under the direction of Father Tom Egan, the nave of the Abbey was restored and roofed in time for the 750th anniversary of its foundation, once again emphasizing its place as an important Connacht spiritual centre and as 'one of the finest examples of the Romanesque style of architecture known as "the School of the West".'[128] In was only in 1987, however, that the ancient Tóchar was restored and since that time every year, starting in April, hundreds of pilgrims walk Tóchar Phádraig in small groups – a distance of 35 kilometres. This year the Abbey celebrates its octo-centenary, justifying its claim to be 'the Abbey that refused to die'.

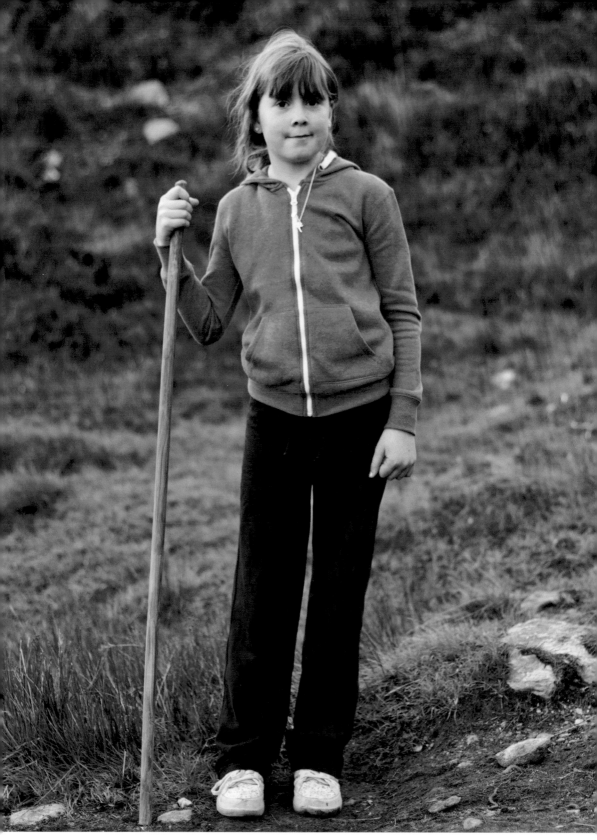

Lara, County Kildare

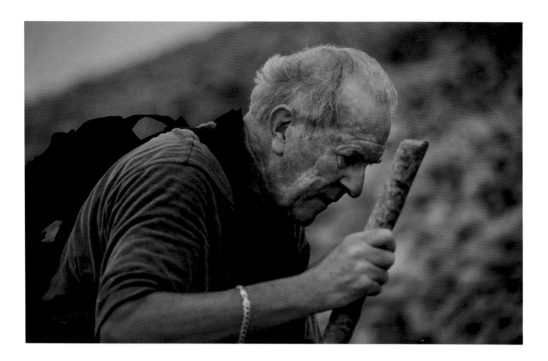

The Steps on the Way

The Tóchar now starts at the Abbey where the pilgrims assemble as individuals and in small groups to follow the ancient way. It is a pilgrimage in the course of which:

> Every tree, every stone, every hill and hollow along the way [seems] to cry out with a story. For everything, it [seems], [has] been adopted into human history. The fields and rocks and streams had been the recipients of man's sweat and blood and tears they had been named and given identity by these same human events.[129]

On the Tóchar there is a strong emphasis on the spirit of the pilgrimage, which the organisers see as being essential in distinguishing the 'pilgrim' from the simple tourist. The tourist comes to see, or to more or less sympathetically observe; the pilgrim comes to participate, to *live* with a heightened awareness the hours that will follow as he or she progresses slowly, alone with

their thoughts, along he remaining trace of the Tóchar. A number of elements that should mark the occasion and give it authenticity are suggested:

Penance – No complaining. Instead say 'Thanks be to God'

Community – Include 'the stranger' in your group – No 'Cliques'

Faith – Light a Candle as symbol of your faith before setting out

Mystery – Silence to be observed at certain designated parts of Tóchar

Celebration – Share your Food, your Joy, your Love and your Care

It is clear that over time the emphasis in the pilgrimage has moderated some of its rigour. However, it still retains its ascetic and penitential dimensions, linking it back to its patrician origins

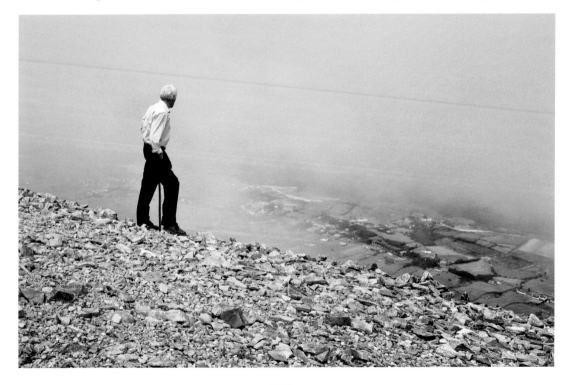

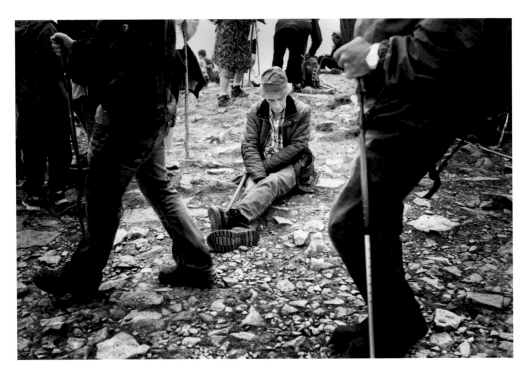

but with the addition of other essential elements: faith, community, mystery or a certain Irish mysticism and the celebration of the faith the mountain has come to symbolise. These represent, perhaps, a more modern, post-conciliar Catholicism, while keeping faith with the foundational narrative. It is this that keeps the pilgrimage alive. The parish priest of Ballintubber Abbey and spiritual custodian of the site, Father Frank Fahey, expresses the spirit of the pilgrimage well:

> As you 'walk the Tóchar', whether on foot or in fantasy, you will be going not only on a spiritual pilgrimage, but on a cultural and historical journey down through the ages also. And both experiences, if fully entered into, should bring about that change of heart and insight of mind which is essential to a pilgrim's progress.[130]

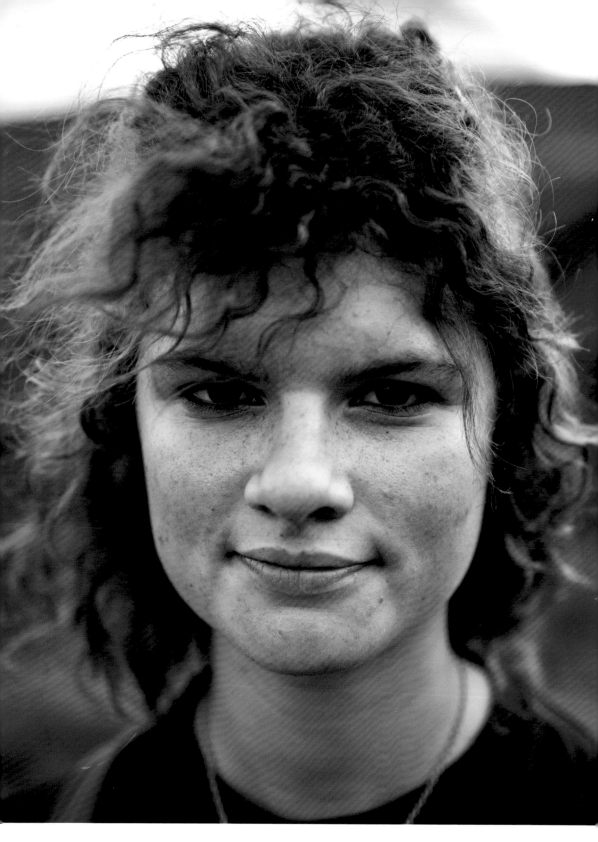

Maelie, France

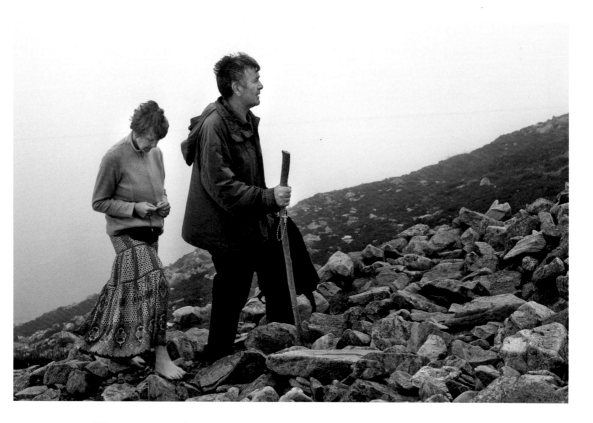

This way leads to Aghagower, with its round tower, suggesting a significant monastic foundation, near which there is a holy well and a sacred tree, with its roots in a soil that is said to have curative properties. Like many holy wells this one has pre-Christian origins.[131] Wells, and the associated trees, fit into the kind of place, which Eliade identified, where one seeks that which is *beyond*, they are amongst the places at the interface between the sacred and the profane. Mary Players provides a striking description of these mysterious places:

> All Holy Wells in Ireland bear a striking resemblance to one another. Each well is usually found in a quiet place, sheltered by trees, and covered by a flat stone slab to preserve it from contamination. Round the well a circle is traced and there are 'stations' or resting places for prayer and meditation at regular

intervals along the outline of the circle. Close to the well there is a crude altar beside a tree trunk on which a crucifix in wood or stone is hung. On the branches of the trees in the vicinity, small pieces of cloth may be fastened. These are memorials of pilgrims' visits. At the close of the visit, the pilgrim may drink some water from the well out of a vessel secured by a chain to a nearby stone or wall.[132]

These are places of popular religious devotion where people come to pray, often with quite specific intentions, and leave simple offerings. They came to prominence in Penal times when they began to replace the more formal, but at that time persecuted, religious practice. This was folk practice and popular

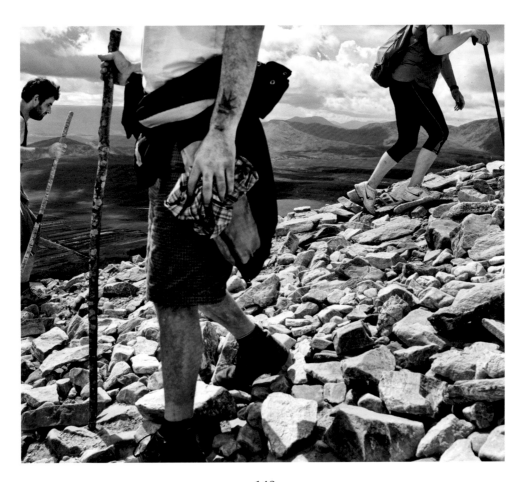

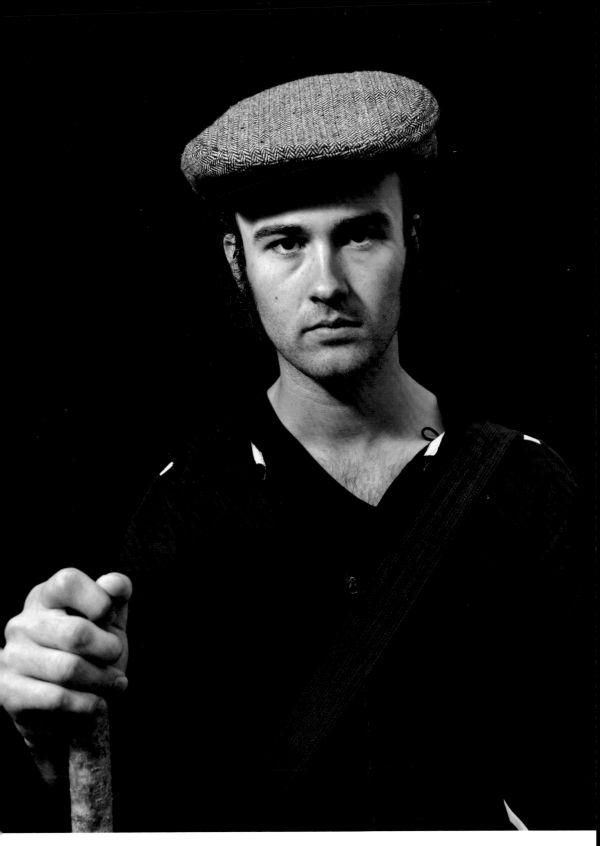

Greg, Canada

devotion, a powerful blend of traditional belief and Christian ritual. The wells are still widely found throughout Ireland and many are still much frequented. The simple votive offerings at the wells are usually small, cheap, religious statues either of the Blessed Virgin or a number of saints including Saint Anthony and Saint Jude, common medals, devotional pictures, and contemporary photographs often of deceased family members, rosary beads, flowers and candles. It is not uncommon to find red rags offered to ward off evil spirits, and in a few cases I have found small plastic eggs, which are clearly related to fertility rites and may well have been offered at least partly to an elder god or goddess as well as the saint of the place who in a syncretistic process may have inherited or usurped the older deity's reputed powers.

Further archaeological evidence from the Early Christian Era to be found at Lankill is a raised stone altar with a small cross-inscribed stone on top of it and an adjacent pillar stone, while a nearby holy well is attributed to Saint Brendan, a saint more often associated with the south of the island while Patrick dominates the north.

While there are a number of sites of interest along the way, the real experience of the Tóchar, as in any pilgrimage, is in the walking, punctuated by prayerful stops or stations. It is this that 'should bring about the change of heart and insight of mind which is essential to a pilgrim's progress'.[133] Here the walking is over some of the most barren landscape in Ireland, a landscape from which there is no escape except through walking on, a landscape where one only encounters the *self* and perhaps glimpses of the *other*. It is the road taken by many of 'those who have gone before us marked by the sign of faith' and by those who travelled it even before *them*, going back into the mists of time, as mythological pilgrimages always do. In more contemporary

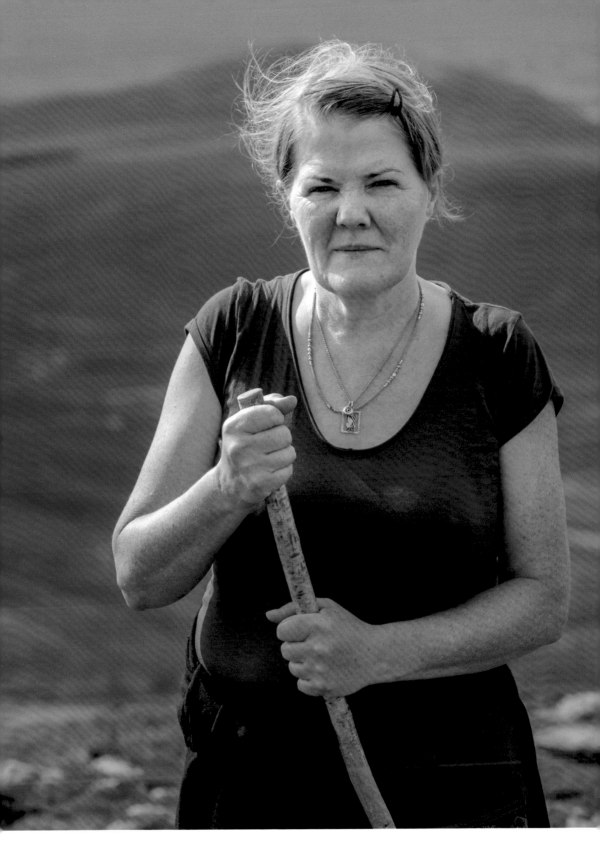

Mary, County Mayo

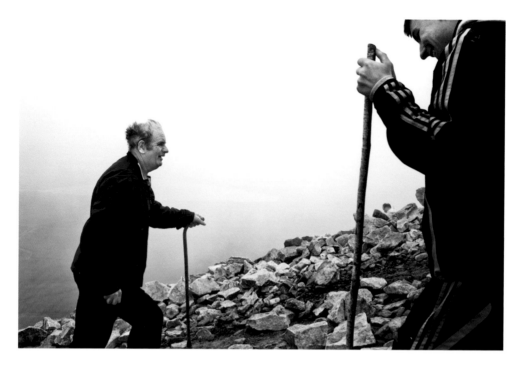

terms, I think the Tóchar Phádraig can be seen in Robert Frost's 'The Road Not Taken', the taking of which, the modern pilgrim hopes, may somehow 'make all the difference'.[134]

The Murrisk Way

While the Tóchar Phádraig is the most ancient route, the most common way is the historical path that has by now left an indelible mark on the mountain and is clearly visible even from a long distance. While one can see the attraction of the older road, there is something very moving about the *way* that starts from the mediaeval friary founded by Augustinian Friars near the village of Murrisk in the middle of the fifteenth century. It winds its way slowly up the mountain and, seen from a distance, it gives a very powerful impression of being not just a mountain path, but a *way* that, in the evocative words of Gerard Manley Hopkins, 'generations have trod, have trod, have trod'.[135]

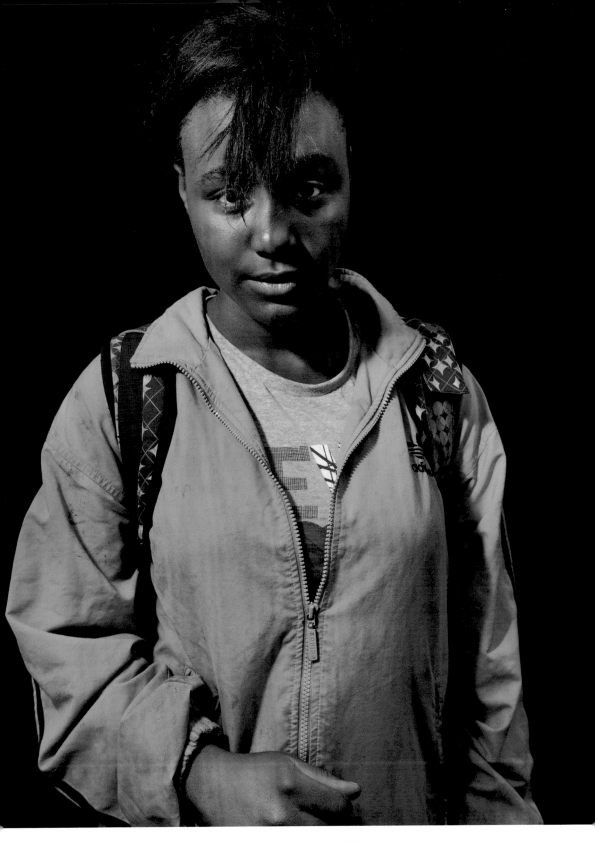

Victoria, County Dublin

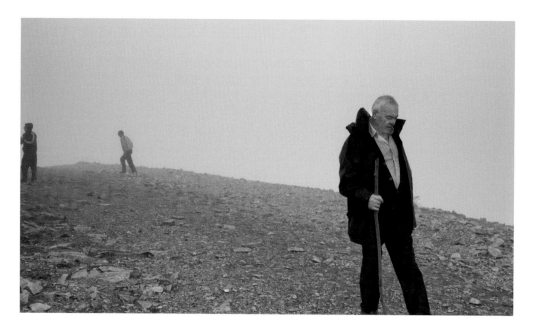

This is the starting point of the annual July pilgrimage, as well as for the many people who climb it throughout the summer. One friend told me he had climbed it well over a hundred times in all seasons and seemed to find something new there each time. One can't look at it without thinking of the millions of people who have trodden it, but also of the stories and the sufferings they bore. Here they:

> … clambered in
> the steps of the saint
> rosary and ash plant in hand,
> drovers of sin
> … barefoot
> leaving their blood on the stones
> a kind of expiation for their
> long forgotten untold sins
> or those of ancestors.[136]

From the photographs in this book it is clear that this spirit is still present in many of the people who make the pilgrimage.

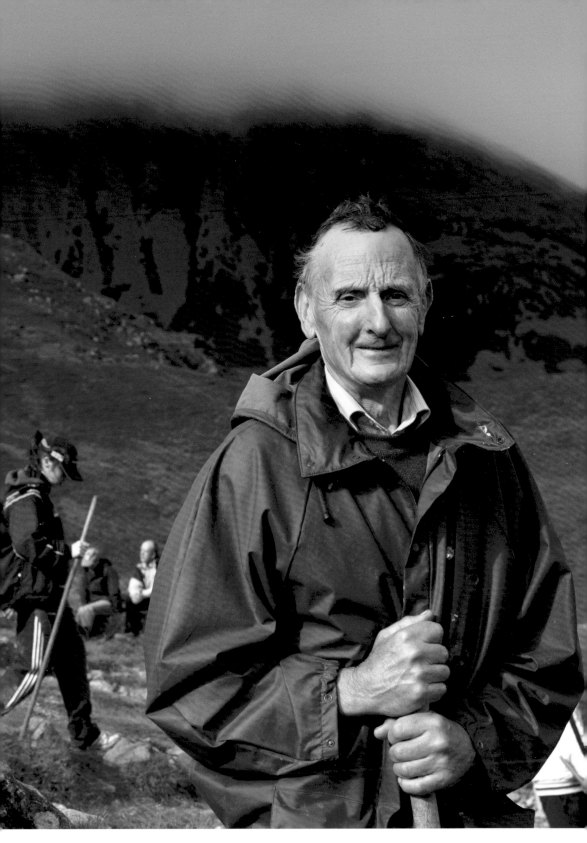

Michael, County Clare

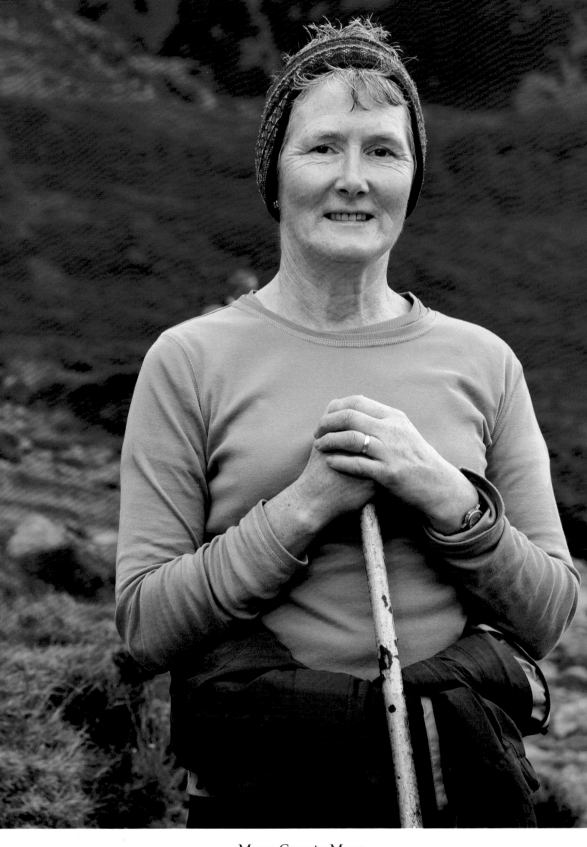

Mary, County Mayo

The climb is the same as ever, and the conditions can vary, but they clutch their stylized walking sticks and often a rosary with an awareness of the fact that many have passed this way before them.

Murrisk Abbey was founded in 1457 by Hugh O'Malley and handed over to the charge of the Augustinian Friars (to be distinguished from the Augustinian Canons who had been at Ballintubber). The winds of change, however, soon began to make themselves felt in the wake of the Reformation, although the Abbey survived for some time isolated as it was in the remote west. The Friars were eventually driven out, however, in 1578 when the Abbey property and lands were granted to James Garvey, a brother of the Church of Ireland Archbishop of Tuam, John Garvey. There may have been some resistance and there is evidence that they may have returned as there is mention of the friary in an inquisition of 1605.[137] While the monastery was suppressed there is evidence that the friars continued to lead a clandestine

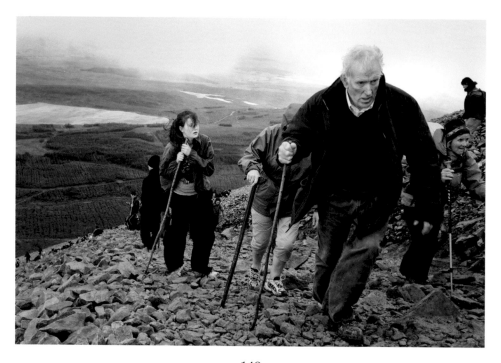

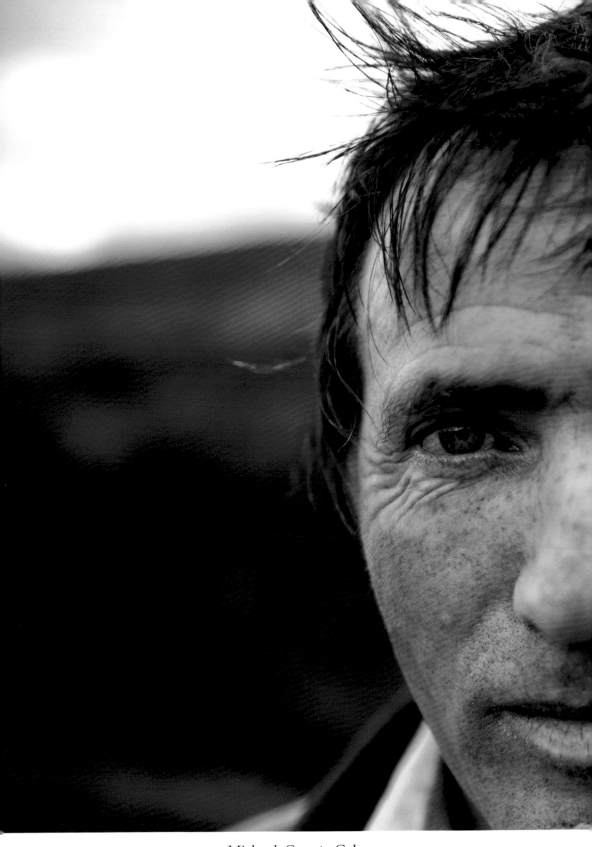

Michael, County Galway

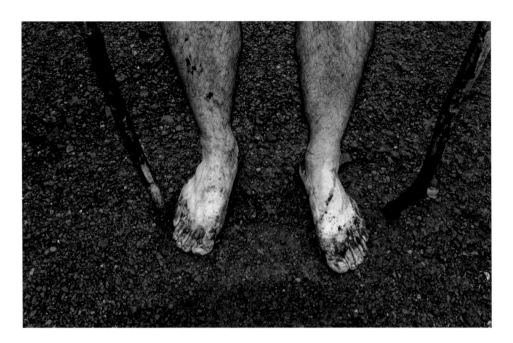

life in the area maintaining religious devotion and practice. A chalice now in Tuam was donated to the Abbey by the son of Granuaile, Theobald, Lord Viscount of Mayo, in 1635 and bears witness to this continued presence in a time of persecution.[138] Murrisk is now also the site of Ireland's National Famine Memorial, designed by Irish artist John Behan, which abstractly resembles a coffin ship filled with dying people. All of this comes together as part of the Reek narrative and its place in local history, and it is certainly an important part of what is remembered in the pilgrimage.

While the way from Murrisk is much shorter, starting at the base of the mountain, there is evidence to suggest that there were several stations that were used by pilgrims as part of the pilgrimage. Perhaps the most interesting site is Caher Island, which lies six miles southwest of Roonagh Pier and is difficult to access. This is said to be 'the last station on the pilgrimage round to Croagh Patrick'.[139] The island, like other such sites, is highly evocative with the ruins of a sixth or seventh century Christian

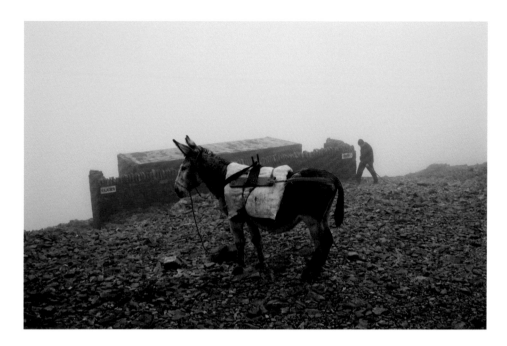

monastic settlement marked by a number of cross decorated pillars, as well as what are thought to be 'cursing stones'. Here Patrick is said to have spent some time after his fast on the mountain and so, not unsurprisingly, the island also has a *Leaba Phádraic*, a flat stone at the southeast gable of the little ruined oratory which, legend holds, served as his bed. Intriguingly, there is also an old path leading to the west, known as Bóthar na Naomh, the saint's road, which 'was said to be the head of a causeway running under the waves in the direction of the Reek'.[140]

If Caher Island was the last station on one of the ways to the Reek, another of these is Kilgeever, 10 kilometres to the west of the mountain, which was where pilgrims used to come to conclude their pilgrimage. At Kilgeever one finds the ruin of the Gothic style church, which appears to have been built between the twelfth and the fifteenth centuries, beside which there is a holy well dedicated to Rí an Domhnaigh, the Lord of the Sabbath.[141]

Harbison writes:

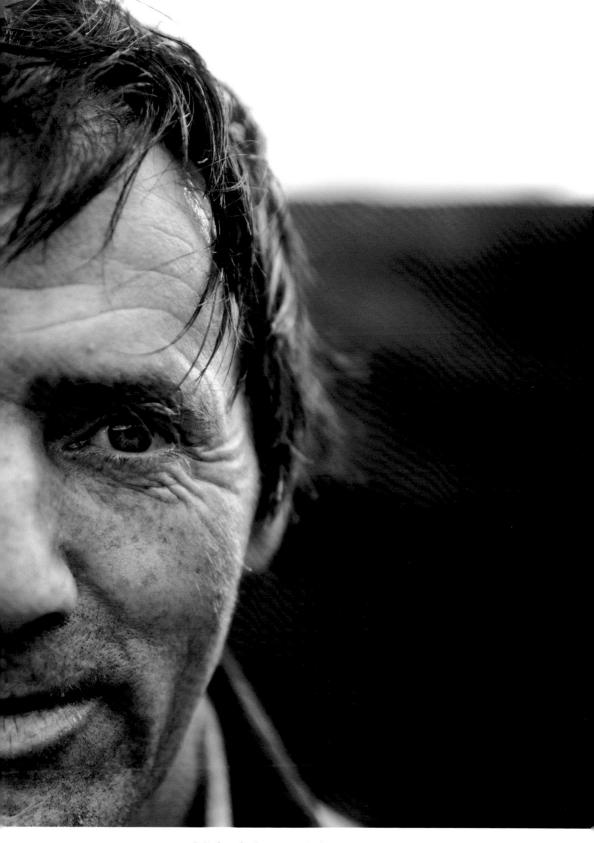

Michael, County Galway

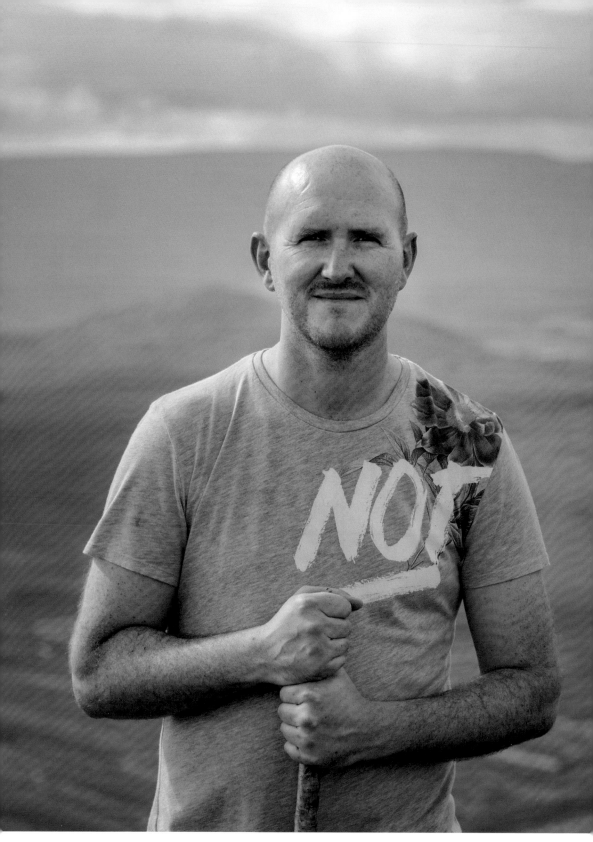

Patrick, County Mayo

Both [Croagh Patrick and Lough Derg) can be traced back his-
torically until they get lost in the uncertain mists of time, and
both are among the few surviving examples in Europe which
give the present-day participant some idea of the true rigours
experienced in going on pilgrimage in mediaeval times.

What emerges here is that while the Reek was certainly the
focus of people's attention, the area around it was home to a cul-
ture going back to pre-Christian times, but also to a Christian
flourishing from about the sixth century on. Today it remains
an area of great interest where the dedicated pilgrim or curious
traveller will find much evidence of this culture, which has in
some senses disappeared, but which in other ways, as the photo-
graphs in this book illustrate, has been woven into the landscape.
This is very much alive in the contemporary pilgrimage.

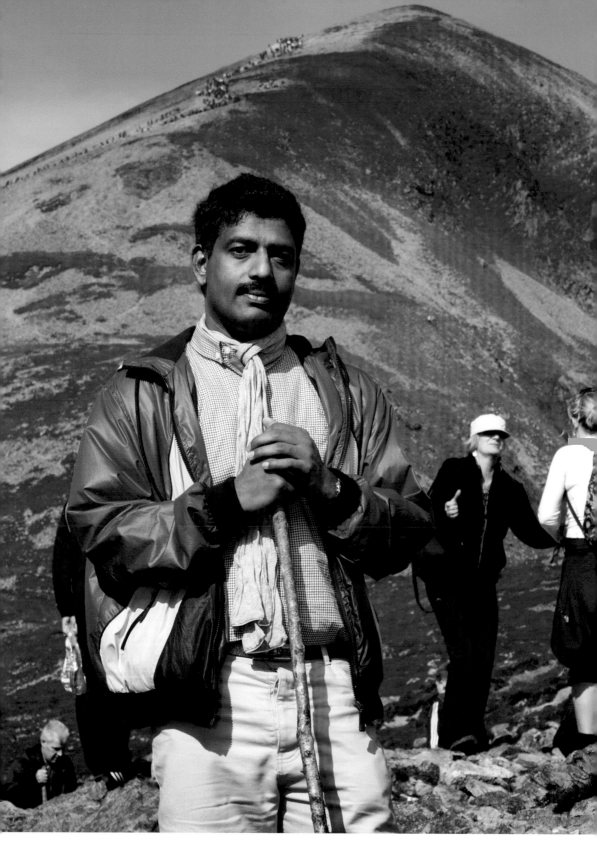

Paul, County Donegal

6.

All Ways Lead to the Summit

Who may ascend into the hill of the Lord?
And who may stand in His holy place? – Psalm 24:3

From wherever the pilgrims have started, the focus is the summit of the holy mountain, the *Cruach*, that gleaming quartzite peak that has drawn people for thousands of years. While still little more than a speck on the horizon it already holds the eye, drawing the pilgrim along in the hope of reaching a place that is out of place and out of time, a sacred place. Looking at the images in this book we cannot know what drew these many very different people here, but we do know that they came in search of something. They have followed the way up to these final stations where they will undertake the Christian rituals of the pilgrimage or perhaps just look on and wonder while others do so.

One of the important aspects of all kinds of religious ritual is that it should be more or less unchanging, although it is in fact often modified to meet changing needs. The ritual on Croagh Patrick is, however, quite tightly outlined in a short document issued by the Catholic Bishops. It consists essentially of three *Leachts*, or penitential stations. The first, *Leacht Beanáin*, where the pre-Christian Festival of the Corn King is thought to have

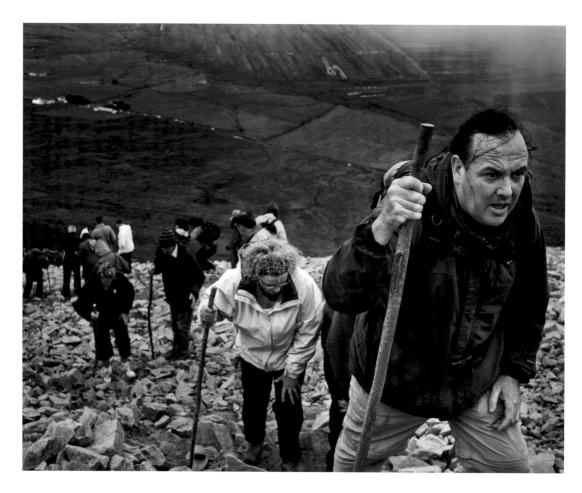

been held, is now named after Patrick's disciple Benignus or Beinéan. This is at the base of the mountain and consists of a small circular cairn of stones. Here the pilgrim recites seven Our Fathers, seven Hail Marys and one Creed. There does not appear to be any specific explanation for the significance of the number seven, but it does occur in the Old Testament account of Creation and is considered typological as it also appears commonly elsewhere in the Bible and in other religions, including the seven circumambulations of the Kabah, the climax of the Hajj at Mecca.[142]

The second *Leacht* is at the summit, where the present church was built in 1905 at the outset of the modern revival. Here again

one kneels first to repeat the ritual prayers and then 'walks fifteen times around the church in a clockwise direction saying fifteen Our Fathers, fifteen Hail Marys and one Creed.' Before leaving the second *Leacht*, the pilgrim visits *Leaba Phádraig* (Patrick's Bed), again repeating the prayers.[143]

The third *Leacht, Reilig Mhuire*, is generally used to refer to three cairns, which may have served as a prehistoric enclosure, again illustrating the assimilation and adaptation of older sites to changing needs. Describing the site in 1838, O'Donovan in his letters recounts how:

> ... the pilgrim after finishing his rounds of the other stations descends by another precipitous path leading from the summit to the south west extremity of the cone or *Cruach*, where the most important of the penitential *Leachts* or monuments are situated. Inside the Great Enclosure or *Garraí Mór* as it is locally called, are three distinct circles at each of which the pilgrim repeats seven Paters, seven Aves and one Creed, travelling all the while on his knees for seven circuits around each one. The *turas* or pilgrimage is then finished.[144]

Here one certainly has the feeling that the old and the new religions somehow meet and become one, while the pilgrim, looking out over Clew Bay and on to the Atlantic, knows that he or she is part of an ancient ancestral tradition that goes back a very long time, as they take part in a ritual in an extraordinary place and in a time that is somehow outside time, if only for a few hours.

A Personal Pilgrimage

I have only climbed Croagh Patrick once, the year before I left school. I was seventeen. The Reek was dimly viewed by the

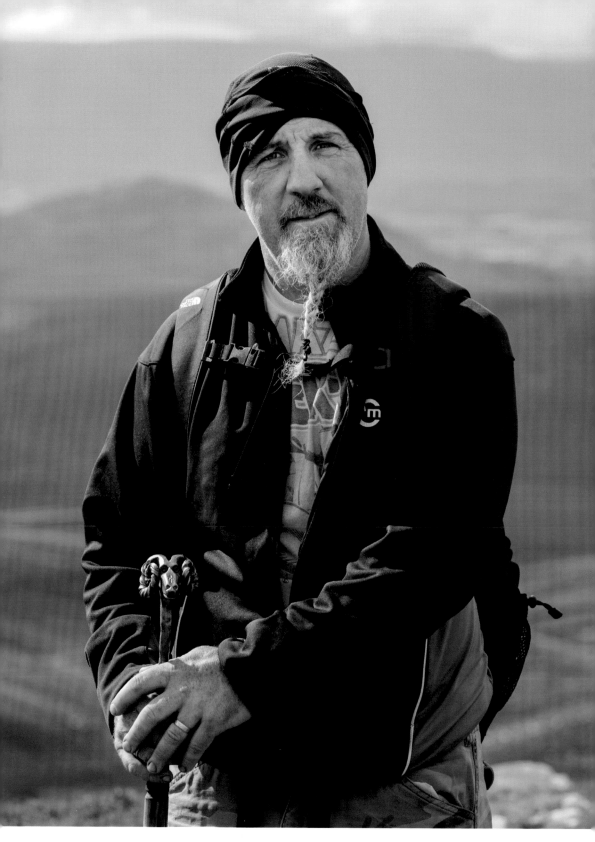

Johnny, County Leitrim

much more austere devotees of Lough Derg, of which my father, though he was not in many ways a particularly religious man, was one. He saw the Reek as very much 'second rate' in terms of its asceticism and so, one imagines, in the resulting 'penitential dividends' when compared with Saint Patrick's Purgatory, where the Corra had finally been 'vanquished'. My mother told me he had done it eleven times, apparently starting when the birth of his first-born (me) appeared to have been delayed – was there some devotion to a fertility goddess I had never heard of? I now believe the austere Lough Derg pilgrimage was also part of his eventually successful effort to conquer the other Irish demon, drink. There was obviously little chance of doing that at Croagh Patrick where at least at the foot of the mountain all kinds of alcohol flowed quite freely and was very much part of the occasion.

Hughes tells us that 'up to the late 1800s the festivities in the pattern field of Murrisk were an integral part of the pilgrimage day'.[145] In my youthful pilgrimage there was little of the self-denial, contemplation or spiritual renewal that had attracted so many, including my father, to Lough Derg – a place I have, for some reason, always avoided. My ascent of what I was later to call this Atlantic Tabor was more an Irish schoolboy summer initiation with two friends, in a month of July that also included the Connacht Football Final and a first visit to the Galway Races. It was a night climb, with probably up to 70,000 people on a very fine, warm night, following a very enjoyable train journey from Castlerea, on those somewhat distant plains of County Roscommon. While it was not a particularly penitential or ascetic experience, it did leave strong images which have come back over the years: people climbing in their bare feet, clutching walking sticks, children with their parents, local sculpted faces as if drawn from Sean Keating paintings, dressed in everyday clothes and with a total absence of the now ubiquitous brightly coloured raingear. These were faces and voices I was familiar with, these were *my people*, and I knew the pilgrimage was very *local*. However, two memories above all remain: the sun rising splendidly over Clew Bay and its many islets and drinking my first bottle of Guinness outside that pub in Murrisk. While it was not a 'Station Island' experience,[146] it was certainly indelible, and it still remains with me as a 'stepping stone', a station of the soul with two boyhood friends.

Postscript

There are only two mistakes one can make along the road
to truth; not going all the way, and not starting…
The foot feels the foot when it feels the ground.
– Gautama Siddhartha, the Buddha

The best views of the Reek, it seems to me, are those from a distance, when the much-trodden Murrisk Way beckons to the eye and invites the mind to rise above the quotidian, to life on another level or at another depth, either above or within the self as it fixes on the glistening quartzite summit. As I start writing this final chapter, I am once again away and looking back at Croagh Patrick from a great distance. This is part of what I see as my own life's pilgrimage, that search for an understanding of what 'lies behind'. What lies behind the idea of 'pilgrimage', what lies on or behind 'the holy mountain', whether it be Kailas, Tabor or Croagh Patrick, a mountain amongst the holy mountains of the world? While the Reek has become closely associated with a particular form of Catholic devotion, I think to find the real sense of it we have to look further. We have to look at other religions and other pilgrimages to come to an understanding of what lies at the heart of all of them.

The View from Chùa Thiên Mụ, the Fairy Woman's Pagoda

I am writing as I look out over the Perfume River, and the mountains behind, in the former imperial city of Hue, an important Buddhist centre in central Vietnam. I spent the morning at the Chùa Thiên Mụ, the Fairy Woman's Pagoda, with its seven-story *stupa*, reaching ever beyond, the tallest religious building in Vietnam. The *Chùa* and adjoining *sangha*, or Buddhist monastic community, are set on a hillside, overlooking the graceful river. There is a constant flow of pilgrims coming to prostrate themselves before the Buddha with prayers and offerings for themselves, their families and, above all perhaps, as my guide Than told me, their remembered ancestors, the dead who are never dead but have passed on to another arising. The devotion is quite extraordinary in a country that is officially only 13 per cent Buddhist, but the figures are one thing and the human reality quite something else. This is part of a journey to Vietnam and Cambodia I undertook at least partly to mark my sixty-fifth birthday but also, I think, the fact that my own personal pilgrimage still goes on. I am professionally and personally fascinated by the various manifestations of the religious and the spiritual in both their traditional and more modern forms. Like many people today, I go to Asia in the knowledge that it has a rich tradition in this regard and has always had a strong attraction for seekers of all kinds. This is a place for those who seek 'holy places', those places we know we cannot enter without taking off our sandals. In this I am, of course, influenced by Christians and others who have looked to Asia for what it has to offer in understanding the wider questions, the questions that somehow really matter and which are so often elided and left unaddressed in an increasingly secularised and materialistic West.

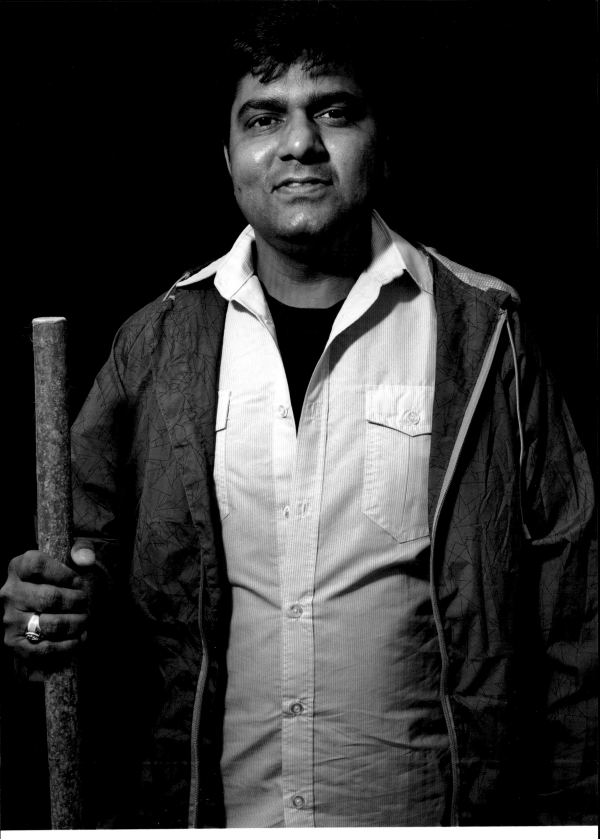

Sarang, India

Griffiths, Le Saux and Merton: The Christian Opening to Asian Spirituality

The Christian monk, Bede Griffiths OSB (1906–1993), who by the end of his life had come to be known as Swami Dayananda ('Bliss of Compassion') engaged deeply with *advaita vedanta*, a philosophy whose principle insight is that the Self is One with Ultimate Reality, thus pushing his theological thinking in an increasingly Hindu direction as he sought to make links and build bridges. He wrote:

> Above all we have to go beyond words and images and concepts. No imaginative vision or conceptual framework is adequate to the great reality…. It is no longer a question of a Christian going about to convert others to the faith, but of each one being ready to listen to the other and so to grow together in mutual understanding.[147]

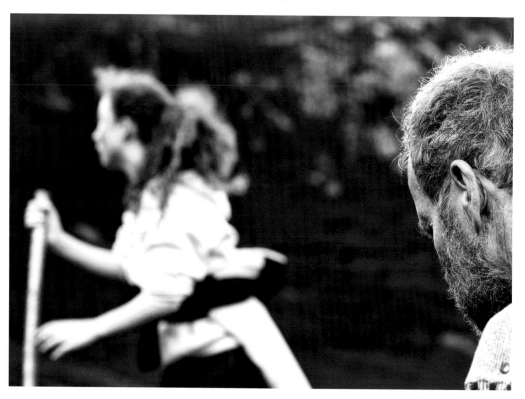

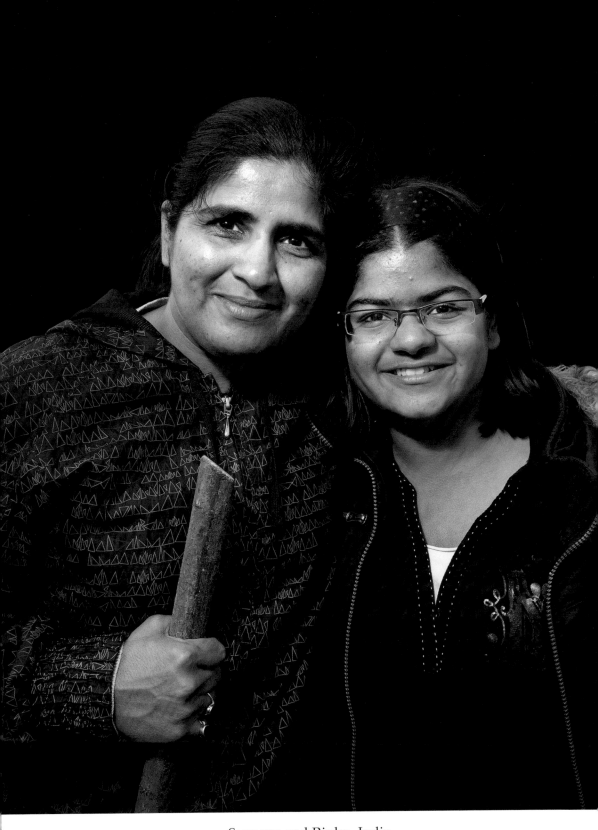

Suvarna and Rinku, India

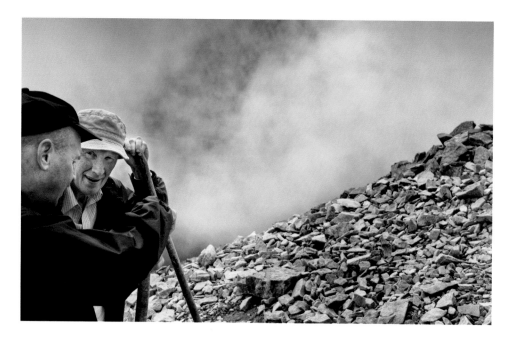

His French Benedictine confrere, Henri Le Saux (1910–1973), known as Abhishiktananda went, perhaps, beyond Griffith in his search for a more radical form of spiritual life, when he adopted *sannyasa*, the life of a mendicant hermit in accordance within Hindu tradition, to become an early pioneer of Hindu-Christian dialogue. Le Saux came to experience the essential oneness of reality, *advaita*, in the final years of his life. On his death bed he declared:

> O I have found the Grail…. The quest for the Grail is basically nothing else than the quest for the Self…. It is yourself that you are seeking through everything. And in this quest you are running about everywhere, whereas the Grail is here, close at hand, you only have to open your eyes…. There is only the Awakening.[148]

One of the people who perhaps did most to promote interest in the religion and spirituality of the East in the West, and particularly in Christian circles, was the Cistercian monk Thomas

Merton (1915–1968). Merton had gained an enormous reputation as a serious spiritual writer but one who appealed far beyond a simply Catholic audience. While remaining very much a traditional monk at Abbey of Gethsemani, in Kentucky, he was also a poet, social activist, and student of comparative religion who began to engage with Buddhism, Taoism, Hinduism, Jainism and Sufism. He had correspondence and conversations with Japanese Zen master D.T. Suzuki (1870–1966). Merton, the Cistercian of the Strict Observance, however, wrote three small books between 1965 and 1968 examining Zen as a result of his exchanges with the master.[149] Merton, the poet, believed that some facets of Zen were present in all authentic creative and spiritual experience. In the engagement with Suzuki he explored the many congruencies of Christian mysticism and Zen, writing:

> I come as a pilgrim who is anxious to obtain not just information, not just 'facts' about other monastic traditions but to drink from ancient sources of monastic vision and experience. I seek not to just learn more quantitatively about religion and monastic life but to become a better and more enlightened monk (qualitatively) myself.[150]

This developed in exchanges with other Buddhist thinkers, notably the Tibetan Buddhist Dzogchen master, Chatral Rinpoche (1913–2015) and the Dalai Lama (b. 1935). Merton's interest was Buddhism and the avenues it opens for contemplation and solitude that are at the heart of contemplative life and, indeed, of more contemporary concepts such as *mindfulness*:

> Solitude is not something you must hope for in the future. Rather, it is a deepening of the present, and unless you look for it in the present you will never find it.

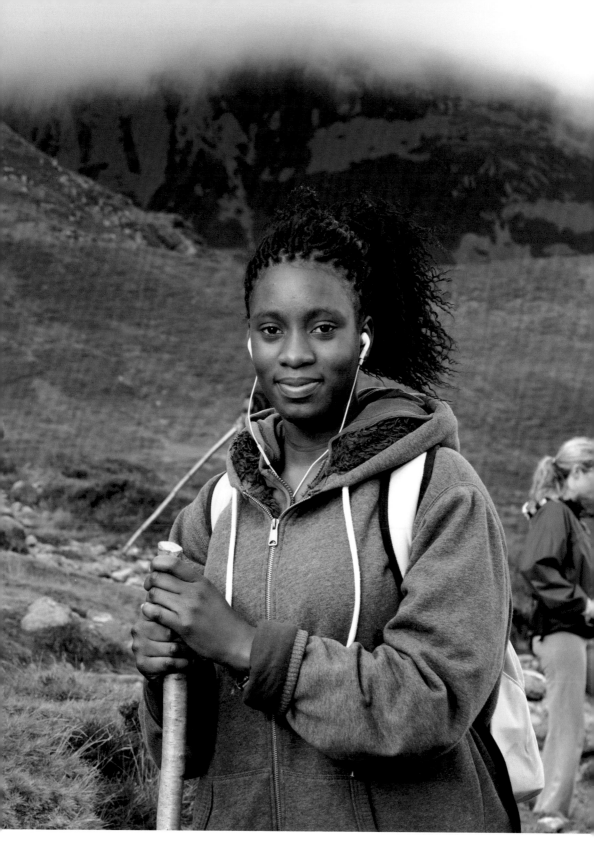

Vivian, County Longford

Unlike both Swami Dayananda and Abhishiktananda, Merton never lived in Asia and, in fact, was on his first trip there, for a series of monastic conferences and encounters, when he was electrocuted in Bangkok in 1968. He left leaving us a fascinating account of his 'pilgrimage' in the posthumous *Asian Journal of Thomas Merton*, which I read again on my last trip to India. While he briefly looks at Hinduism he does not seem to really warm to it, and we are left with the clear impression that his real interest was Buddhism as lived in the *sangha*, the monastic community. As John A. Coleman writes, in the journal:

> ... [he] recounts in detail his sense that the dialogue with Buddhism was not to become some facile syncretism and did involve a scrupulous respect for important differences. Yet he had found in Suzuki, the Dalai Lama and the Vietnamese Buddhist monk, Thich Nhat Han, sources to help him drink from this ancient source and yet remain a Catholic monk.[151]

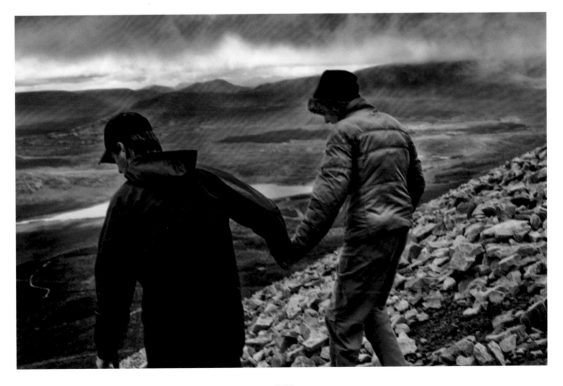

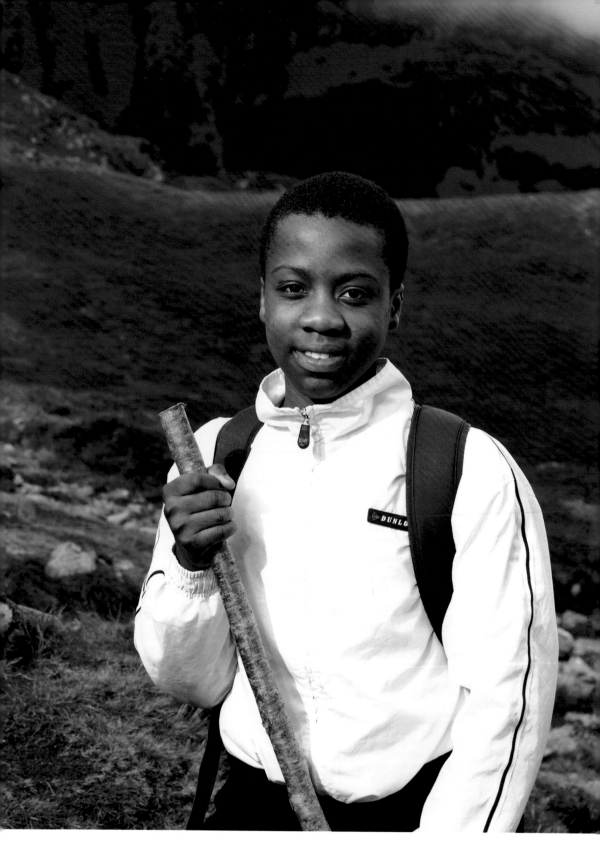

Peter, County Longford

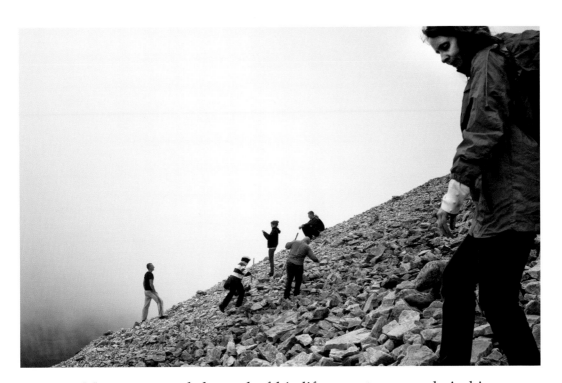

Merton, toward the end of his life, saw two people in himself, 'one ascetic, conservative, traditional, monastic. The other radical, independent, and somewhat akin to beats and hippies and poets in general.'[152] In this, he was part of a wider intellectual and artistic movement in the United States that engaged with Buddhism, which had been present in America since the beginning of the nineteenth century. This was almost certainly due in large part to the Vietnam war. Despite the repression of Buddhism and other forms of religion during the communist period, it remained a major factor in life in Vietnam and individual monks played a central symbolic role at this critical period in Vietnamese history. On 11 June 1963, Thích Quảng Đức (1897–1963), a Mahayana Buddhist monk, abbot of the Phước Hòa Pagoda, also sometimes known as Bodhisattva Thích Quảng Đức, drove an Austin car to a busy intersection in Saigon to protest the persecution of Buddhists by the South Vietnamese government led by Ngô Đình Diệm (1901–1963), an American puppet. In an

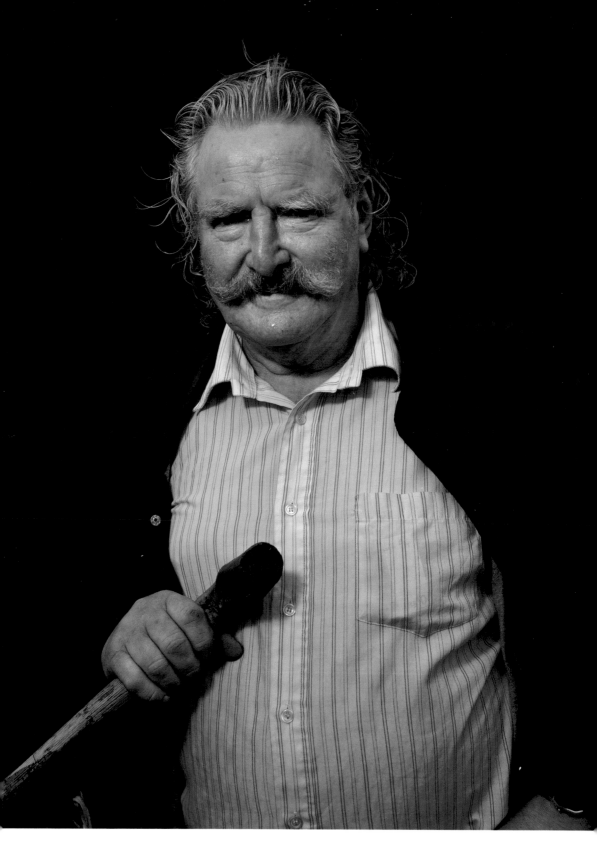

Peter, County Galway

act that seemed to go against the sacrosanct Buddhist precept of *ahimsa*, or non-violence, he set fire to the car and thus immolated himself. In a letter he left he explained his radical act:

> Before closing my eyes and moving towards the vision of the Buddha, I respectfully plead to President Ngô Đình Diệm to take a mind of compassion towards the people of the nation and implement religious equality to maintain the strength of the homeland eternally. I call the venerables, reverends, members of the sangha and the lay Buddhists to organize in solidarity to make sacrifices to protect Buddhism.[153]

This event, captured in a famous photograph, led to an enormous public response and an increased sympathy for Buddhist thinking. Several of the Beat Generation engaged at differing levels, including Jack Kerouac (1922–1969), on a relatively superficial level,[154] but more seriously Gary Snyder (b. 1930),[155] and the celebrated Beat poet Allen Ginsberg (1926-1997),[156] described as a 'poet and bodhisattva', both of whom has a lifelong commitment and engaged deeply: 'I celebrate my non-self, I sing my non-self.' His death, by all accounts, was that of a mystic, marked, as it seems to have been, by great grace and serenity.[157] The composer Phillip Glass (b. 1937) and, on a more popular level, the Beatles, and notably George Harrison (1943–2001), like Glass, became very involved with both Indian music and spirituality and led many people to an interest in these new religious. In talking to many of the people who climb Croagh Patrick one finds strong traces of this kind of post-modern thinking, there is a search for a deeper spirituality and a sense of meaning that often escapes us and they think at least some part of it may be found here.

India – A Land of Pilgrimage

A few years ago I fulfilled a long held desire to visit India, a country I had become enthralled by largely through the remarkable journalism of Sir Mark Tully (b. 1935), for many years the BBC World Service's 'voice of India.' Tully, speaking beautifully in his plummy tones, had always shown a deep critical empathy for and understanding of his adopted country, and he was highly respected by Indians, especially at difficult moments of national crisis.[158] I had to wait but I eventually got to India, which was, to use a cliché, far beyond my best dreams, teeming with life, culture, history – and religion.

Varanasi and the Ganga

On my second visit I went to the holiest river of Hinduism, the Ganga or Ganges at Varanasi (Benares), its holiest city. Here millions of Hindus have made the pilgrimage, year in and year out, for thousands of years from all over India, often walking for hundreds of kilometres. I encountered Brahmins, the priests, and *sadhus*, the wandering holy men, but also, of course, the many ordinary people of all castes who come, often several times, to fulfil their sacred obligation or to cremate their dead and release them to the sacred waters, the highest blessing.

Here they bathe in its waters, thus rendering homage to their ancestors and to their gods as they reverently cup the holy water in their hands, lifting it over their heads and allowing it to fall back into the river; they offer flowers and rose petals and float shallow clay dishes filled with oil and lit with wicks. Returning to their home towns and villages they carry small quantities of river water for future use in rituals. In the early dawn, as the river was bathed in a suffused misty light, I made my way through the fetid and narrow alleys of the city, joining them

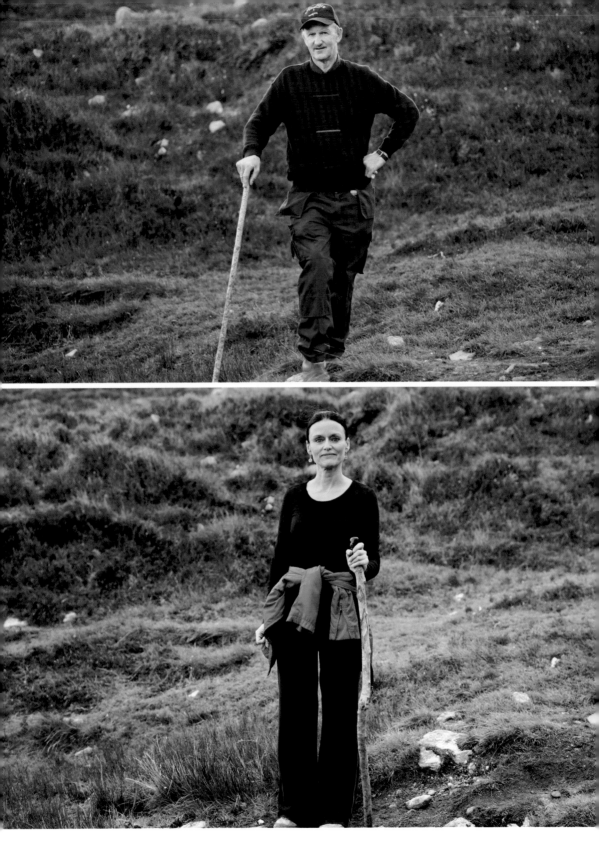

Richard, County Kilkenny (top) and Sheila, County Sligo (bottom)

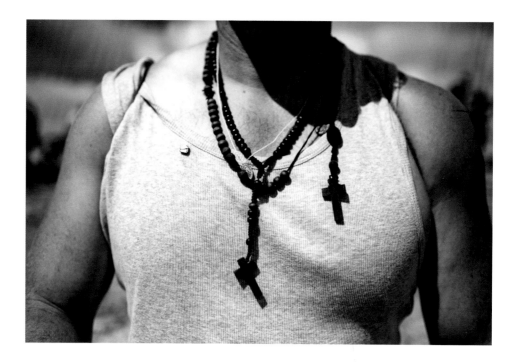

as they descended to the holy waters. It was a deeply moving experience to watch the sun rise over what is one of the most important religious sites in the world and, as I left, to have a Brahmin daub my forehead with the yellow ochre and tie a little *kalava*, a braided, saffron-coloured string bracelet around my wrist to signify that I too had accomplished my *puja*. I had made the pilgrimage and had honoured the spirit of the great river.

Sarnath and the Buddhist Dharma

Sarnath is a small city located some 13 kilometres northeast of Varanasi, near the confluence of the Ganges and the Gomati rivers. At its heart is a peaceful deer park, where Gautama Buddha 'first set in motion the Wheel of the Dharma',[159] when he taught the Dharma of the Four Noble Truths and the Noble Eightfold Path, which are the foundations of Buddhism, and where the Buddhist *sangha*, made up of the first five disciples, came into

Pauline, County Clare

existence. In the small museum one finds one of the earliest im-
age of the Buddha in India from the Gupta period (320–646 CE),
the quintessential image of the Buddha 'enshrining a kind of
celestial calm, serenity, a gentle smile, divine glow and unique
composure.'[160]

Not surprisingly, Sarnath has become a place of pilgrimage,
for Buddhists from India and abroad. Several countries in which
Buddhism is a significant religion, among them Thailand, Ja-
pan, Tibet, Sri Lanka and Myanmar, have established temples
and monasteries here, each in its own very different style. As
I walked around amongst the many ruins in the immaculate
gardens, near the remains of the Dhamek Stupa, built in 500 CE,
I met an elderly monk, clad in the traditional *tricivara*, the triple
set of robes, sitting quietly in the garden. Having greeted him,
he invited me to sit down. He had come, as a pilgrim, to Sarnath

Valerie, County Mayo

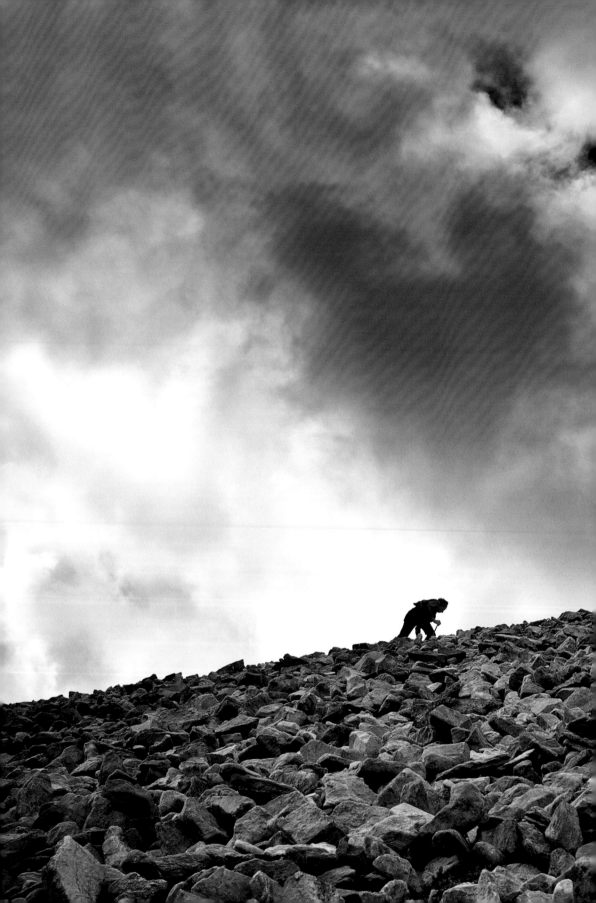

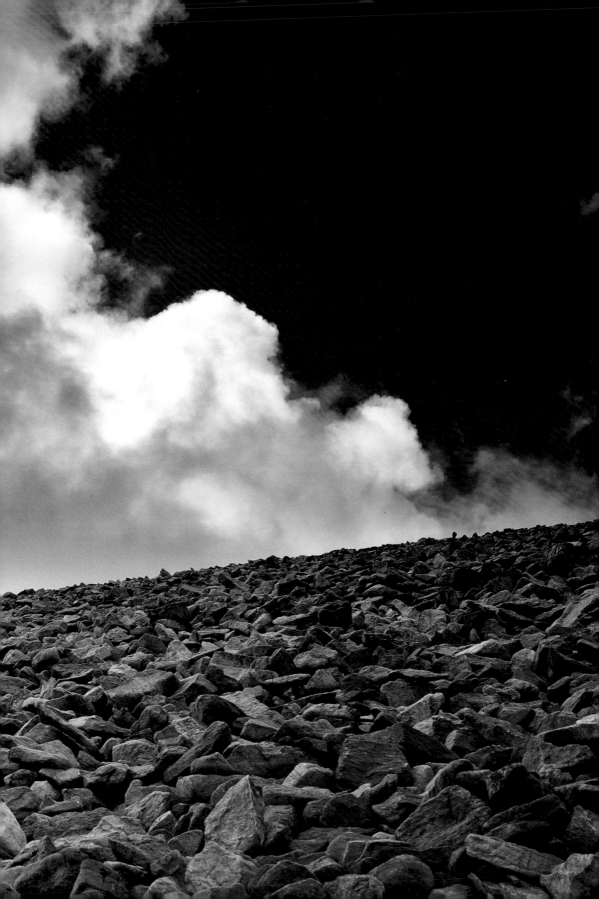

Peter, County Sligo

twenty-five years earlier as a recently retired policeman, he told me, and he had remained there ever since. He had been born a Hindu in Pushkar, which I had visited some weeks previously. This is the second holiest city in Hinduism, and one of the oldest in India, where Lord Brahma is said to have descended into the holy lake. Reflecting on the Upanishads, the Hindu scriptures that are also of great importance in the development of Buddhism, he told me that on arriving in Sarnath he had reached a moment of deep understanding of Noble Truths and a conversion to the Eightfold Path that led him to join the *sangha* and to remain. In a way, he had come home to Buddhism, reaching either the end or the real beginning of his search as he adopted the *dharma*, the Buddhist path that he had been following for twenty-five years and would no doubt follow in to a new arising, whatever that might be. At that moment he seemed to personify everything that was best in Buddhism. Did I envy him? Probably a little, and certainly such moments live on in the mind and they are at the heart of pilgrimage, his and mine. I have little doubt that such moments occur in all kinds of pilgrimages, great or little epiphanies that somehow alter or even change people's lives.

The Nizamuddin Dargah – A Sufi Shrine

Preparing for a trip to India in 2013, I read William Dalrymple's fascinating book on New Delhi, *City of Djinns*.[161] In the book, Dalrymple led me to the Nizamuddin Dargah, a small but significant shrine commemorating a great Sufi scholar and saint, right down in the heart of the city. My *tuk tuk* driver took me through the narrow streets to the entrance to the area. Here, I took off my shoes, paid ten rupees, and left them on the provided racks with hundreds of others. For a further few rupees, I bought a disposable *topi*, the small skullcap used by Indian Muslims for prayer, and a

small bag of rose petals to scatter on the shrine in the Sufi tradition. Having left my driver to look after his *tuk tuk*, I had to walk the remaining distance to the shrine through a maze of narrow alleys within the shrine complex right at the heart of the great city. The *dargah* is the mausoleum of one of the most revered Sufi scholars and saints, Nizamuddin Auliya (1238–1325 CE).

Like many sacred places in India, it is visited not just by thousands of Muslims but also by many Hindus, Christians and people from other religions, who come to pay their respects to a holy man. The complex also has the tombs of Ab'ul Hasan Yamīn ud-Dīn Khusrau, better known as Amīr Khusrow (1253–1325 CE), a much loved Sufi musician, poet and scholar, known as the father of the Urdu language and *qawwali* music. More unusually, perhaps, given the common perception of Islam and its attitudes to women, we also find here the tomb of the Mughal princess, Jehan Ara Begum (1614–1681), the daughter of the Mughal Emperor Shah Jahan (1592–1666), who built the Taj Mahal in memory of his favourite queen, his third wife Mumtaz Mahal, who died in childbirth in 1631. Her presence here reflects the Sufi belief in the equality of the women and men.[162]

Sufism, a mystic and ascetic movement which originated in about the ninth or tenth centuries, known as the Islamic Golden Age, seems to fit well with the wider Indian cultural tradition and there was much striking cross-fertilisation of thought and style with Hinduism and aspects of Buddhism, often reflected in Mughal and Rajput architecture. Sufism is defined as 'a school for the actualization of divine ethics [which] involves an enlightened inner being, not intellectual proof; revelation and witnessing, not logic'. These divine ethics are not 'mere social convention', but rather 'a way of being that is the actualization of the attributes of God'.[163] It is a rich mystical tradition that has more recently come under attack from Islamist extremists for its very different

approach to the faith of the Prophet, where poetry and *qawwali*, a form of Sufi devotional music, play such a large part.

Arriving in the shrine early in the morning, I found a place full with life. Hundreds of people filed past through a small mausoleum where the saint was buried as others sat outside in prayer. The pilgrims kissed the tomb and scattered rose petals, offering prayers for themselves and their families. *Qawaali* throbbed in the background, singing the faith in the heat of the day with remarkable passion and devotion. I offered a small donation and joined the queue waiting to offer their respects. Every time I slip off my dusty pilgrim sandals, leaving them at the entrance with many others, pay a few cents for a candle, a bunch of rose petals or a few sticks of incense, I feel a sense of solidarity with the people who are, as I often put it, 'going about the business of

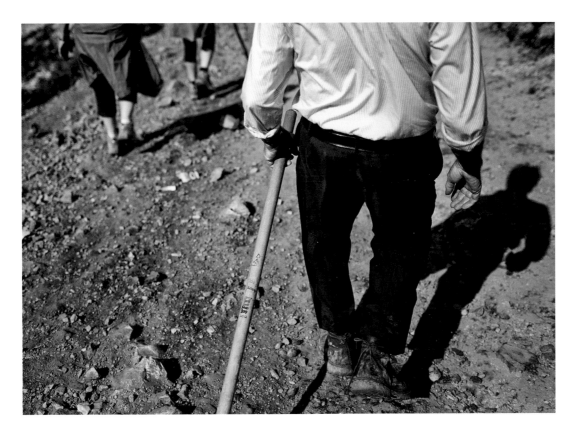

religion', which to them is the business of life. It is very much the same when the pilgrims buy a new stick at the foot of Croagh Patrick or a cheap plastic rosary beads – they are taking part in an ancestral practice which is in its own way an important part of the continuing business of life, if only for that one day.

Back to the Beginning

In his research Robert Macfarlane happened across what he said was a sixth century Tibet word, *shul*. My own suspicion that its origins may well lie much further back in Sanskrit or Pali, the early language of Buddhism and one of the earliest Proto-Indo-European languages. The word has several meanings, several related to the feet. It may mean a mark that remains behind, a footprint, but also a scarred hollow in the ground where something may have once stood; it can also be the channel worn through rock where a river runs in flood, or the indentation on the grass where an animal has rested. I have the idea that it may well be part the origin of the English word *shoe* or the German *schuh,* and even the root of the French world *chaussure*, all related to the feet and indeed to footprints. More intriguing and, perhaps, not so far-fetched as one might imagine, given the significance of Proto-Indo-European, is the possibility that it might also be the origin of the Gaelic word *siúil*, meaning simply *to walk*. Pilgrimage of whatever kind is, as I have pointed out earlier, essentially about walking, about following in the footprints of others and eventually leaving footprints of our own as we pass through. It has become clear to me that pilgrims everywhere are doing the same thing as 'my people', the pilgrims of Croagh Patrick, where some still go barefoot to the summit of their holy mountain but always leaving a *shul*, a trace on the path as they pass by.

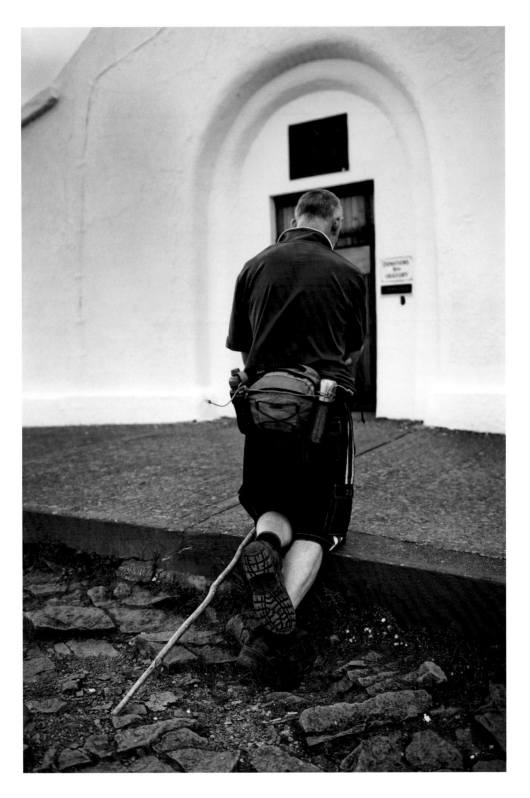

Why Do They Do It?

While Croagh Patrick has become a largely assimilated Catholic devotional exercise, taking its present form in the nineteenth century, it is clearly much more than that. Talking to people, it becomes clear that it is multi-layered, since, as we have seen, its history stretches back much further and there are many strands to what has taken place at the mountain over many millennia and still today. This is, in fact, part of its real power, the hold it has on the imagination of the people who engage with it, just like Varanasi or Sarnath or the Nizamuddin Dargah. In my engagement with all of these pilgrimages and places it has become clear to me that it is not the theology but rather the *doing*, it is the walking, the following, the kneeling, the *being there* that really matters. Why do they do it?

I met Mick O'Dea, one of our most prominent artists,[164] on Inislacken in July 2016. He was painting while I was taking photographs and surreptitiously sketching the abandoned houses on the deserted island. Mick told me he had been coming to Inislacken for seventeen years, observing that this somehow 'marks the passing of the year', another of those secular pilgrimages. However, he also said that he climbs the Reek each year with something of the same logic of 'marking time'. 'A lot of people from Clare do it, and my family has been doing it for seventy years, so I just do it.' This is, no doubt, why many people do it, the living out of a tradition, remembering and honouring the memory of those 'who have gone before marked by the sign of faith', even if our faith is perhaps not quite the same as theirs. The value is in the doing, in the remembering and in the faithfulness to something that is somehow bigger than ourselves. It is, perhaps, both a seeking for and a return to some kind of source both beyond and within the *self*, like all the pilgrimage we have looked at.

Joe and Mary, County Kilkenny

The actor Martin Sheen, who walked parts of the *camino* in 2003, says:

> I love the Camino. It's a beautiful route and a deeply personal journey. People take the pilgrimage for many reasons, and each comes to grips with the inner journey, which is really a yearning for transcendence.

This is not an uncommon view but it is increasingly not the only one in a post-religious world. Sheen's son, Emilio Estevez, who directed their joint film *The Way* and who describes himself as secular, agrees, even if he sees it slightly differently.

> I just wanted to make an honest film. If you're a person of faith, you'll find something in this movie that speaks to you. If you're not, you'll find something of interest too. But what I love about the Camino is that the road is a metaphor for our lives: *Are we walking in truth? Are we walking with integrity?* That's what speaks the loudest to me in this film.[165]

The same could certainly be said of the Reek. There is something going on here that is somehow beyond simple devotional practice and indeed, as Estevez points out, has a lot to do with truth and integrity, as Szustek and Bereska have also noted. In the course of my conversations with the pilgrims three words occurred repeatedly: *tradition, remembering* and *penance* in that order. Many of the people I encountered were indeed religious in the traditional sense, but many were not and still they went there and will go there again many times for these same reasons.

Carmel, a pilgrim, wrote to Tom Szustek:

> I climbed when I was 13 when people did it in the dark, it was very different then. I then started in 2001 and have climbed it every year since. I do it for many reasons. I like a challenge; I

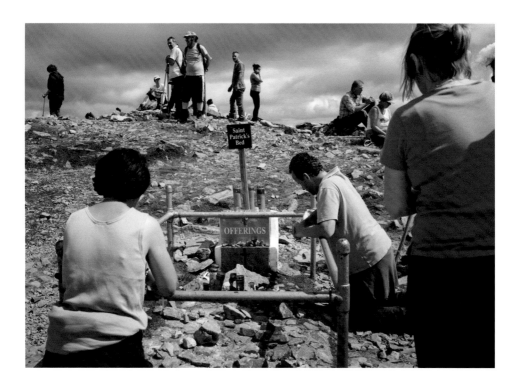

am spiritual (although brought up a catholic) so find it very
rewarding climbing on my own. I also love the camarade-
rie on the day. I try not to miss a year. Most of all it's such
a beautiful place to be and the feeling of achievement at the
end is wonderful.

Michael, from Galway, climbs the mountain every year and
recently in aid of a charity.

The first time I climbed it was in 1993 (and) I have done it ev-
ery year since. I [did] it this year for Galway Hospice on June
15. That is twice I did it this year. (Climbing) is something I
like very much to do. So far I have it done 22 times.

In more strictly traditional terms, Ronan completed the pil-
grimage barefoot as a penance, while John and Breege also ac-
knowledge that they do it as penance, while adding, 'we also do

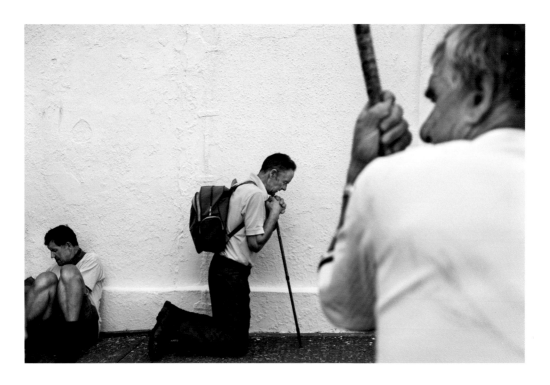

it for health reasons'. This is echoed by Jarlath and Carmel who bring together many of the central themes when they say:

> We climb Croagh Patrick most years just to say thanks to God for the past year and the good health we enjoy. We also pray for all our dead and remember all the sick, also to meet other people and be a part of the challenge on such a holy mountain. There is always a good feeling when we have completed the climb. We feel we have given something back to God.

The Reek has never been without its lighter moments and, in many ways, it is inextricably linked to the whole culture of summer in Connacht – the Championship, the Galway Races, the Reek. Edith forwarded a lovely letter to Tom Szustek, written by her father John, with whom she climbed the Reek, which brings much of this together:

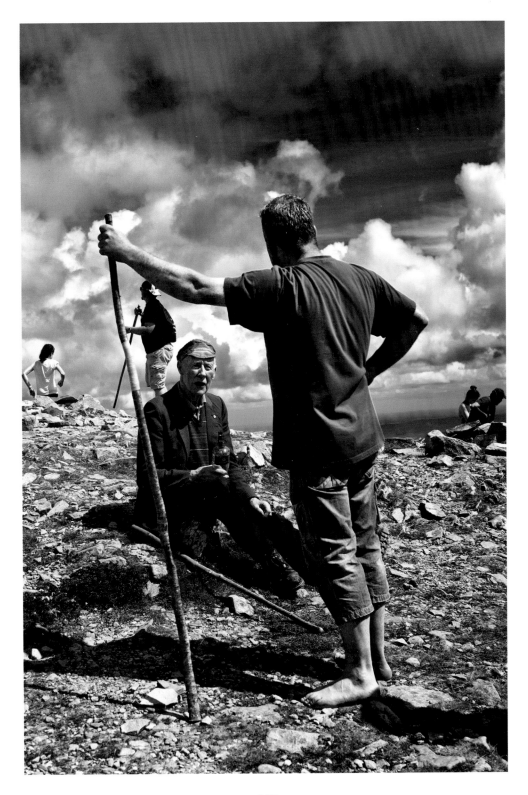

Hi Tom – We have a nice story on how we came to climb the mountain.

I am from Co Sligo but we now live in Dublin. On the Saturday evening Sligo played Kildare in the GAA championship in Roscommon, we went to this match where Sligo suffered one of their worst defeats ever, we left there and stayed in a Camping site near Castlebar on that night. On the Sunday morning we rose early and climbed Croagh Patrick. Edith was a reluctant pilgrim, on at least 2 occasions during the ascent she sat down and refused to go any further but with some coaxing(and a few threats) she made it to the top. In fact she was secretly very proud that she had achieved that.

Secondly, my wife and I were married 30 years ago on August 3rd and 30 years ago I had also climbed the reek as a pilgrimage with my Brother who has since passed away, just prior to my wedding. It was the only time I had made the climb.

So it was a reflection of that and coincided with the GAA match and I later remarked that I wasn't sure which was the worse penance, the horrendous defeat of Sligo or the climbing of the reek, but, the one coupled with the other meant that I had certainly done my penance for the year.

John

It seems to me that these testimonies illustrate the many reasons people undertake pilgrimage of any kind but they speak very beautifully for the people in this book. As I have written already, they really have little to do with any theology but all to do with their own lives, and often their aspirations, their hopes and also their suffering. They are honouring a tradition and a memory, and they are seeking to make sense of their lives. All of this is illustrated in the photographs which speak so eloquently about *these people of mine,* these pilgrims of Croagh Patrick.

Endnotes

1 Peter Harbison, *Pilgrimage in Ireland*, New York: Syracuse University Press, 1994, pp. 71-110.

2 See http://uspecto.com.

3 See *Granta* 1989, 10th Birthday Special, Penguin Books, 1989, pp. 201-209.

4 Patrick Claffey, 'Atlantic Tabor', *Poetry Ireland Review*, 38, Summer 1993, pp. 33-34.

5 *Granta* 1989, 10th Birthday Special, Penguin Books, 1989, pp. 201-209.

6 Gerry Badger and Marie Klimešová, 'Sing a Sad Song, and Make It Better', see Markéta Luskačová Monography Torst Prague http://www.MarkétaLuskačová.com/publications/05-Markéta-Luskačová-monography-torst-prague.

7 *Granta* 1989, 10th Birthday Special, p. 204.

8 *Dukkha* is the first of the Four Noble Truths, the truth of suffering and the belief that that all human experience is transient and that suffering results from excessive desire and attachment.

9 *Moksha* is a term in Hindu, Buddhist and Jain philosophy which refers to various forms of emancipation, liberation, and release from *Dukkha*.

10 *The Maha Kumbh Mela* 2001 indianembassy.org accessed 03/02/2016.

11 *Granta* 1989, 10th Birthday Special, p. 208.

12 See Clifford Geertz, (1984) 'From the Native's Point of View: On the nature of anthropological understanding,' in *Culture Theory: Essays on Mind, Self, and Emotion*. Edited by R. A. Shweder and R. LeVine, New York: Cambridge University Press, 1984, pp. 123-136.

13 E. Estyn Evans, *Ireland and the Atlantic Heritage: Selected Writings*, Dublin: Lilliput, 1996, p. 60.

14 James Hastings and John A. Selbie, *Encyclopaedia of Religion and Ethics, Part 19* (New York, 2003), p. 12.

15 Seamus Heaney, *Seeing Things*, 'Crossings' XXXII, Faber and Faber, 1991, p. 90.

16 Mircea Eliade, *The Sacred and the Profane: The Nature of Religion*, Harvest/HBJ Publishers, 1957, pp. 9-12.

17 Diane Cole, 'Pilgrims' Progress', *National Geographic*, 203/4, 2008.

18 'The Jubilee is called Holy Year, not only because it begins, is marked, and ends with solemn holy acts, but also because its purpose is to encourage holiness of life. It was actually convoked to strengthen faith, encourage works of charity and brotherly communion within the Church and in society and to call Christians to be more sincere and coherent in their faith in Christ, the only Saviour.' See What is a Holy Year, http://www.vatican.va/jubilee_2000/docs/documents/ju_documents_17-feb-1997_history_en.html (accessed May 2, 2015).

19 See The National Geographic Channel, Kumbh Mela, http://natgeotv.com.au/tv/kumbh-mela/kumbh-mela-facts.aspx.

20 See John Bowker, 'Homo religiosus.' *The Concise Oxford Dictionary of World Religions*, 1997.

21 In Catholicism, popular piety has been described as 'a true treasure of the People of God' (John Paul II, 1987). In a directory on the matter in 2001 the Congregation for Divine Worship notes that: 'Genuine forms of popular piety, expressed in a multitude of different ways, derives from the faith and, therefore, must be valued and promoted. [They are considered important] in promoting the faith of the people, who regard popular piety as a natural religious expression, they predispose the people for the celebration of the Sacred Mysteries.'(Directory on Popular Piety and the Liturgy, #4).

22 José Casanova, *Public Religions in the Modern World*, Chicago: University of Chicago Press, 1994, See Ch 4: 'Poland: From Church of the Nation to Civil Society'.

23 'Shrine of Guadalupe Most Popular in the World', *Zenit*, June 13, 1999.

24 See Derry Brabbs, *The Road to Santiago*, London: Lincoln, 2004, ch 1.

25 John Muir, 1913, in Linnie Marsh Wolfe, ed., *John of the Mountains: The Unpublished Journals of John Muir*, 1938.

26 Robert Macfarlane, *The Old Ways: A Journey on Foot*. London and New York: Penguin Hamish Hamilton and Viking, 2012, p. 23.

27 Søren Kierkegaard, letter to Jette (1847).

28 Henry David Thoreau, *Walden; or, Life in the Woods*, London: Norton Critical Edition,1966, p. 61.

29 SparkNotes Editors. 'SparkNote on Walden.' SparkNotes LLC. 2003. http://www.sparknotes.com/lit/walden/ (accessed May 1, 2015).

30 Jack Kerouac, *On the Road* , New York: Viking Press, 1957.

31 Mount Kailash (also Mount Kailas) is a peak in the Kailash Range (Gangisê Mountains), which forms part of the Transhimalaya in Tibet. The mountain has never been climbed and all attempts to do so have been banned by the Chinese government.

32 *Bön* is a Tibetan religious tradition or sect, it can be distinguished from Buddhism in a number of its myths, while in general its teachings, terminologyand rituals are quite close to Tibetan Buddhism.

33 Robert Macfarlane, *The Old Ways*, p. 261.

34 Colin Thubron Paperback Q&A: Colin Thubron on Colin Thubron on To a Mountain in Tibet http://www.theguardian.com/books/2012/jan/24/paper-backqa-colin-thubron-mountain-tibet (accessed 08/05/15).

35 Colin Thubron, *To a Mountain in Tibet*, London: Chatto and Windus, 2011, p. 9.

36 John Brierley, *Pilgrim's Guide to the Camino de Santiago*, Forres, Scotland: Findhorn Press (Camino Guides) 2014 (11th edition), p. 8.

37 Robert Macfarlane, *The Old Ways*, pp. 26-27.

38 Patrick Claffey, 'Atlantic Tabor'.

39 Peter Harbison, *Pilgrimage in Ireland*, p. 69.

40 The term *cruach* has its etymological origins in Old Irish and is commonly used to designate a stack of corn, a rick, heap or conical pile. It is only rarely used to designate a mountain, a notable exception being Cruach Mhór at 932 meres, in MacGillycuddy's Reeks and, of course Cruach Phádraig. The diminutive term *cruachán* is more frequently used to describe a small hill, of which there are several examples, notably Cruachan Aí, a sacred centre for Druidic teaching, magical practice and mythological champions at Rathcroghan, County Roscommon. It was the home of the Warrior Queen, Medb of Connacht, and scene of *Táin Bó Cúailnge* (the Cattle Raid of Cooley) (http://www.rathcroghan.ie/, accessed 05/05/15). The Aigle in the old name for what is now Cruach Phádraig may refer to *aige*, 'act of celebrating or holding festivals' (Michael Dames, *Ireland: A Sacred Journey*, Dorset: Ted Smart, 2000, p. 155) thus confirming its ritual significance.

41 Harbison, *Pilgrimage in Ireland*, p. 68.

42 Dames, *Ireland: A Sacred Journey*, p. 155.

43 Technically a mountain has an altitude greater than that of a hill, usually greater than 2,000 feet (610 meters).

44 Harbison, *Pilgrimage in Ireland*, p. 68.

45 Thubron, *To a Mountain in Tibet*. p. 5.

46 Mircea Eliade, *The Sacred and the Profane*, p. 38.

47 Ibid., p. 39.

48 Ibid., p. 9.

49 Ibid., p. 12.

50 Minya Konka, also known as Mount Gongga is the highest mountain in Sichuan province, China, locally known as 'The King of Sichuan Mountains'. It rises to 7,000 metres (23,000 feet.)

51 Robert Macfarlane, *The Old Ways: A Journey on Foot*, pp. 278-79.

52 http://www.mayo-ireland.ie/en/things-to-do/outdoor-activities/walking/croagh-patrick-ridge.html.

53 Lorna Siggins, 'Megalithic rock-scribing found near Croagh Patrick', *Irish Times*, February 27, 2015.

54 For details of this very interesting and important site see ttp://www.heritageireland.ie/en/west/ceidefields.

55 Mircea Eliade, *The Sacred and the Profane*, p. 11. Eliade posits a sharp distincion between the sacred, relating to God, gods, spirits, mythical ancestors and otherworldly forces and the profane or the 'inworldly'. In his view for pre-rational, religiously porous, man, myth is employed to articulate what he describes as 'breakthroughs of the sacred (or the 'supernatural') into the World', hierophonies as he calls them as distinct from the more restrictive term 'theophany' which would refer specifically to the appearance of a god.

56 See Charles Taylor, *A Secular Age*, Belknap: London, 2009, pp. 35-42. Taylor makes the distinction between 'porousness' which he considers to have been part of the condition of an earlier religiosity which was open to all kinds of supernatural intervention including possession by both malevolent and benevolent spiritual forces and the modern 'bounded' or 'buffered' self, which is, in this sense, invulnerable and impervious to such forces.

57 Mircea Eliade, *The Sacred and the Profane*, p. 11.

58 Dames, *Ireland: A Sacred Journey*, p. 155.

59 See Máire MacNeill, *The Festival of Lughnasa: A Study of the Survival of the Celtic Festival of the Beginning of Harvest*. Oxford University Press, 1962.

60 J.B. Whittow, *Geology and Scenery in Ireland*, London: Penguin, 1974, pp. 172-73.

61 Macfarlane, *The Old Ways*, p. 273.

62 See Robin Horton 'African Conversion', *Africa: Journal of the International African Institute*, Vol. 41, No. 2 (Apr., 1971), pp. 85-108.

63 Steve Bruce, *Religion in the Modern World: From Cathedrals to Cults*, Oxford: OUP, 1996, ch. 3.

64 Harbison, *Pilgrimage in Ireland*, p. 67.

65 Ibid., p. 35.

66 See *Ireland: A Sacred Journey*, p. 35 for a short but useful explanation of this goddess.

67 Harry Hughes, *Croagh Patrick: A Place of Pilgrimage, A Place of Beauty*, Dublin: O'Brien Press, 2010, p. 21.

68 Rev. James Page, 'Ireland: Its Evils Traced to Their Source' (London, 1836), p. 62 in McNally, *The Evolution of Pilgrimage*, p. 92.

69 Ibid., p. 77.

70 Caesar Otway, 'Tour in Connaught' (Dublin, 1839), p. 317 in McNally, *The Evolution of Pilgrimage*, p. 92.

71 William Makepeace Thackery, *The Irish Sketch Book and Contributions to the 'Foreign Quarterly Review'* 1842-4, Oxford University Press, 1863.

72 Victor and Edith Turner, *Image and Pilgrimage in Christian Culture: Anthropological Perspectives* (Oxford, 1978), p. 123.

73 Fiona Rose McNally, 'The Evolution of Pilgrimage in Early Modern Ireland', MLitt thesis, Depart of History, Nui Maynooth, 2012, p. 25.

74 Hughes, *Croagh Patrick*, p. 12.

75 Cit MacNeill, *The Festival of Lughnasa*, p. 72.

76 Janet Tanner, 'The Irish Penitentials and Contemporary Celtic Spirituality', *The Way*, 48/2 (April 2009), pp. 63–7

77 'Strictly speaking, a "penitential" is a libellus (small book) designed for pastoral use covering every kind of misbehavior that Christians consider "sinful" (i.e., offensive to God in contrast to a breach of legal requirements), arranged within a specific theological framework, specifying detailed amounts of penance as remedies.' http://what-when-how.com/medieval-ireland/penitentialsmedieval-ireland/ (accessed 12/05/15).

78 Harbison, *Pilgrimage in Ireland*, p. 235.

79 Fiona Rose McNally, 'The Evolution of Pilgrimage', p. 5 citing Jonathan Sumption, *The Age of Pilgrimage: The Medieval Journey to God* (Totowa, 2003), p. 137.

80 This practice of climbing at night was abandoned several years ago on health and safety grounds.

81 John Cunningham, 'Lough Derg: The spirit of a holy place', *Spirituality*, July-August 1997 accessed at www.

82 Citing Peter Harbison, Fiona Rose McNally, notes that from the twelfth century the Augustinians were responsible for taking over many of the earlier Irish monastic establishments. It would seem probable that this was with a view to bringing them into conformity with wider Church discipline and probably rooting out what were perceived as the vestiges 'heathenism' surviving on the extremities of Europe.

83 Michael Dames makes this point when he notes that Patrick did not have any connection with Lough Derg until several centuries after his death. He adds that 'a group of Catholic anchorites (hermits) *had* settled on Lough Derg by the seventh or eighth centuries, to lead a quiet life, but on Station Island, and now nothing of all of this.' Dames, *Ireland: A Sacred Journey*, p. 19.

84 See Dames, *Ireland: A Sacred Journey*, p. 35.

85 McNally, *The Evolution of Pilgrimage*, p. 90.

86 Igor Stravinky, *The Rite of Spring* is a ballet and orchestral concert composed in 1910-13 based on pagan rites of sacrifice.

87 Dames, *Ireland: A Sacred Journey*, p. 158.

88 Cit. in Hughes, *Croagh Patrick*, p. 23.

89 William Makepeace Thackery, *The Irish Sketch Book and Contributions to the 'Foreign Quarterly Review'* 1842-4, Oxford University Press, 1863.

90 Dames, *Ireland: A Sacred Journey*, p. 158.

91 Harbison, *Pilgrimage in Ireland*, p. 68.

92 The pledge of total abstinence from alcohol imposed on children at the time of their confirmation.

93 McNally, *The Evolution of Pilgrimage*, p. 92.

94 See http://www.nationalgallery.ie/en/Collection/Collection_Highlights/Painting_and_Sculpture/Orpen.aspx (accessed 17/05/2015).

95 McNally, *The Evolution of Pilgrimage*, p. 92.

96 Una Agnew, 'Faith in Patrick Kavanagh's Work', http://www.iec2012.ie/media/AgnewSSLDrUna-Friday1.pdf (accessed 30/05/15).

97 Donnchadh Ó Corráin, 'Paul Cullen' in *Emancipation, Famine and Religion: Ireland under the Union, 1815–1870*, http://multitext.ucc.ie/d/Paul_Cullen (accessed 18/05/15).

98 Ciarán O'Carroll, *Cullen: Portrait of a Practical Nationalist*, Dublin: Veritas 2008, p. 17.

99 Larkin, Emmet, 'The devotional revolution in Ireland, 1850-75' in *American Historical Review*, lxxvii, no. 3(1972), pp. 625-52.

100 O'Carroll, *Cullen*.

101 Seamus Heaney, 'Requiem for the Croppies', *Door into the Dark*, London: Faber, 1969.

102 Bernard O'Reilly, *John MacHale, Archbishop of Tuam: His life, times, and correspondence*, New York and Cincinatti, 1890 https://archive.org/stream/johnmachale01oreiuoft/johnmachale01oreiuoft_djvu.txt.

103 See http://www.catholicireland.net/the-lion-of-the-west-archbishop-johnmchale.

104 See http://www.catholicireland.net/the-lion-of-the-west-archbishop-johnmchale.

105 Anon, *Most Rev. Dr. John MacHale, Archbishop of Tuam: A Pen Picture of a Patriot of the Penal Days*, http://www.mayolibrary.ie/en/LocalStudies/Mayo-People/RevDrJohnMacHale/ (accessed 19/05/15).

106 Sean Freyne (1935–2013), ordained a priest in the diocese of Tuam, he was a lecturer in Sacred Scripture at St Patrick's College, Maynooth. He later left the ministry and eventually became Director of the Centre for Mediterranean and Near Eastern Studies at Trinity College Dublin.

107 Enda McDonagh, Professor of Moral Theology and Canon Law at the Pontifical University at Maynooth in 1958-1995. Founded the InterChurch Association of Moral Theology, he was also involved with the conducting of ecumenical retreats with the Church of Ireland and other Anglican clergy. In 2007 he was appointed an ecumenical canon at St. Patrick's Cathedral, Dublin.

108 John O'Donoghue (1956-2008), philosopher, poet, priest, mystic. O'Donoghue became widely known and admired following publication of his book *Anam Cara* (1997) and this was followed by several other works in the broad area of spirituality, including a volume of poetry, *Connemara Blues*.

109 Lawrence J. Taylor, *Occasions of Faith: An Anthology of Irish Catholics*, University of Pennsylvania Press, 1995, p. 174.

110 McNally, *The Evolution of Pilgrimage*, p. 131.

111 Thomas E. Hachey and Lawrence J. McCaffrey, *The Irish Experience since 1800: A Concise History* (3rd ed., New York, 2010), p. 70 cit in McNally, *The Evolution of Pilgrimage*, p. 131.

112 Tim Robinson, 'Introduction' in J.M. Synge, *The Aran Islands*, London: Penguin 1992.

113 McNally, *The Evolution of Pilgrimage*, p. 131.

114 Hughes, *Croagh Patrick*, p. 22.

115 John Healy, *The Life and Writings of Saint Patrick* (Dublin, 1905), p. 654. Cit in McNally, *The Evolution of Pilgrimage*, p. 132.

116 John Shovlin, 'Pilgrimage and construction of Irish national identity' in *Proceedings of the Harvard Celtic Colloquium*, xi (1999), p. 68.

117 Anderson, Benedict, *Imagined Communities: Reflections on the Origin and Spread of Nationalism*, London: Verso, 1991

118 McNally, *The Evolution of Pilgrimage*, p. 132.

119 Ibid.

120 Hughes, Croagh Patrick, p. 27 citing Anthony Murphy and Richard Moore, *Island of the Setting Sun*, Dublin: Liffey Press, 2008.

121 See Tóchar Phádraig, Co. Mayo, http://www.heritagecouncil.ie/landscape/initiatives/the-pilgrim-paths/tochar-phadraig/ (accessed 28/05/15).

122 http://www.ballintubberabbey.ie/histPath.htm (accessed 27/05/15).

123 The term *fools for Christ* or *holy fools* has its origin in 1 Corinthians 4:10. there are many examples in the early church and this was continued in the *yurodivy* (or *iurodstvo*) of Eastern Orthodox asceticism. These apparently foolish figures present themselves as social misfits who contest social norms and shock with unconventional behavior while delivering prophecies. See also 1 Corinthians 3:19-21.

124 http://www.ballintubberabbey.ie/histIsland.htm (accessed 27/05/15).

125 http://www.ballintubberabbey.ie/histBurn.htm (accessed 28/05/15).

126 See Nicholas P. Canny, *Making Ireland British 1580–1650*, Oxford 2001.

127 Hughes, *Croagh Patrick*, p. 45.

128 See http://www.heritagecouncil.ie/landscape/initiatives/the-pilgrim-paths/tochar-phadraig/(accessed 28/05/15.

129 http://www.ballintubberabbey.ie/vg_tocP.htm (accessed 29/05/15).

130 Fr Frank Fahey in *Tóchar Phádraig: A Pilgrim's Progress*, Ballintubber Abbey Publication, Mayo, 1989, p. v.

131 See http://www.holywell.seomraranga.com/holywellsireland.htm (accessed 29/05/15).

132 See http://www.holywell.seomraranga.com/holywellsireland.htm (accessed 29/05/15).

133 http://www.ballintubberabbey.ie/vg_tocP.htm.

134 Robert Frost, 'The Road Not Taken', Mountain Interval, 1920.

135 Gerard Manley Hopkins, 'God's Grandeur', *Poems*, 1918 in *Gerard Manley Hopkins: A Selection of his Poems and Prose*, London: Penguin, 1953, p. 26.

136 Patrick Claffey, 'Atlantic Tabor'.

137 See http://irishantiquities.bravehost.com/mayo/murrisk/murrisk.html).

138 Hughes, *Croagh Patrick*, p. 73.

139 Harbison, *Pilgrimage in Ireland*, p. 69.

140 Ibid., p. 146.

141 http://www.clewbaytrail.com/show.php?SitesID=10 (accessed 02/06/15).

142 See Karen Armstrong, *Fields of Blood: Religion and the History of Violence*, London: Vintage, 2014, p. 160.

143 See 'Stations of the Reek' http://www.catholicbishops.ie/wp-content/up-loads/2013/07/Reek-Sunday-Stations-of-the-Reek-booklet.pdf accessed 12/04/15.

144 See O'Donovan (1838), cit. in *Travel in Time*, Mayo 28 Carrowmacloughlin. See http://www.travels-in-time.net/e/ireland28moneng.htm accessed12/04/15.

145 Hughes, *Croagh Patrick*, p. 23.

146 Seamus Heaney, *Station Island*, London: Faber, 1984. The title sequences in this volume recounts Heaney's experience on Lough Derg where large numbers of people submit for three days to a strictly penitential regime of fasting and prayer, long vigils around the station 'beds', said to be the remains of monastic huts.

147 See Shirley du Boulay, *Beyond the Darkness: A Biography of Bede Griffiths*, Alresford, UK: O Books, 2003.

148 Abhishiktananda, Swami, *Ascent to the Depth of the Heart: The Spiritual Diary (1948-1973) of Swami Abhishiktananda*, Delhi (ISPCK), 1998.

149 Thomas Merton, *The Way of Chuang Tzu*, New Directions. 1965; *Mystics and Zen Masters*, Farrar, Straus and Giroux. 1967; *Zen and the Birds of Appetite*. New Directions. 1968.

150 John A. Coleman, 'Thomas Merton and Dialogue with Buddhism' *America*, Jul 13 2012 http://americamagazine.org/content/all-things/thomas-merton-and-dialogue-buddhism accessed 14/07/16.

151 John A. Coleman, 'Thomas Merton and Dialogue with Buddhism'.

152 John Moses, *Divine Discontent: The Prophetic Voice of Thomas Merton*, London: Bloomsbury, 2014.

153 Thích Nguyên Tạng , Tiểu Sử Bố Tát Thích Quảng Dức (in Vietnamese), Fawker: Quảng Đức Monastery, 2005

154 Jack Kerouac, *The Dharma Bums*, New York: Viking Press, 1958.

155 Gary Snyder, *Nobody Home: Writing, Buddhism, and Living in Places*, with Julia Martin, Trinity University Press, 2014.

156 Scott A. Mitchell, 'Buddhism and the Beats' www.oxfordbibliographies.com accessed 14/07/16.

157 Gilles Farcet, Allen Ginsberg, *Poète et bodhisattva Beat*, Paris, Editions Le Relie, 2004.

158 Mark Tully, *No Full Stops in India*, London: Penguin, 1988.

159 See http://www.buddhanet.net/e-learning/buddhistworld/sarnath.htm(accessed 03/08/16).

160 Anon, 'Evolution of the Buddha Image', http://www.exoticindiaart.com/article/lordbuddha/ accessed 15/07/16.

161 Dalrymple, William, *City of Djinns: A Year in Delhi*, London: Penguin, 1993.

162 See Key Beliefs at http://nizamuddinauliya.com/nizamuddin-auliya.html.

163 'What is Sufism?' The Nimatullahi Order http://www.nimatullahi.org/what-is-sufism/sufism-defined/ accessed 16/07/16.

164 Mick O'Dea (b. 1958), an Irish artist best known as a painter of portraits and historical subjects. President of the RHA.

165 'Interview: Martin Sheen Finds Transcendence', *Christianity Today*, October 5, 2011 http://www.christianitytoday.com/ct/2011/octoberweb-only/fatherbecomesson.html accessed 20/07/16.